WELCOME TO THE LAW OF ART

The purpose of this book is simple: to serve as a picture book to aide you on your journey toward inner peace and enlightenment.

The quotes found within are from a vast array of thought leaders ranging from ancient philosophers, spiritual guides, scientists, poets, and businessmen. And although these quotes origniate from seemingly contrasting sources they all reflect timeless universal truths geared toward reminding you of your divine nature to help you operate as the best possible version of you.

What would God do today? Create. So I would like to express the highest level of gratitude to every artist and photographer featured in this volume for allowing The Creator to flow through them and gift the world with these powerful visuals. At the end of the book you will find a directory that includes each of the artists contact info along with links to view and purchase their work.

Adieu my fellow ulta-light beings; go forth, work miracles, and spread the light.

Love You All,
Jeremy Patton

P.S. Have fun and author your story as you wish.

COMPEMDIUM

COLLAGES

PAINTINGS

PHOTOGRAPHY

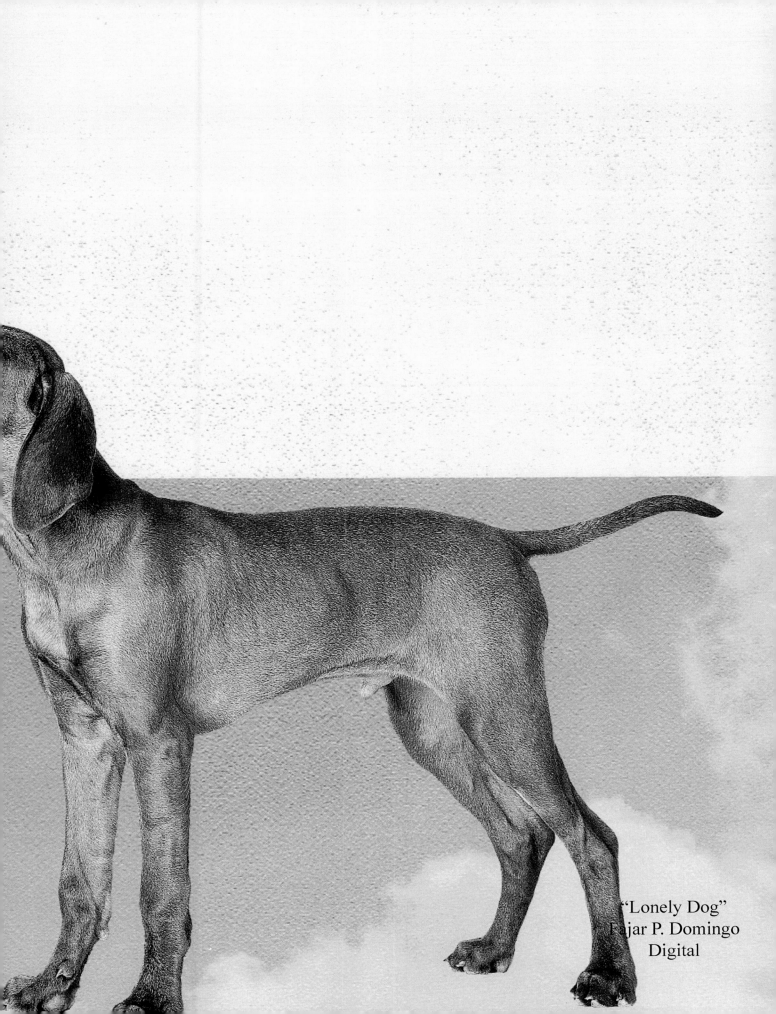

"Lonely Dog"
Fajar P. Domingo
Digital

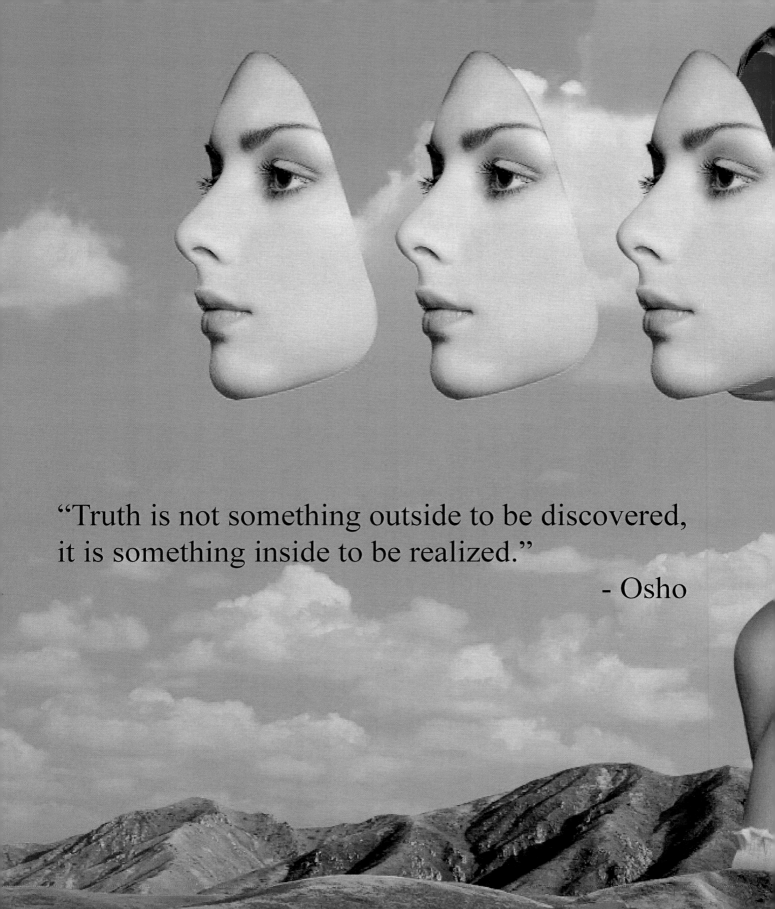

"Truth is not something outside to be discovered,
it is something inside to be realized."

- Osho

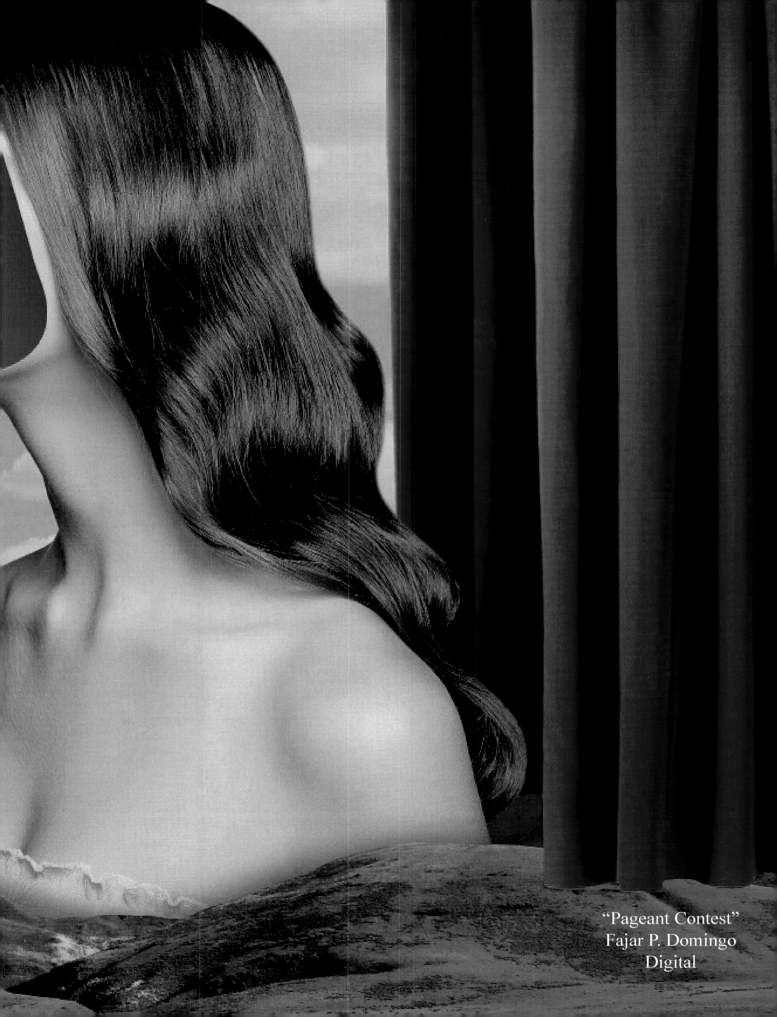

"Pageant Contest"
Fajar P. Domingo
Digital

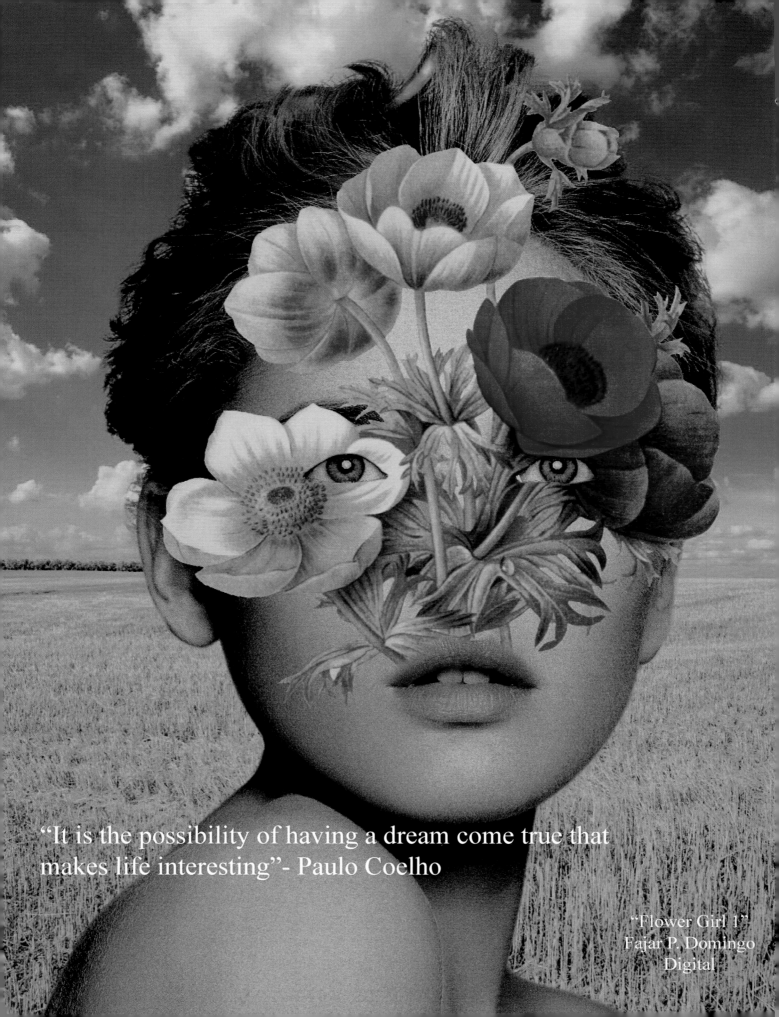

"It is the possibility of having a dream come true that makes life interesting"- Paulo Coelho

"Flower Girl 1"
Fajar P. Domingo
Digital

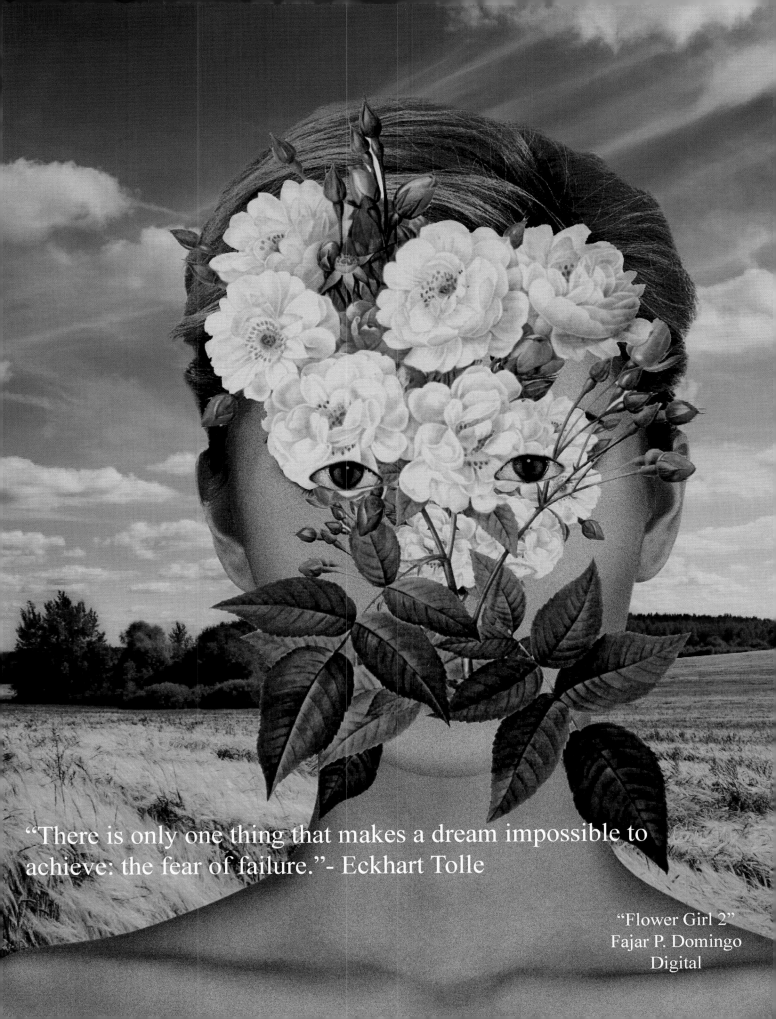

"There is only one thing that makes a dream impossible to achieve: the fear of failure."- Eckhart Tolle

"Flower Girl 2"
Fajar P. Domingo
Digital

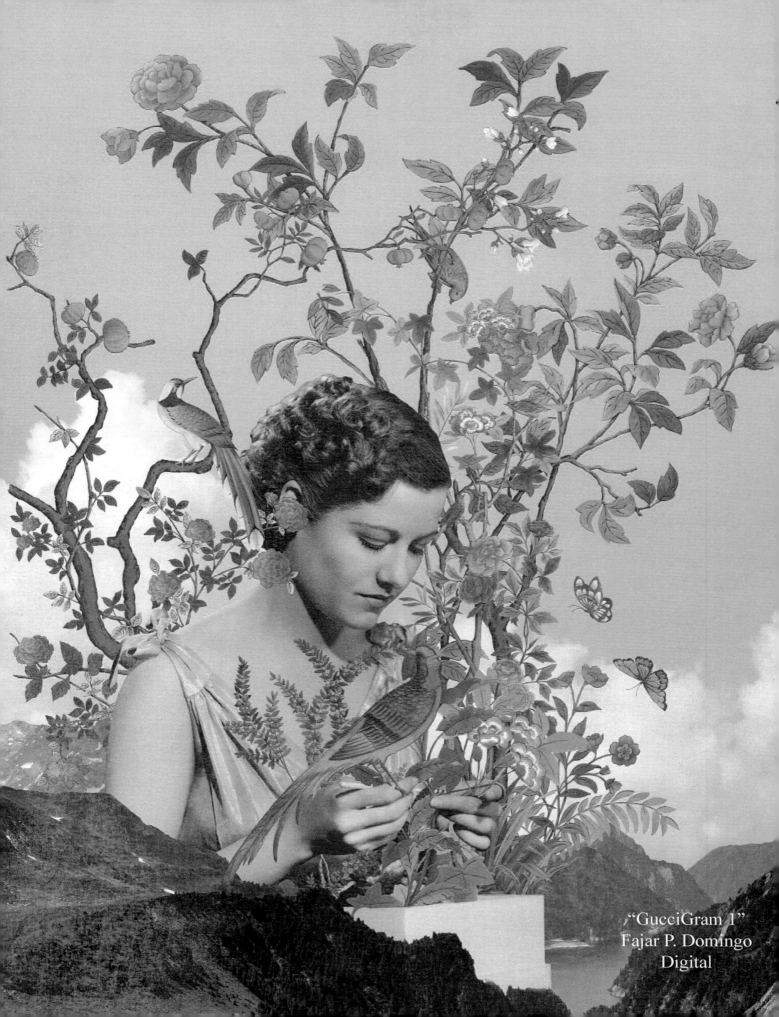

"GucciGram 1"
Fajar P. Domingo
Digital

"All negativity is caused by an accumulation of psychological time and denial of the present.

Unease, anxiety, tension, stress, worry - all forms of fear - are caused by too much future, and not enough presence.

Guilt, regret, resentment, grievances, sadness, bitterness, and all forms of nonforgiveness are caused by too much past, and not enough presence."
 - Eckhart Tolle

"God is life. God is life in action. The best way to say, "I love you, God," is to live your life doing your best. The best way to say, "Thank you, God," is by letting go of the past and living in the present moment, right here and now. Whatever life takes away from you, let it go. When you surrender and let go of the past, you allow yourself to be fully alive in the moment. Letting go of the past means you can enjoy the dream that is happening right now."

- Miguel Ruiz

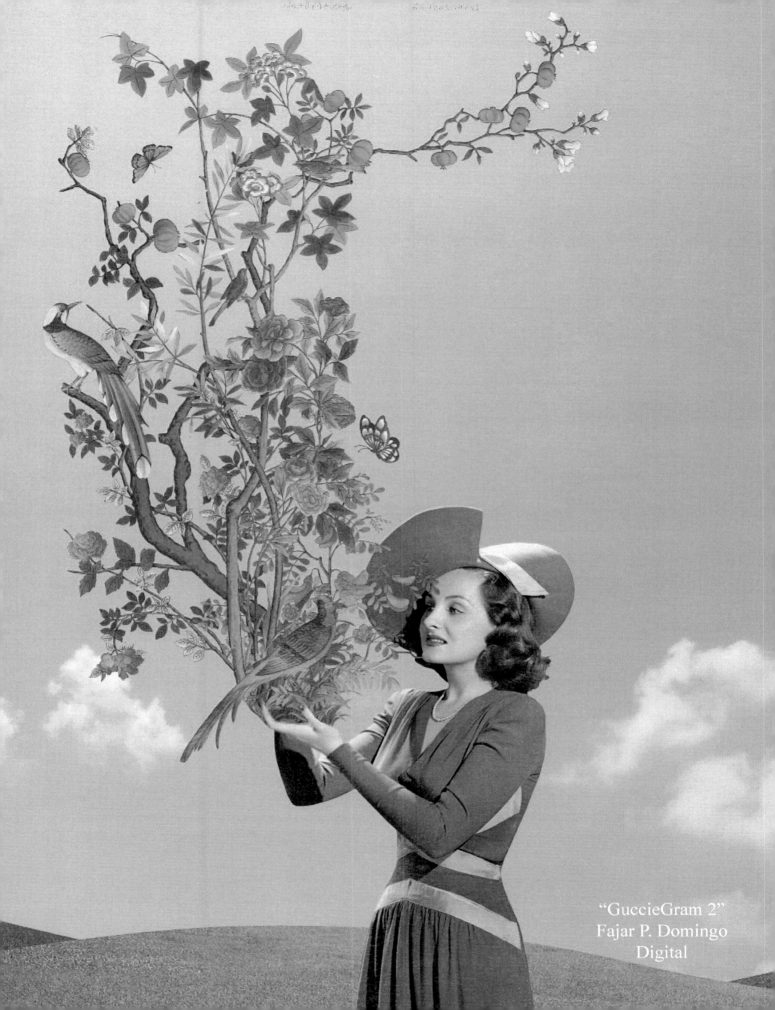

"GuccieGram 2"
Fajar P. Domingo
Digital

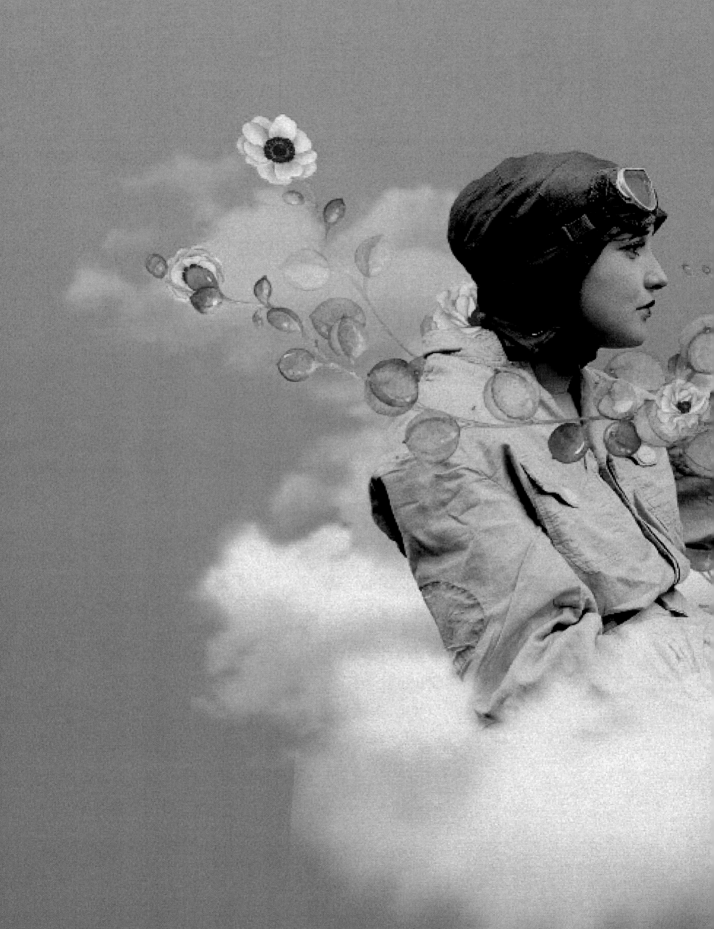

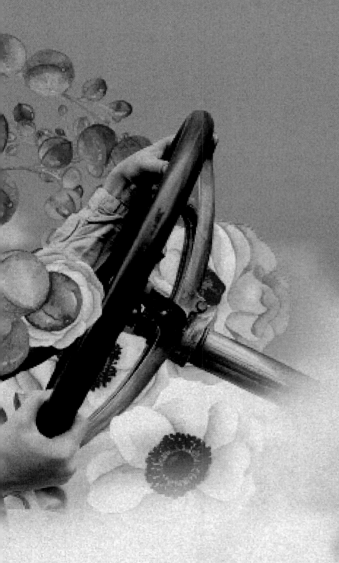

"You were born with wings, why prefer to crawl through life."
-Rumi

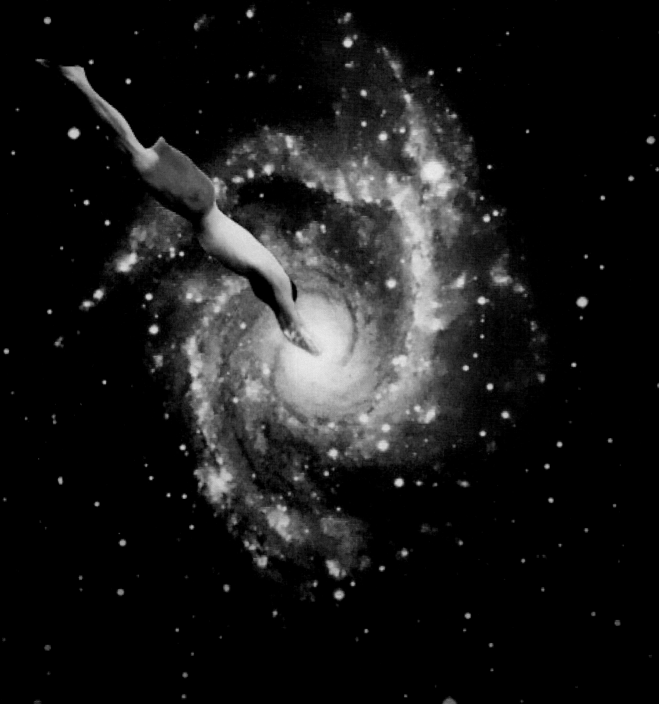

"Life begins where fear ends" -Osho

"Untitled"
Kerry Lambert
Analog Collage

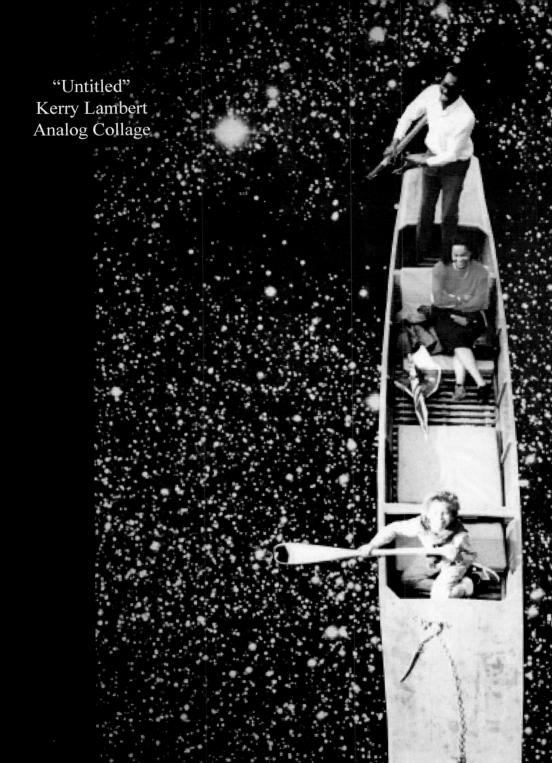

"We are travelers on a cosmic journey, stardust, swirling and dancing in the eddies and whirlpools of infinity. Life is eternal. WE have stopped for a moment to encounter each other, to meet, to love, to share. This is a precious moment. It is a little parenthesis in eternity."- Paulo Coelo

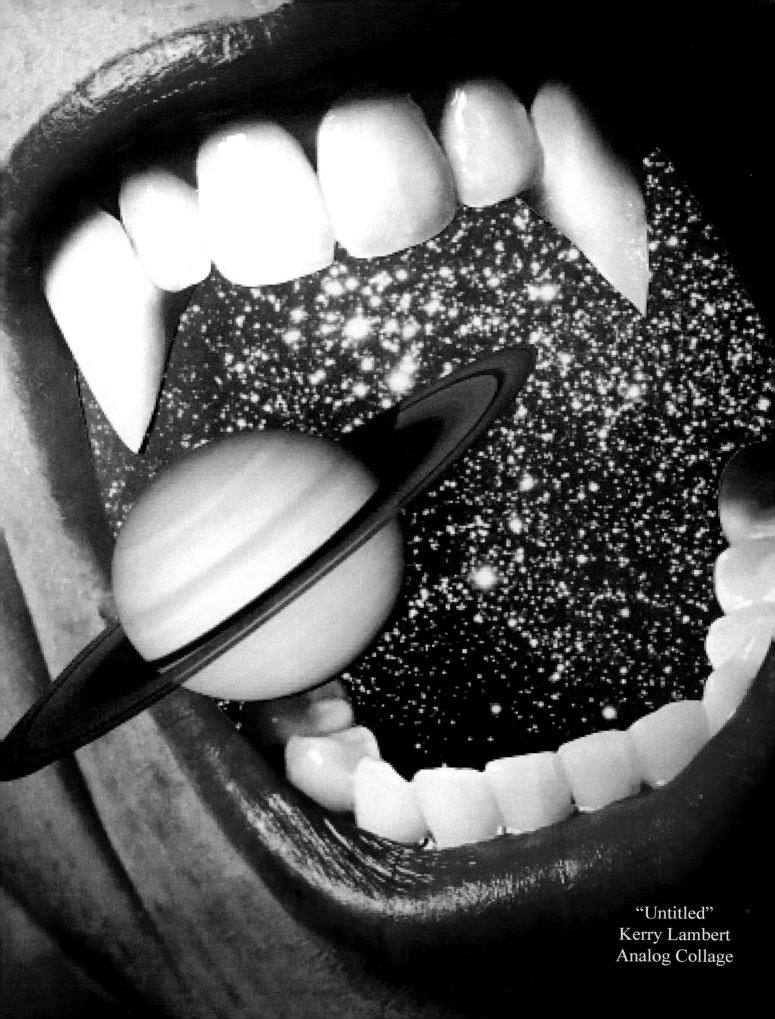

"Untitled"
Kerry Lambert
Analog Collage

"We humans have always sought to increase our personal energy in the only manner we have known, by seeking to psychologically steal it from the others - an unconscious competition that underlies all human conflict in the world."

-James Redfield

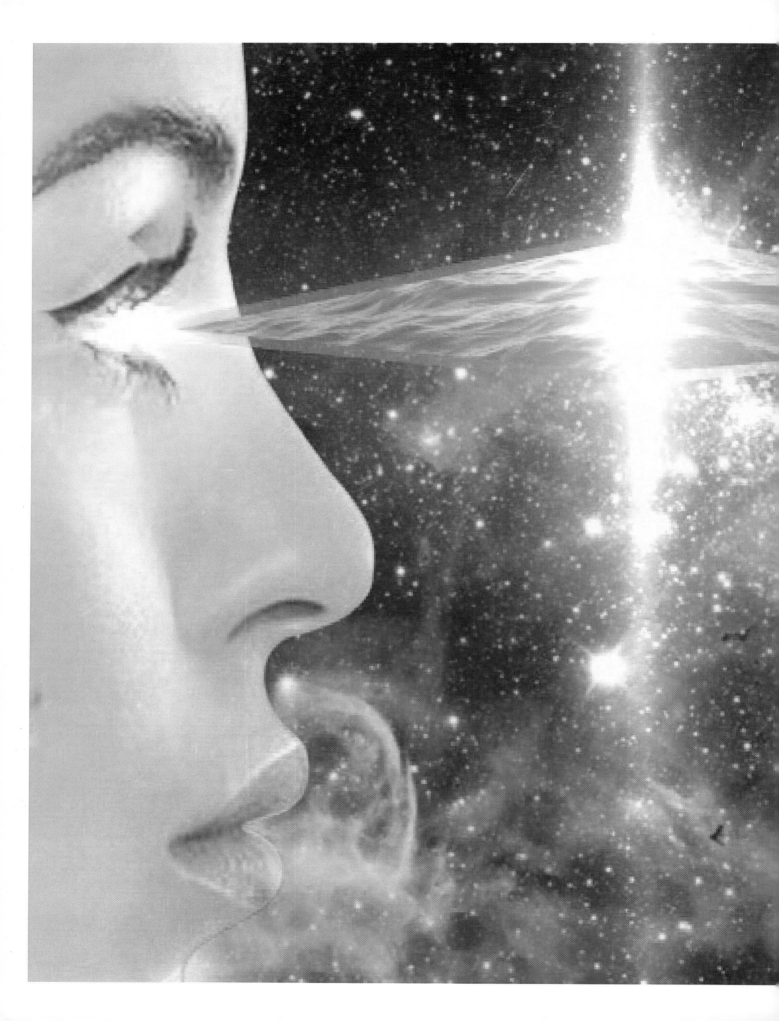

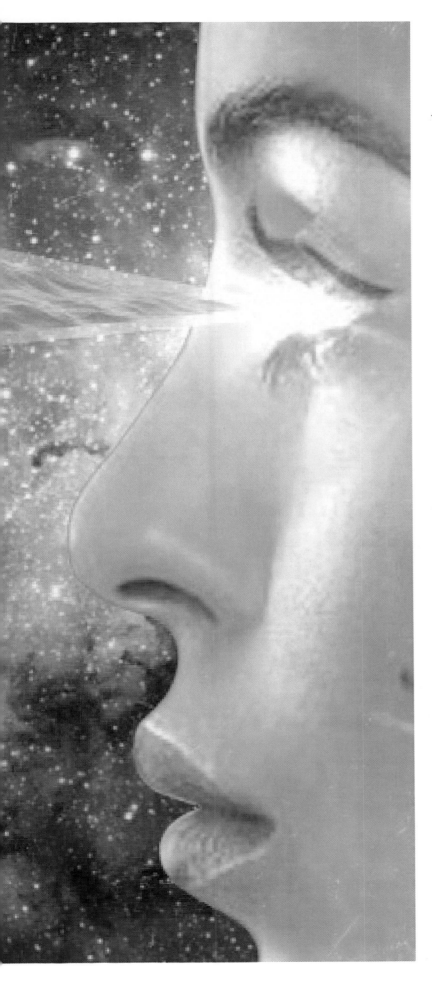

"Untitled"
Kerry Lambert
Analog Collage

"When you fight yourself to discover the real you, there is only one winner."
-Stephen Richards

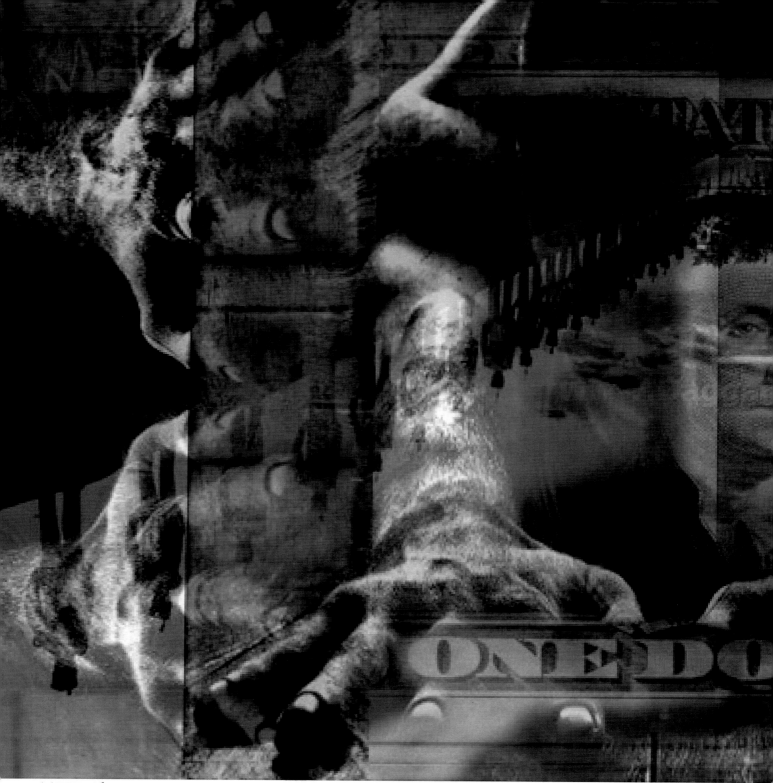

"When you are afraid of anything, you are
Remember that where your heart is, there
you value. If you are afraid, you are valuin

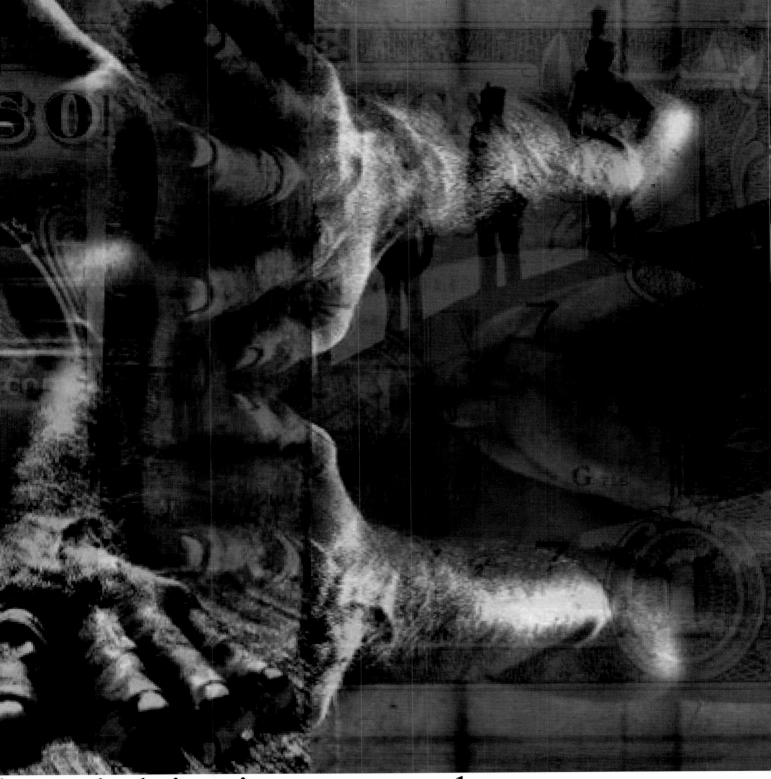

knowledging its power to hurt you.
our treasure also. You believe in what
wrongly." - A Course In Miracles

"Attachment is blinding, for it lands an imaginary halo of attractiveness over the object of desire."

-Parmhansa Yogananda

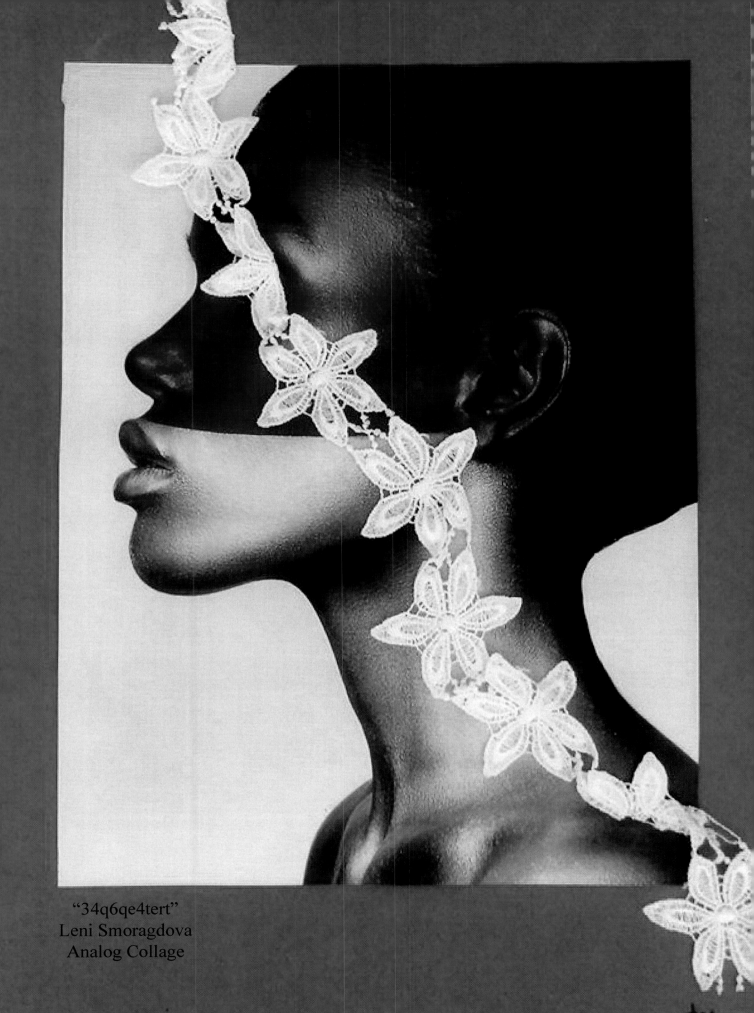

"34q6qe4tert"
Leni Smoragdova
Analog Collage

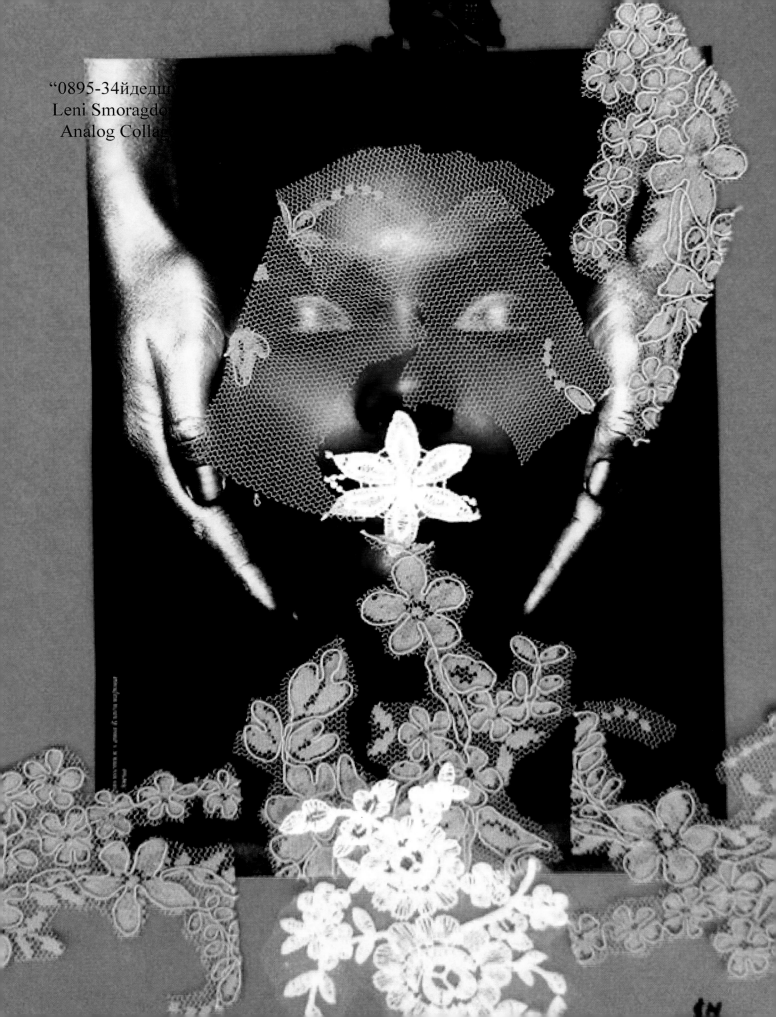

"0895-34йдедш
Leni Smoragdo
Analog Colla

"The most pathetic person in the world is someone who has sight but no vision."
 - Helen Keller

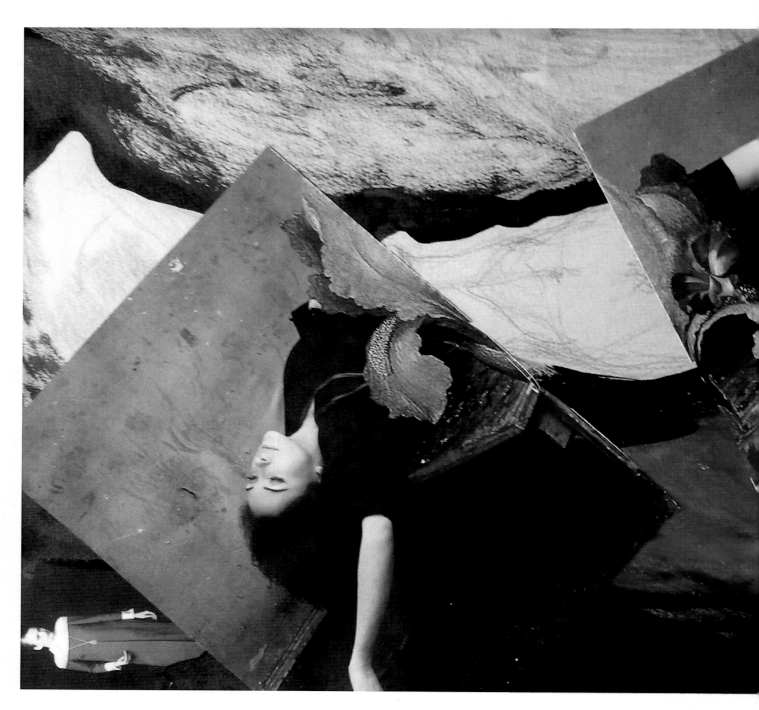

"hg87t986tguygvfj"
Leni Smoragdova
Analog Collage

"The real question is not whether life exists after death. The real qunestion is whether you are alive before death."
-Osho

"Nobody has the power to take two steps together; you can only take one step at a time." - Osho

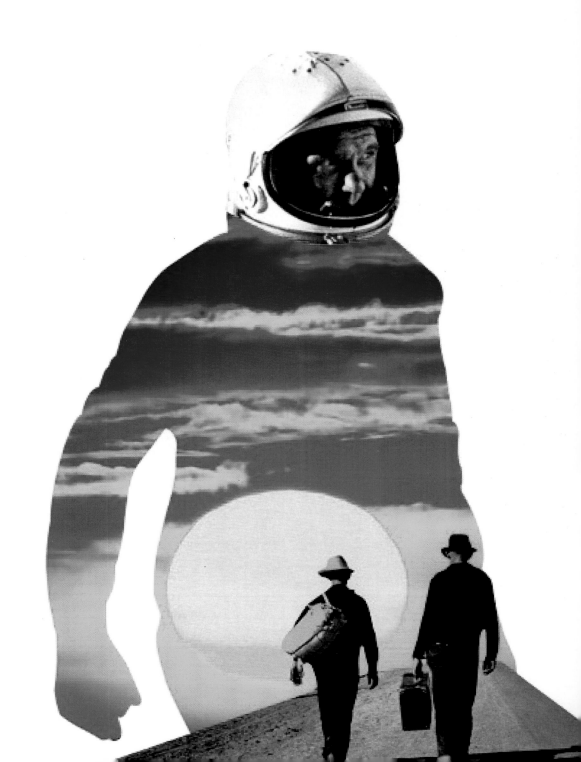

"Follow Me"
Vasilis Delis
Digital Collage

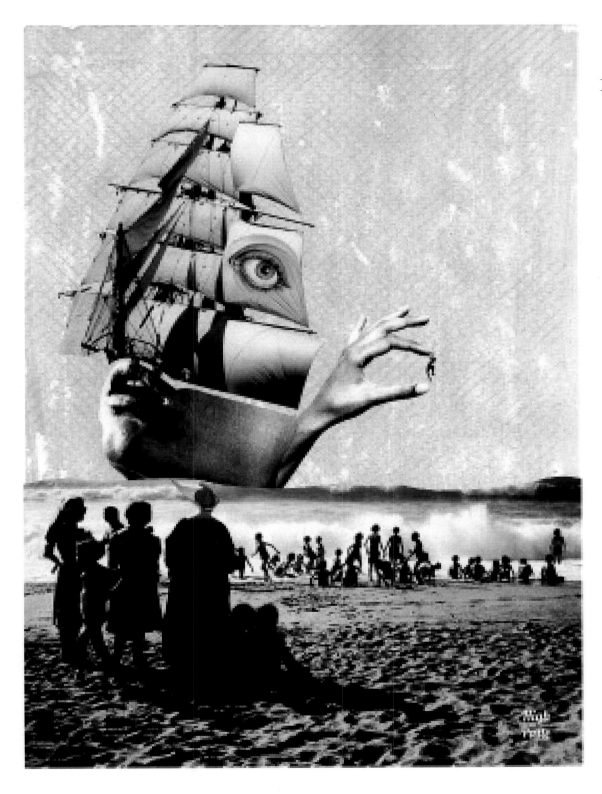

"I am not afraid of storms for I am learning how to sail my ship."
- Louisa May Alscot

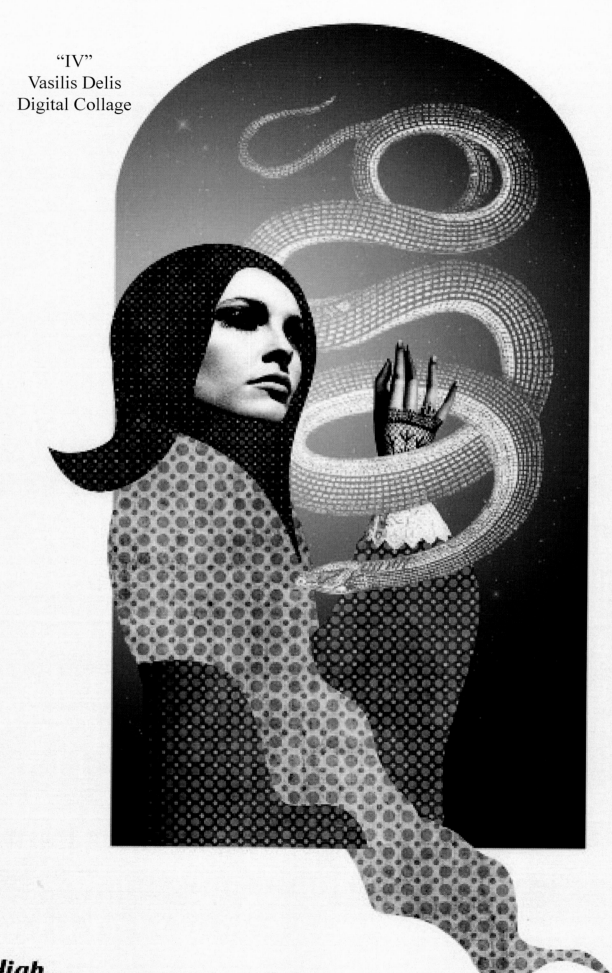

"IV"
Vasilis Delis
Digital Collage

High
on

"And no man hath ascended up to heaven, but he that came down from heaven, even the Son of man which is in heaven. And as Moses lifted up the serpent in the wilderness, even so must the Son of man be lifted up: that whosoever believeth in him should not perish, but have eternal life" (John 3:13-15)

"The Holy Spirit sees the world as a teaching device for bringing you home"

"The Holy Spirit guides you into life eternal, but you must relinquish your investment in death, or you will not see life though it is all around you."

- A Course In Miracles

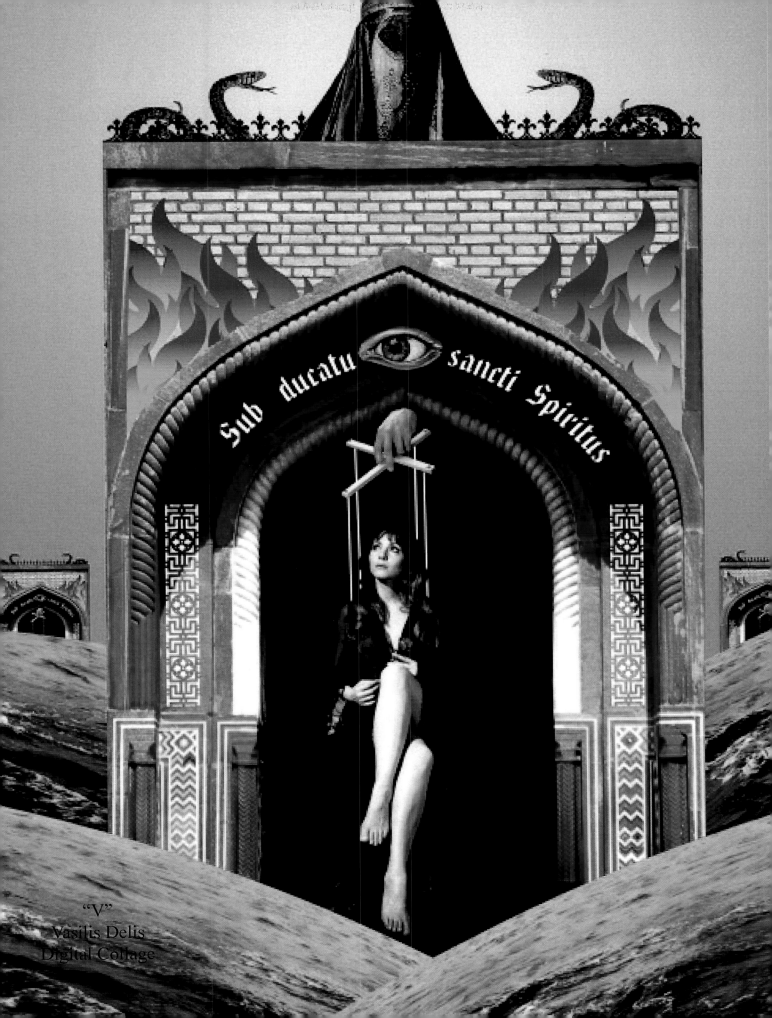

Sub ducatu sancti Spiritus

"V"
Vasilis Delis
Digital Collage

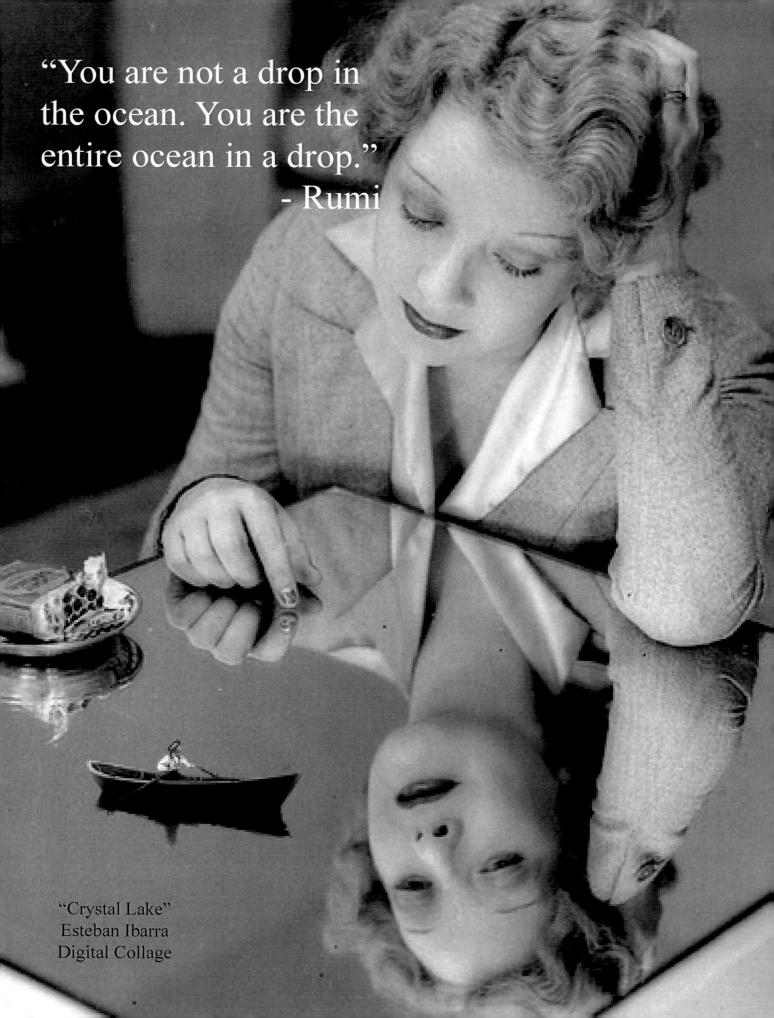

"You are not a drop in the ocean. You are the entire ocean in a drop."
- Rumi

"Crystal Lake"
Esteban Ibarra
Digital Collage

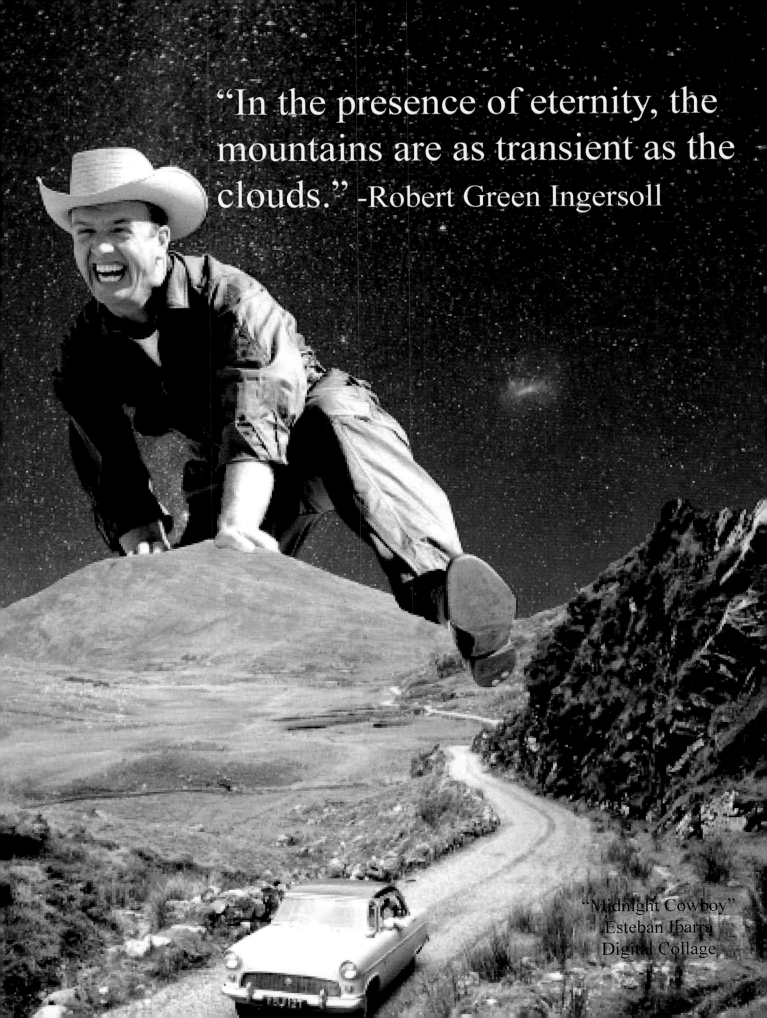

"In the presence of eternity, the mountains are as transient as the clouds." -Robert Green Ingersoll

"Midnight Cowboy"
Esteban Ibarra
Digital Collage

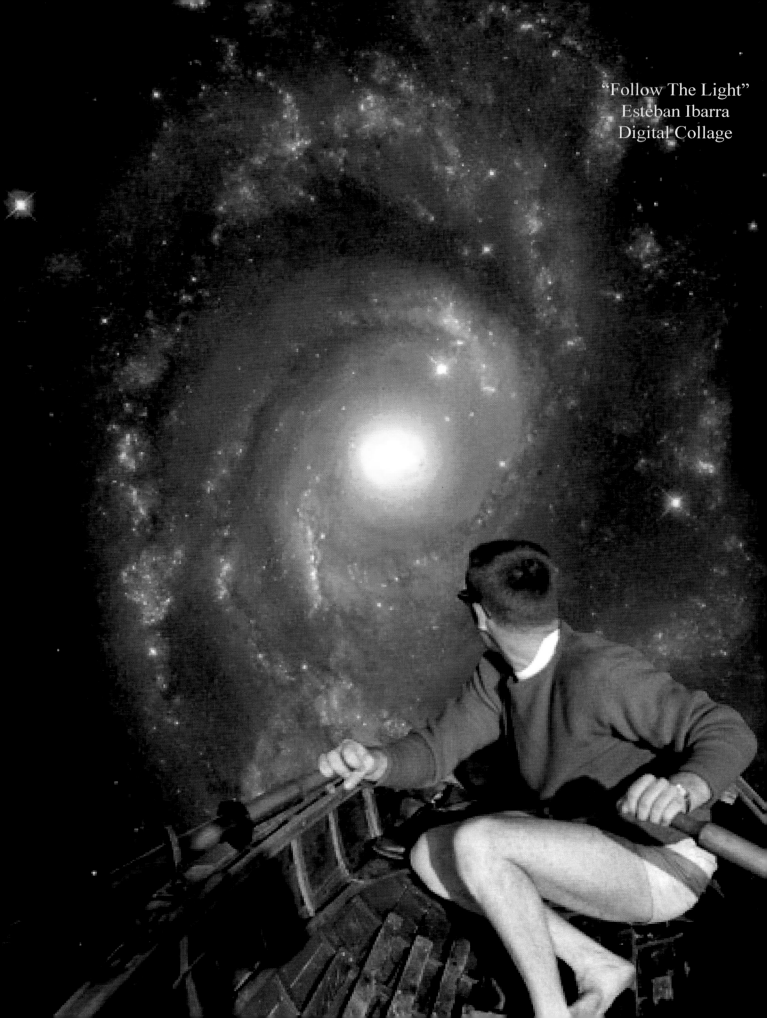

"Follow The Light"
Esteban Ibarra
Digital Collage

"We can easily forgive a child who is afraid of the dark; the real tragedy of life is when men are afraid of the light." - Plato

"Faith is the strength by which a shattered world shall emerge into the light." -Helen Keller

"To know yourself as the Being underneath the thinker, the stillness underneath the mental noise, the love and joy underneath the pain, is freedom, salvation, enlightenment."
-Eckhart Tolle

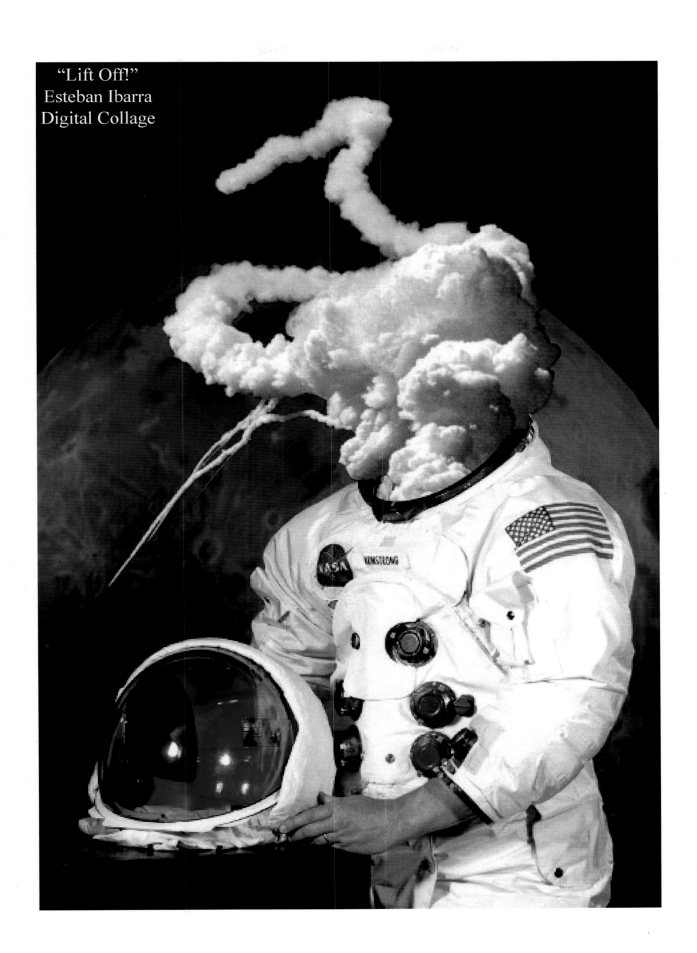

"Lift Off!"
Esteban Ibarra
Digital Collage

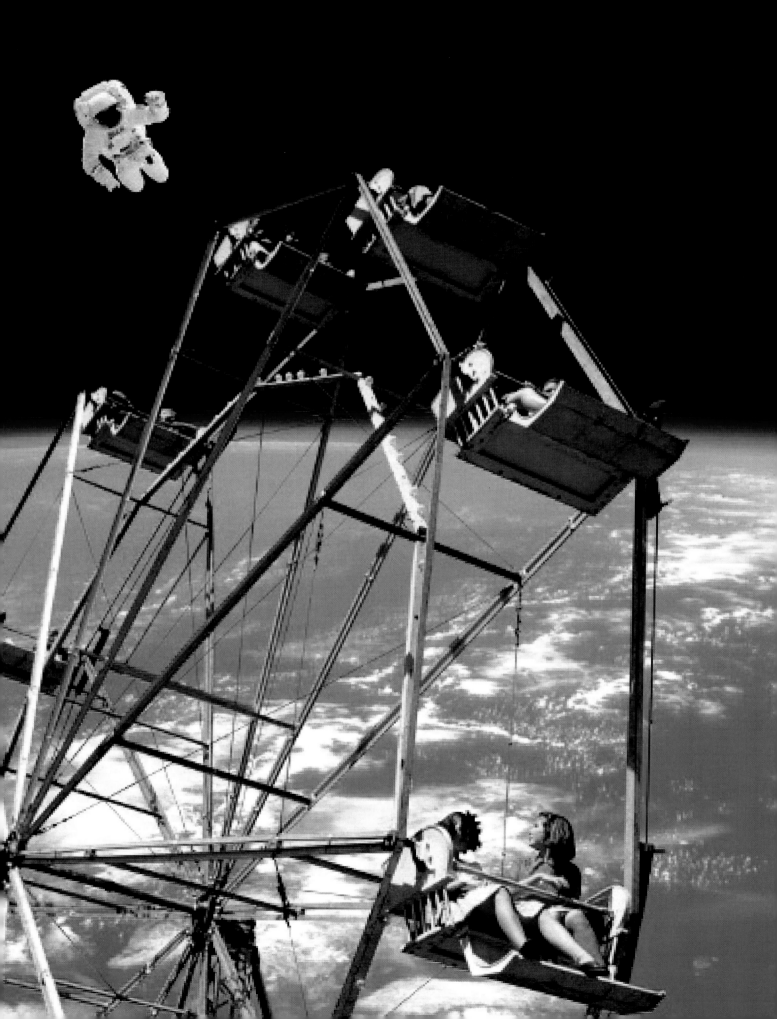

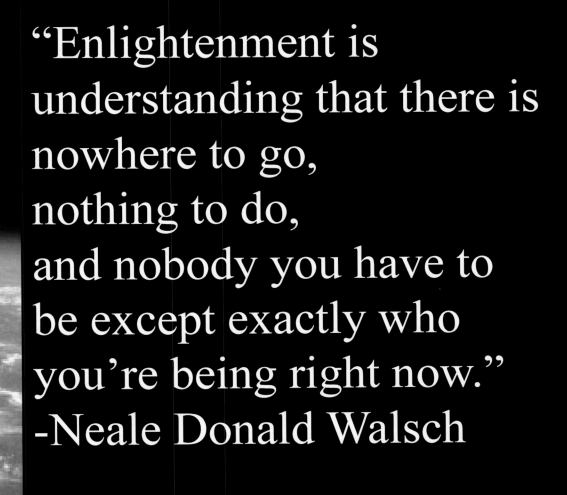

"Carnival Game"
Esteban Ibarra
Digital Collage

"Enlightenment is understanding that there is nowhere to go, nothing to do, and nobody you have to be except exactly who you're being right now."
-Neale Donald Walsch

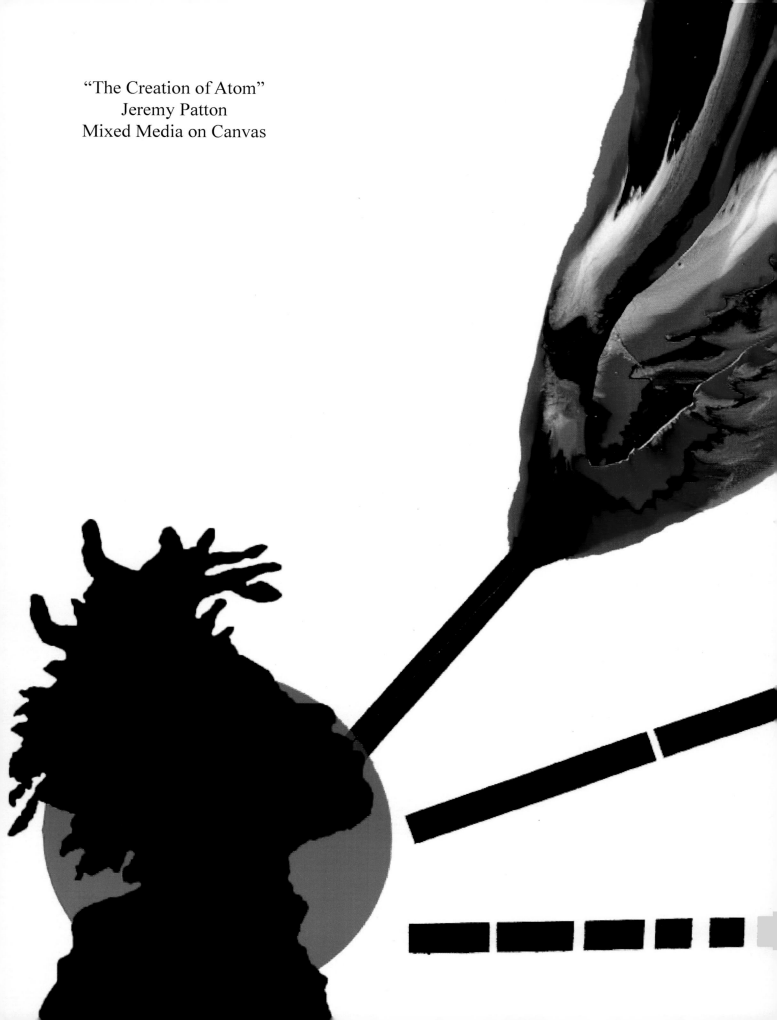

"The Creation of Atom"
Jeremy Patton
Mixed Media on Canvas

The Creation Of Atom is my re-interpretation of Michelangelo's Creation Of Adam. The three lines symbolize man's journey as he becomes more whole (holy) and rediscovers his connection with the ever flowing Energy that is God. The man is found within the circle to depict oneness with the infinite; i.e. the ratio of the circle's circumference to its diameter is PI, which is an irrational number than never ends and never repeats…it is infinite.

"Few appreciate the real power of the mind, and no one remains fully aware of it all the time. However, if you hope to spare yourself from fear there are some things you must realize, and realize fully. The mind is very powerful, and never loses its creative force. It never sleeps. Every instant it is creating. It is hard to recognize that thought and belief combine into a power surge that can literally move mountains. It appears at first glance that to believe such power about yourself is arrogant, but that is not the real reason you not believe it. You prefer to believe that your thoughts cannot exert real influence because you are a ctually afraid of them…There are no idle thoughts. All thinking produces form at some level."

-A Course In Miracles

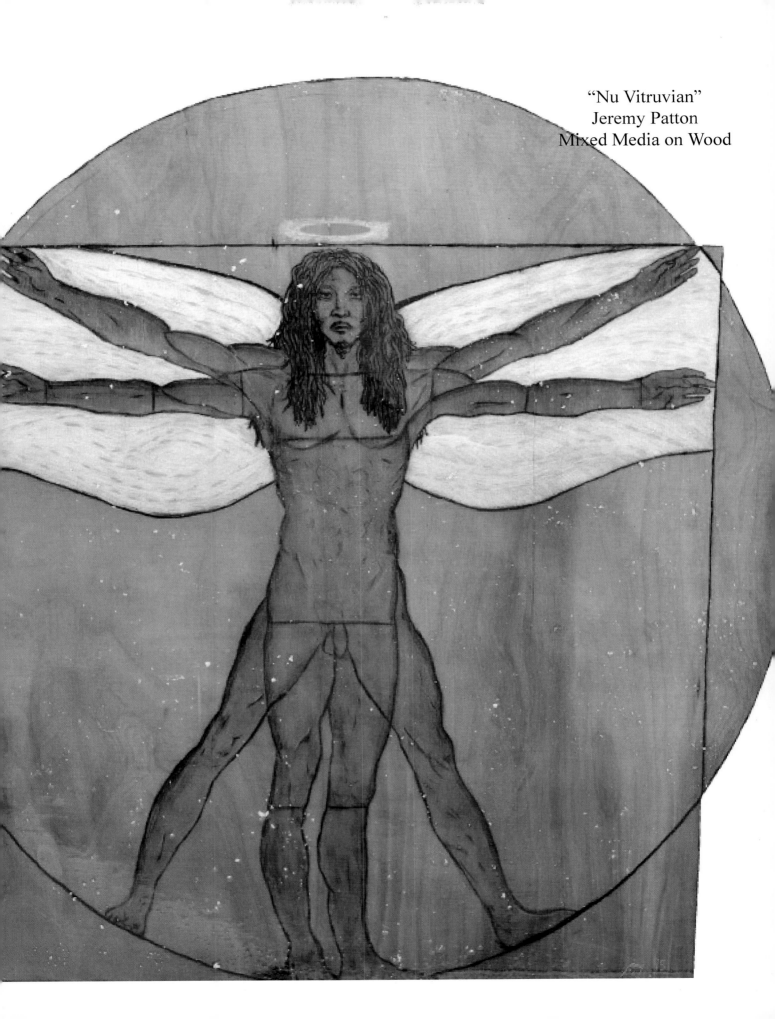

"Nu Vitruvian"
Jeremy Patton
Mixed Media on Wood

"Being infinite, God ca
human or stone; yet He
can rightly say that Go
well."

ot be limited to any form,
manifest in all forms. One
manifests in every man as

aramahansa Yogananda

"Lord Of The Chakras"
Jeremy Patton
Acrylic on Canvas

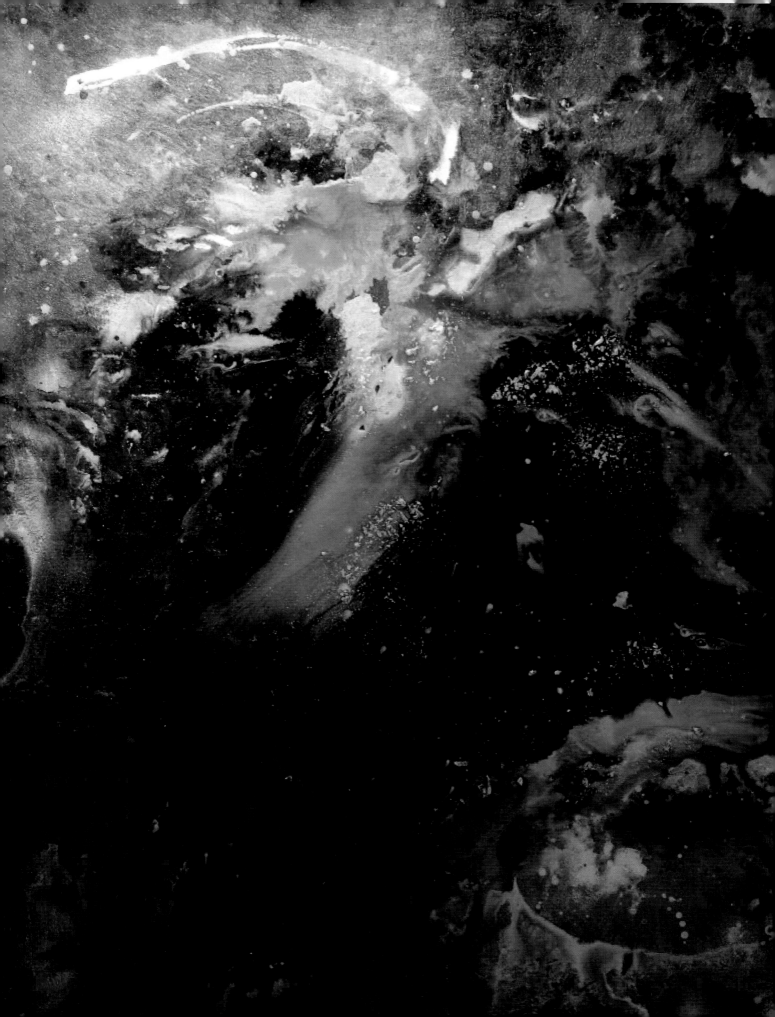

"I look up at the ni[ght]
and I know that, ye[s]
are part of this Uni[verse]
we are in this Univ[erse]
perhaps more impo[rtant]
than both of those [facts]
that the Universe is [in us.]
When I reflect on t[hat]
I look up—many p[eople]
feel small, because [they're]
small and the Univ[erse is]
big, but I feel big, [because]
my atoms came fro[m those]
stars."

-Neil deGrass[e Tyson]

"& Beyond"
Jeremy Patton
Mixed Media
on Wood

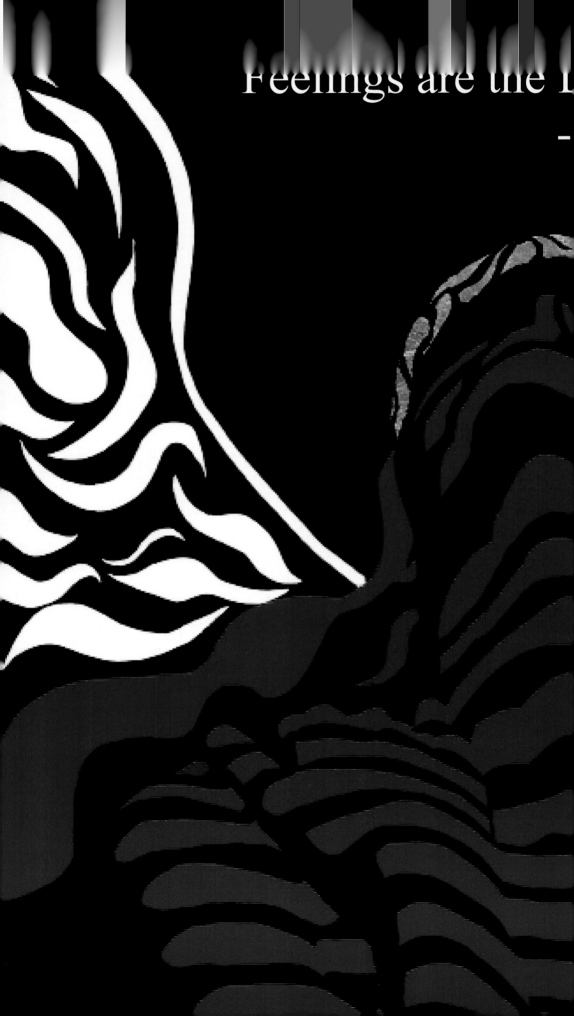

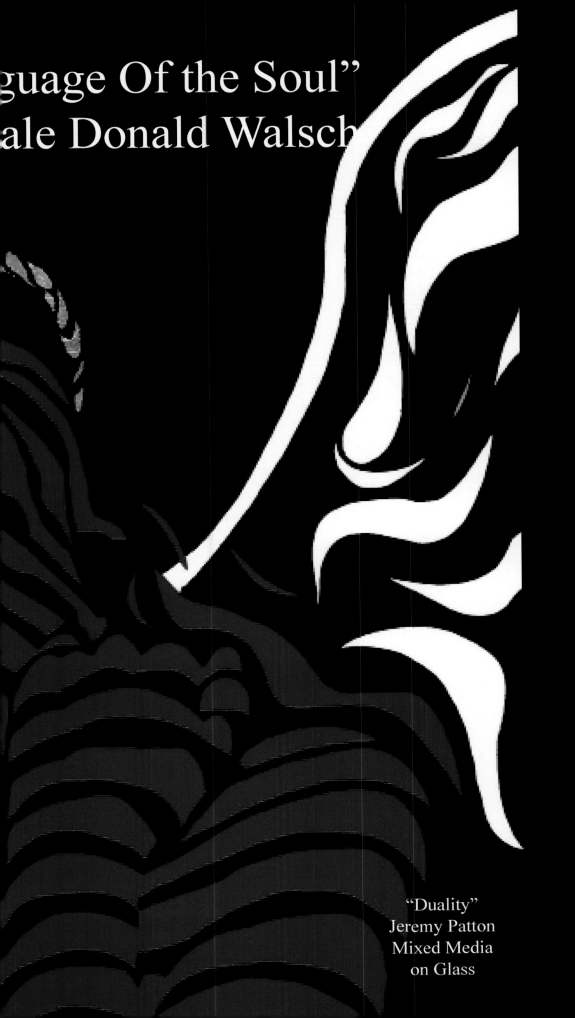

guage Of the Soul"

ale Donald Walsch

"Duality"
Jeremy Patton
Mixed Media
on Glass

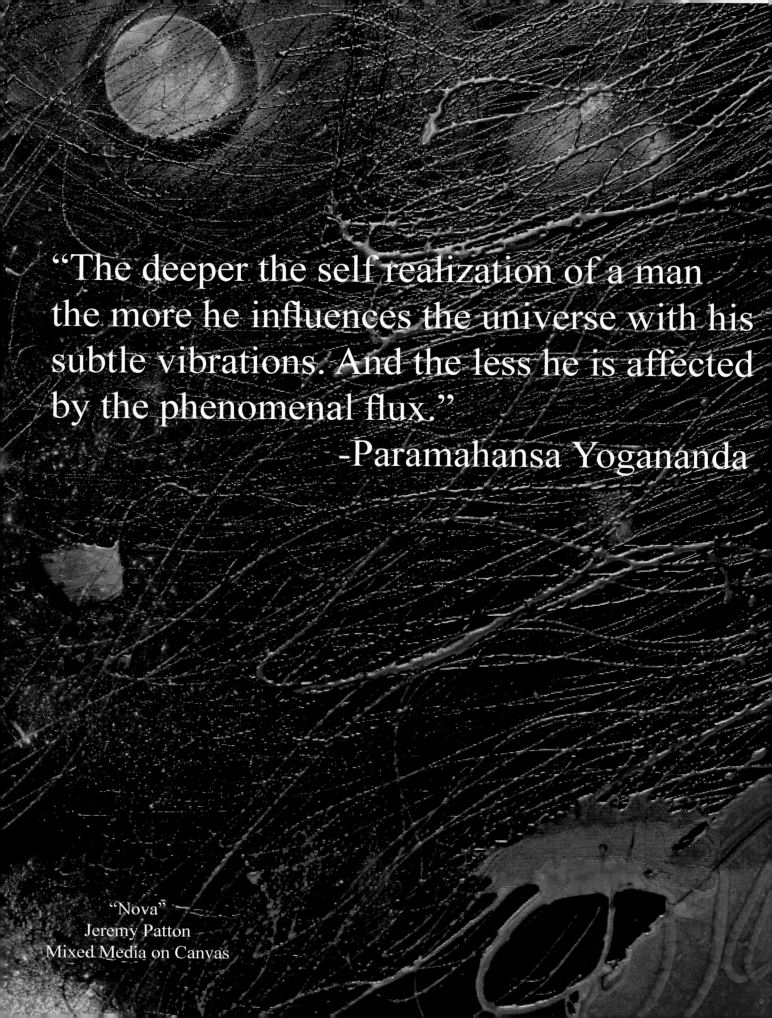

"The deeper the self realization of a man the more he influences the universe with his subtle vibrations. And the less he is affected by the phenomenal flux."
 -Paramahansa Yogananda

"Nova"
Jeremy Patton
Mixed Media on Canvas

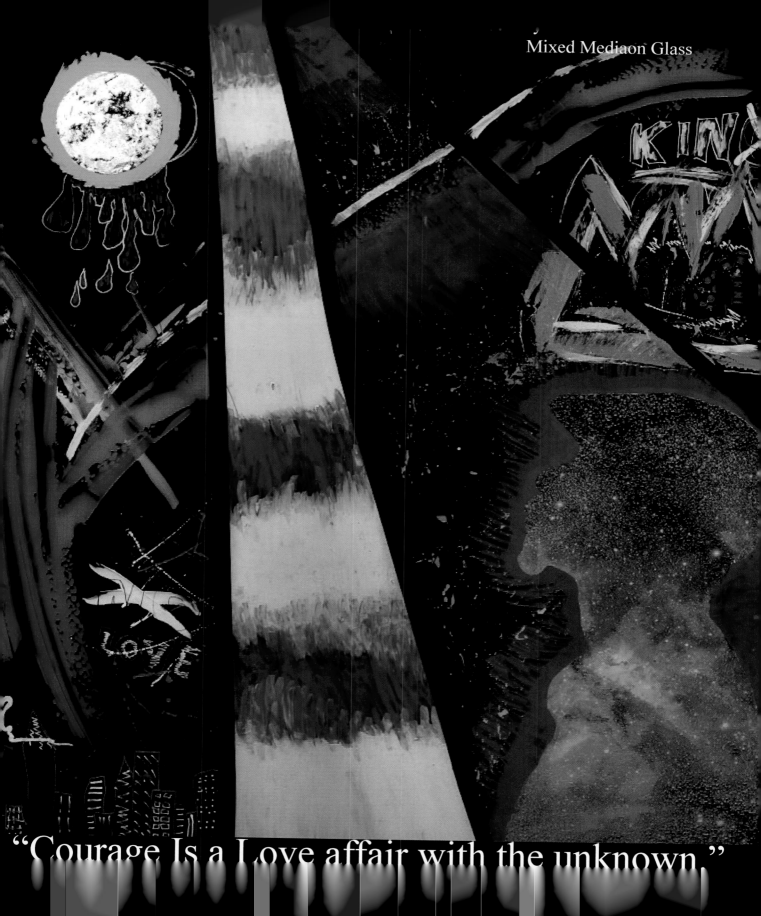

Mixed Mediaon Glass

"Courage Is a Love affair with the unknown."

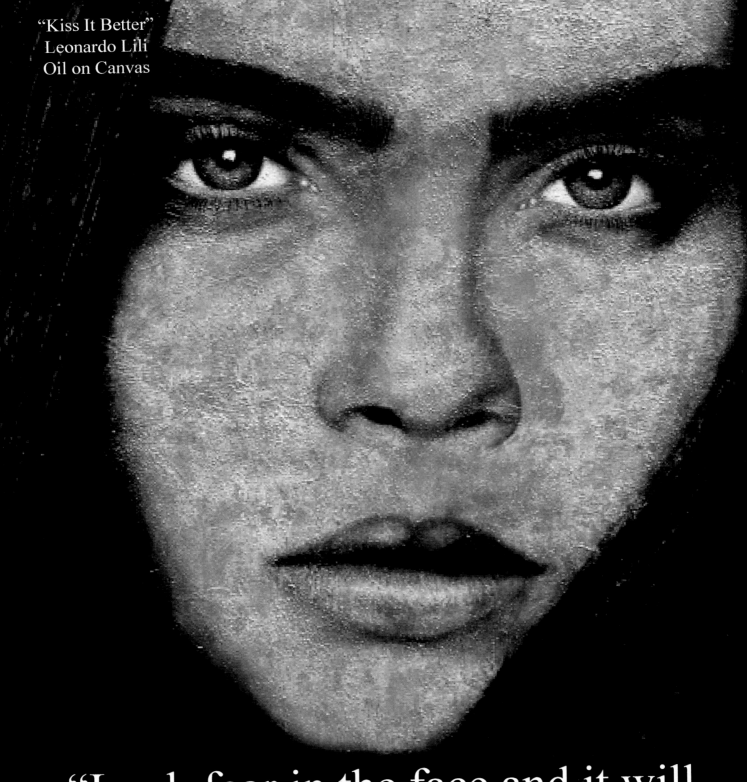

"Kiss It Better"
Leonardo Lili
Oil on Canvas

"Look fear in the face and it will cease to trouble you."

- Paramahansa Yogananda

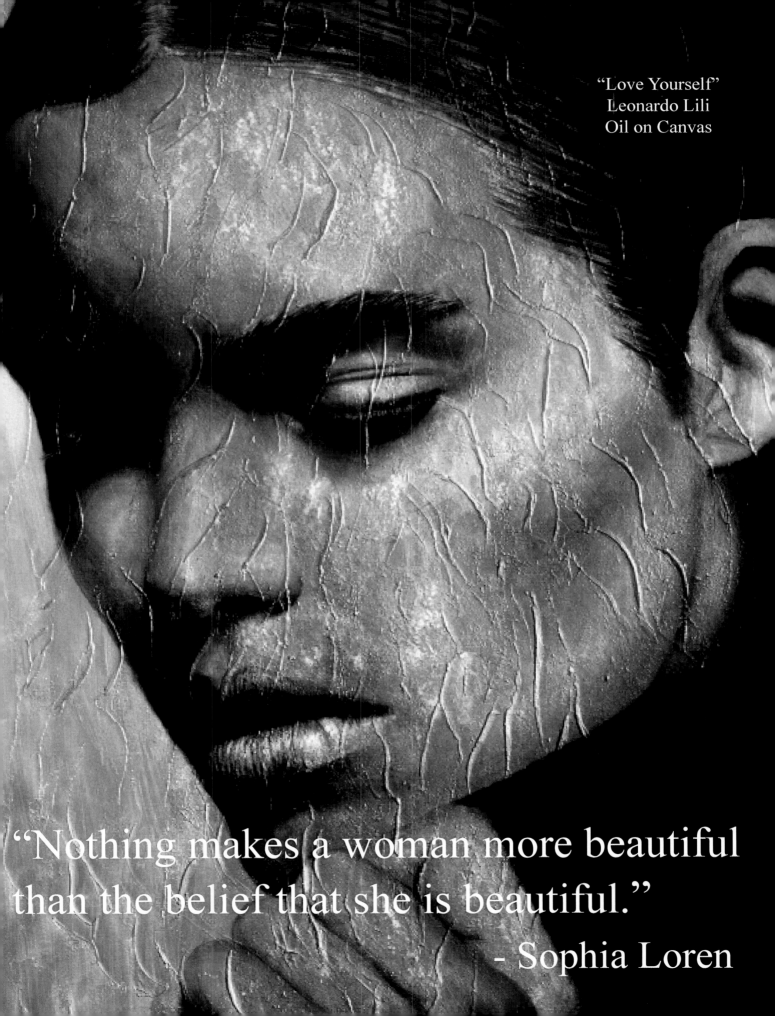

"Love Yourself"
Leonardo Lili
Oil on Canvas

"Nothing makes a woman more beautiful than the belief that she is beautiful."
- Sophia Loren

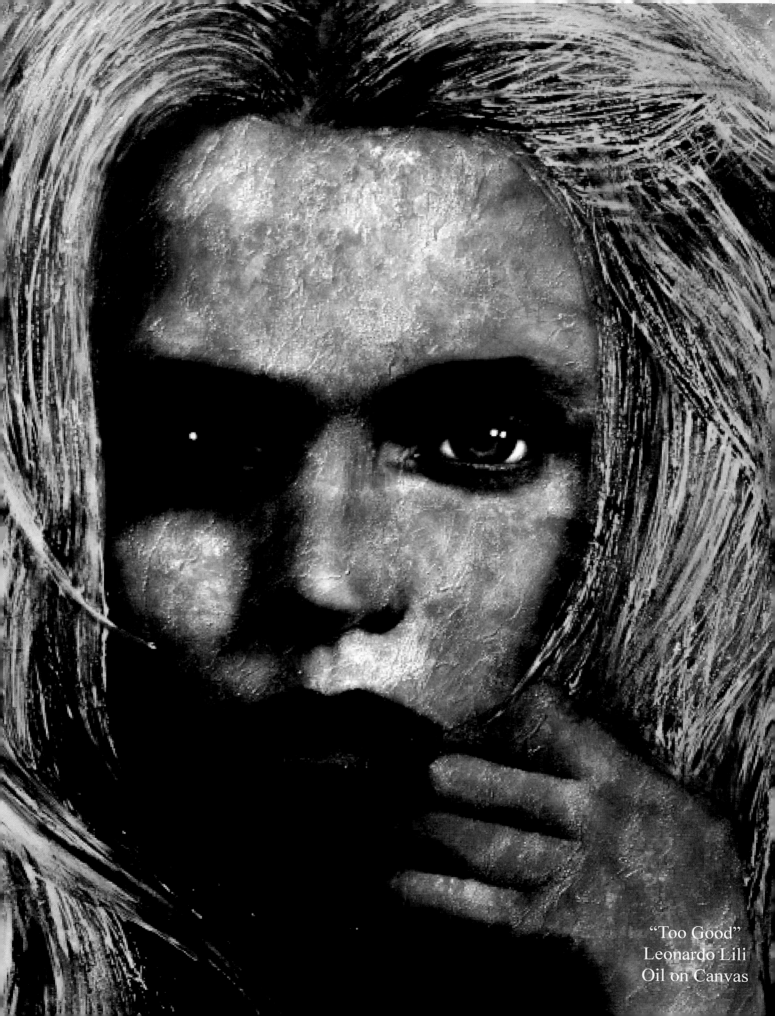

"Too Good"
Leonardo Lili
Oil on Canvas

"The effect of life in society is to complicate and confuse our existence, making us forget who we really are by causing us to become obsessed with what we are not."

-Zhuangzi

"If someone is not treating you with love and respect, it is a gift if they walk away from you. If that person doesn't walk away, you will surely endure many years of suffering with him or her. Walking away may hurt for a while, but your heart will eventually heal. Then you can choose what you really want. You will find that you don't need to trust others as much as you need to trust yourself to make the right choices."

-Miguel Ruiz

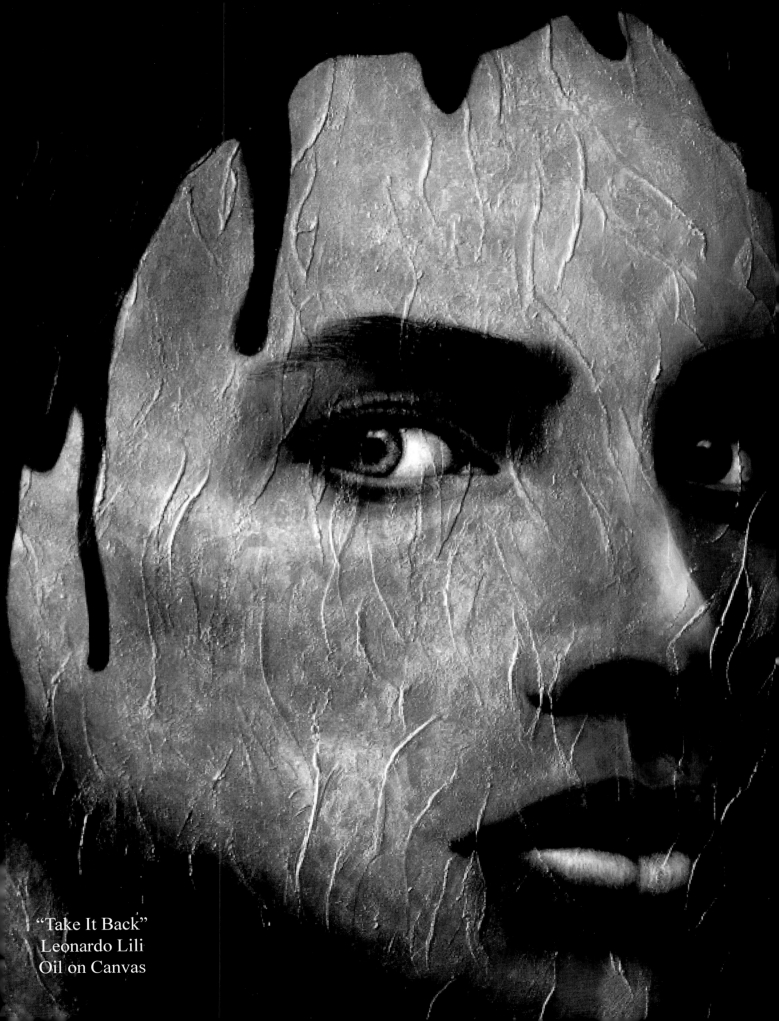

"Take It Back"
Leonardo Lili
Oil on Canvas

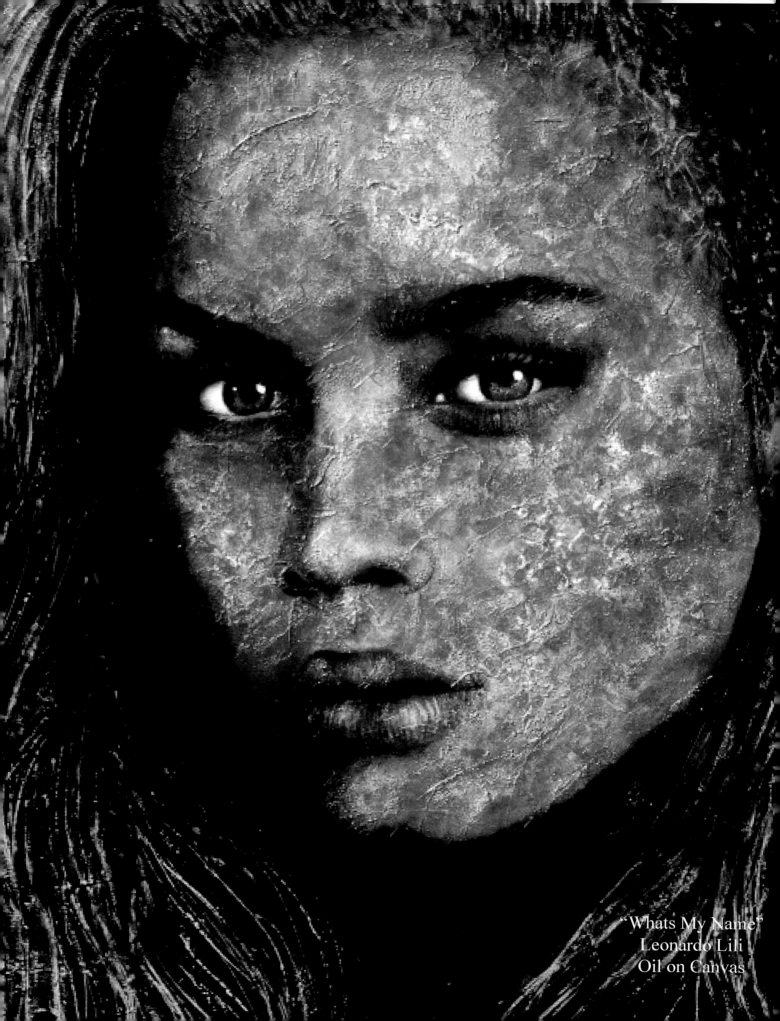

"Whats My Name"
Leonardo Lili
Oil on Canvas

"If you knew your potential to feel good, you would ask no one to be different so that you can feel good. You would free yourself of all of that cumbersome impossibility of needing to control the world, or control your mate, or control your child. You are the only one who cre-ates your reality. For no one else can think for you, no one else can do it. It is only you, every bit of it you."

-Ester Hicks

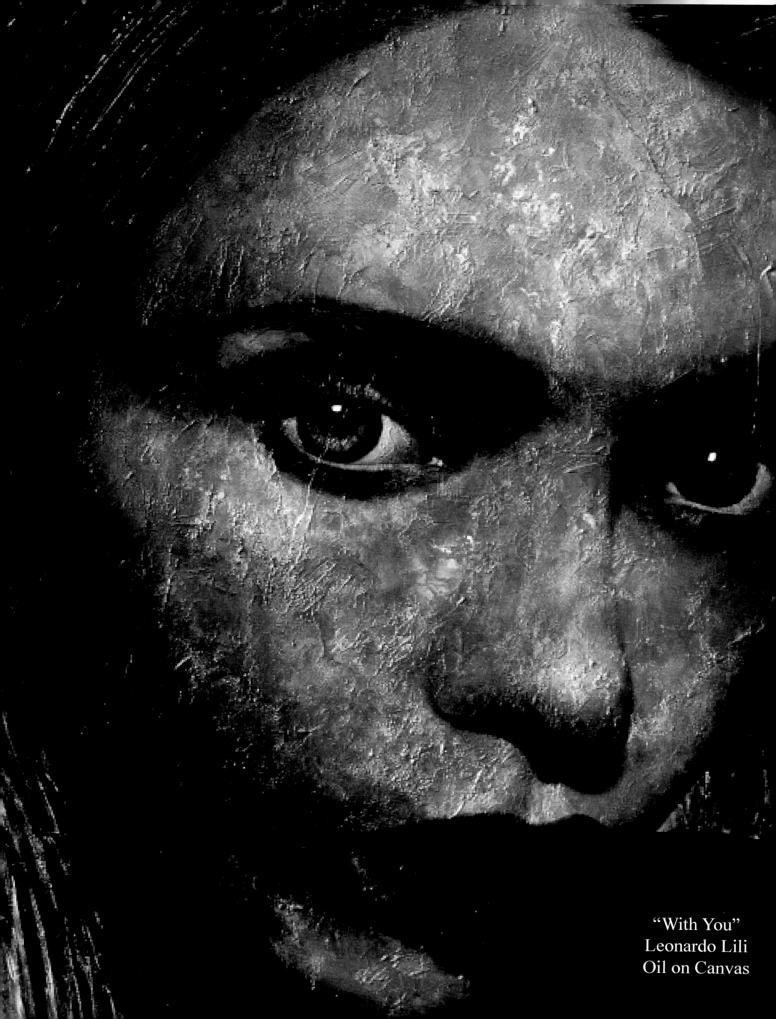

"With You"
Leonardo Lili
Oil on Canvas

"When we love we always strive to become better than we are. When we strive to become better than we are, everything around us becomes better too."

-Paulo Coelho

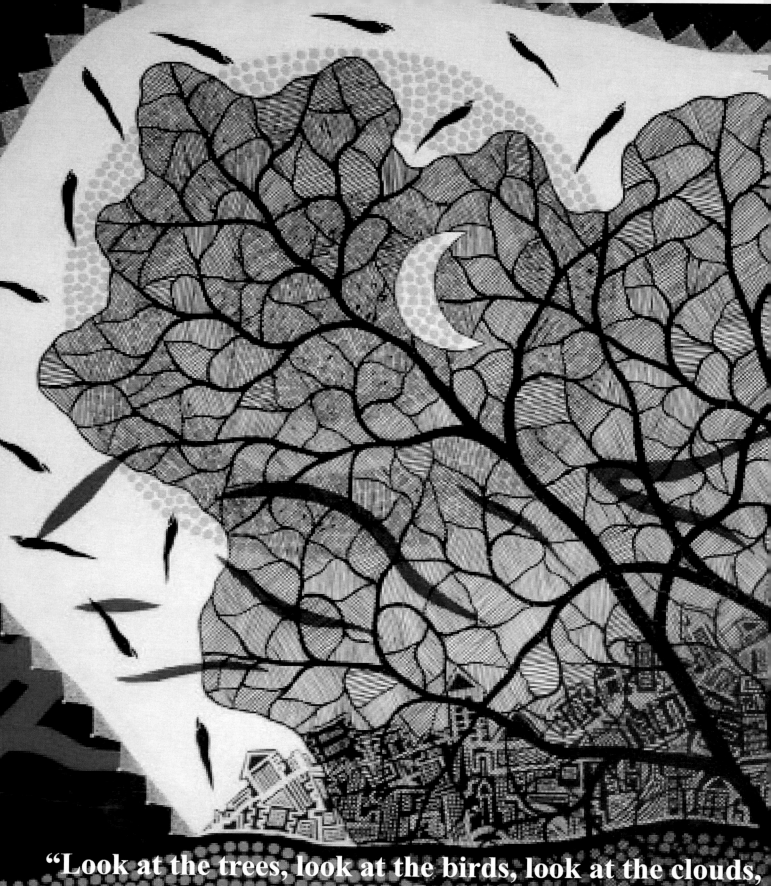

"Look at the trees, look at the birds, look at the clouds, that the whole existence is joyful. Everything is simply become prime ministers or presidents and they are not ance. Look at the flowers - for no reason. It is simply u

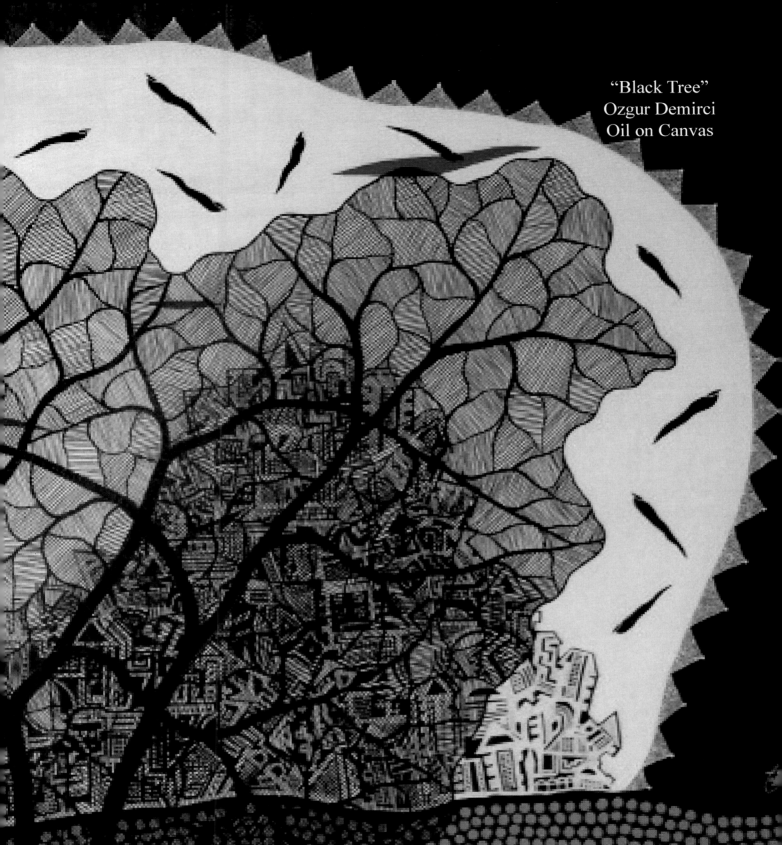

"Black Tree"
Ozgur Demirci
Oil on Canvas

at the stars... and if you have eyes you will be able to see
y. Trees are happy for no reason; they are not going to
g to become rich and they will never have any bank bal-
ievable how happy flowers are." - Osho

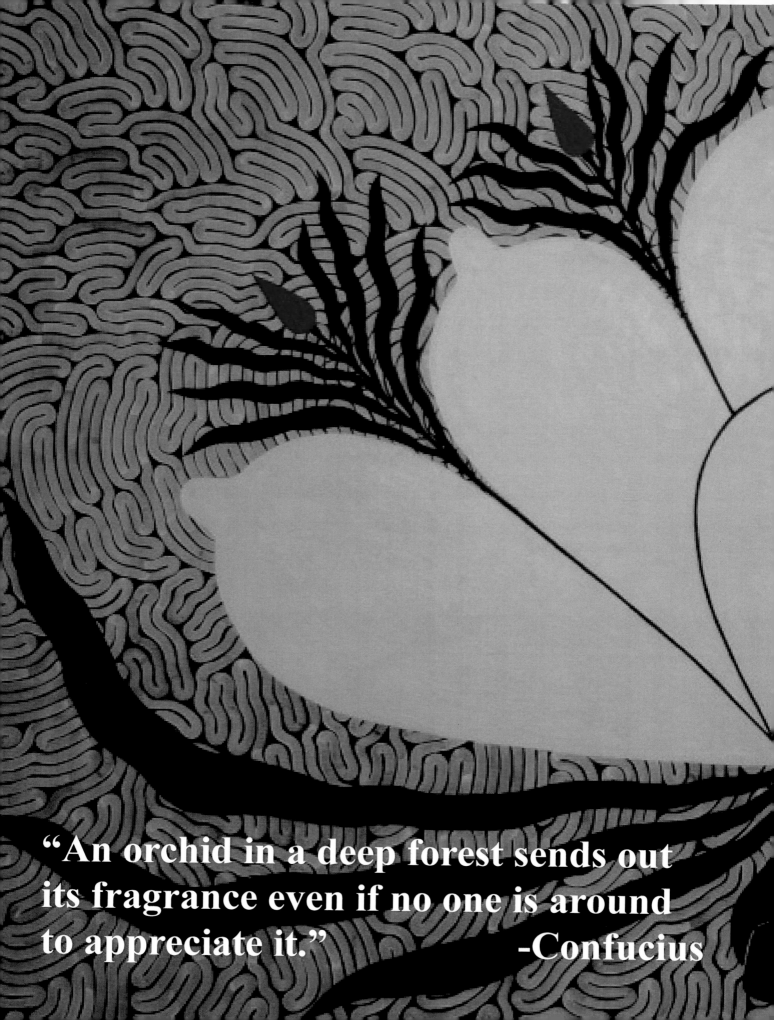

"An orchid in a deep forest sends out its fragrance even if no one is around to appreciate it."
-Confucius

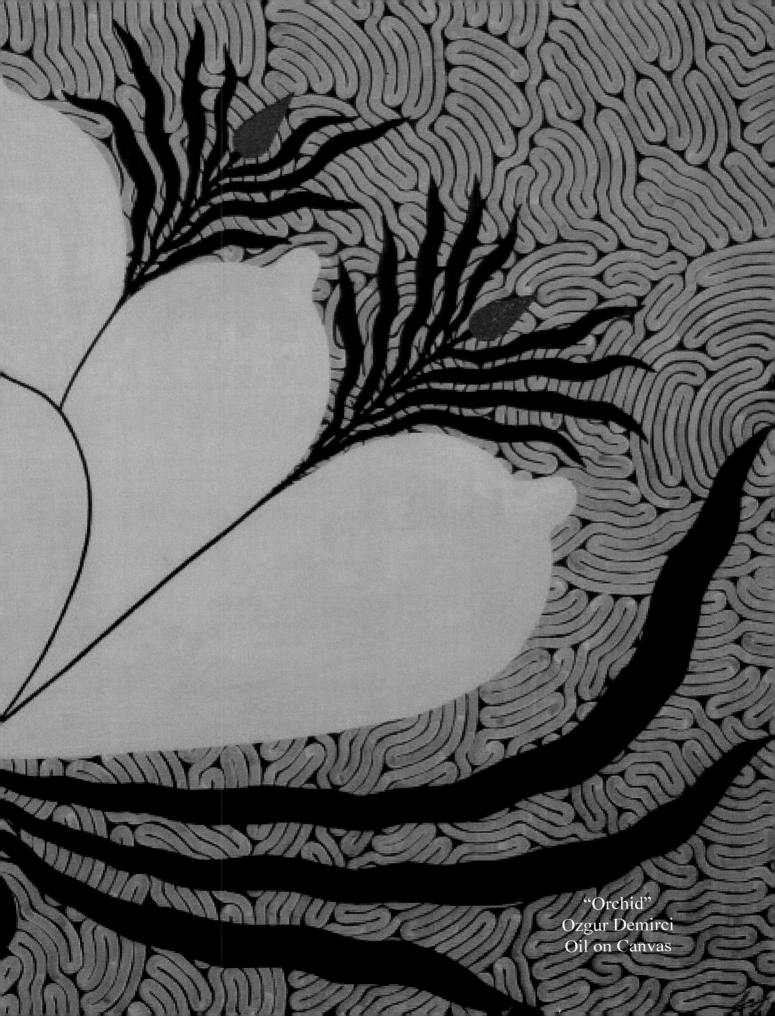

"Orchid"
Ozgur Demirci
Oil on Canvas

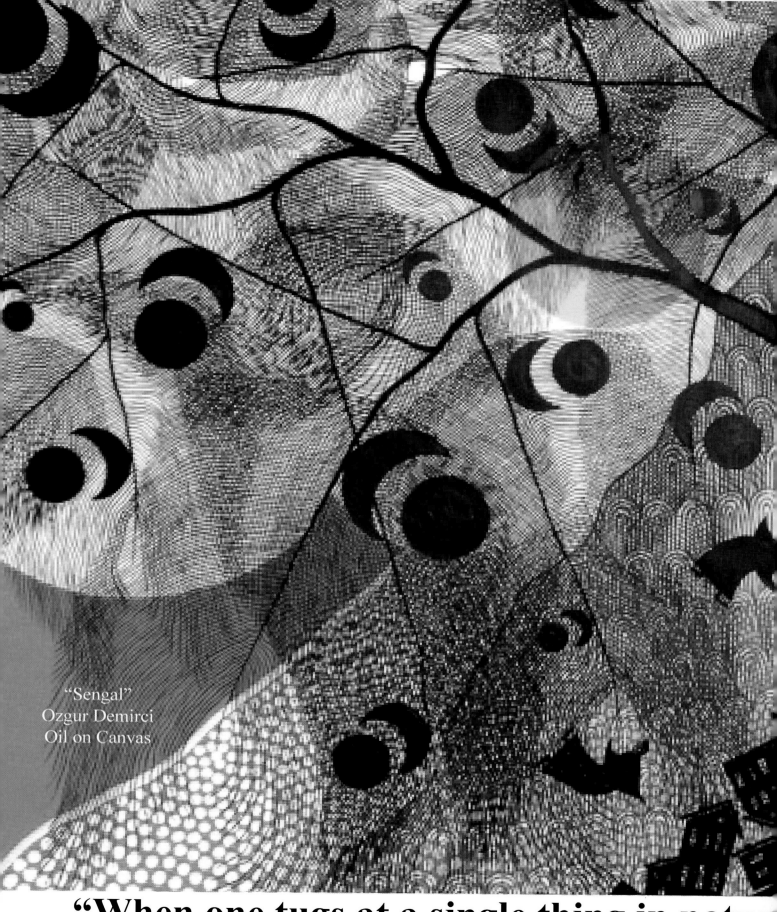

"Sengal"
Ozgur Demirci
Oil on Canvas

"When one tugs at a single thing in natur

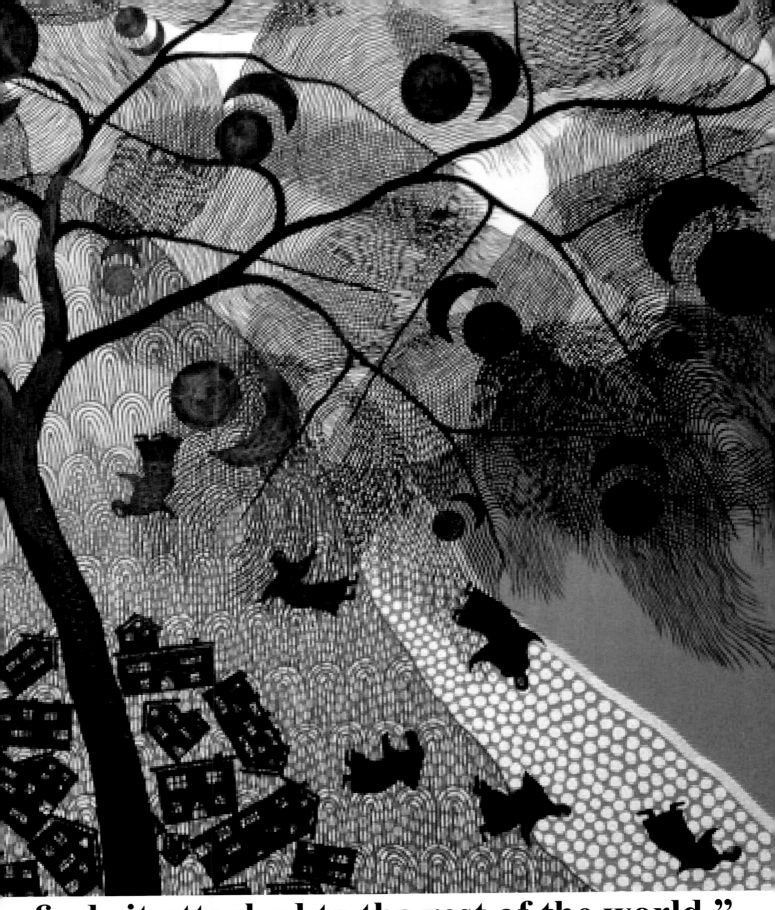

e finds it attached to the rest of the world."
-John Muir

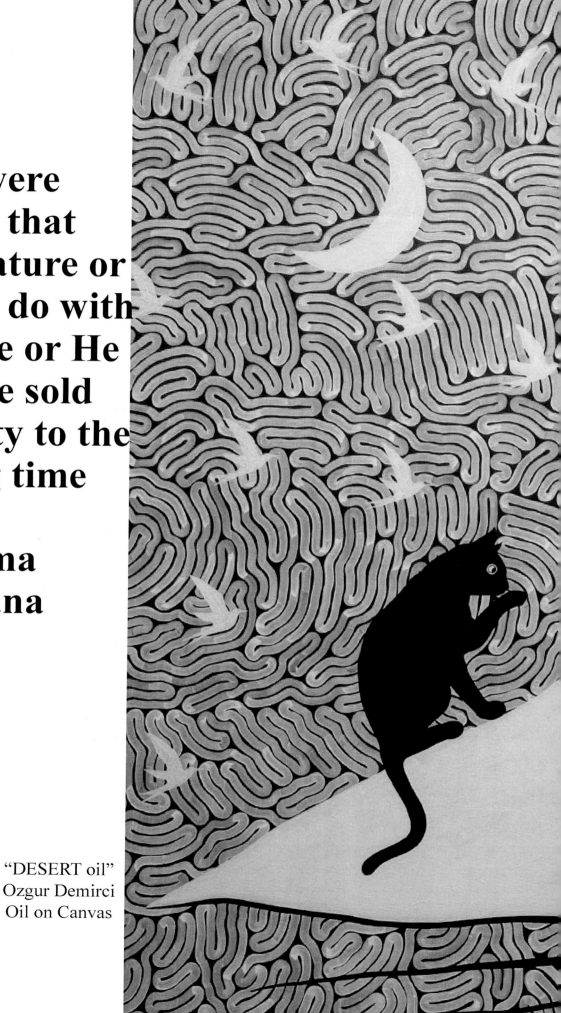

"If there were something that Mother Nature or God could do with money, She or He would have sold immortality to the rich a long time ago."
-Mokokoma Mokhonoana

"DESERT oil"
Ozgur Demirci
Oil on Canvas

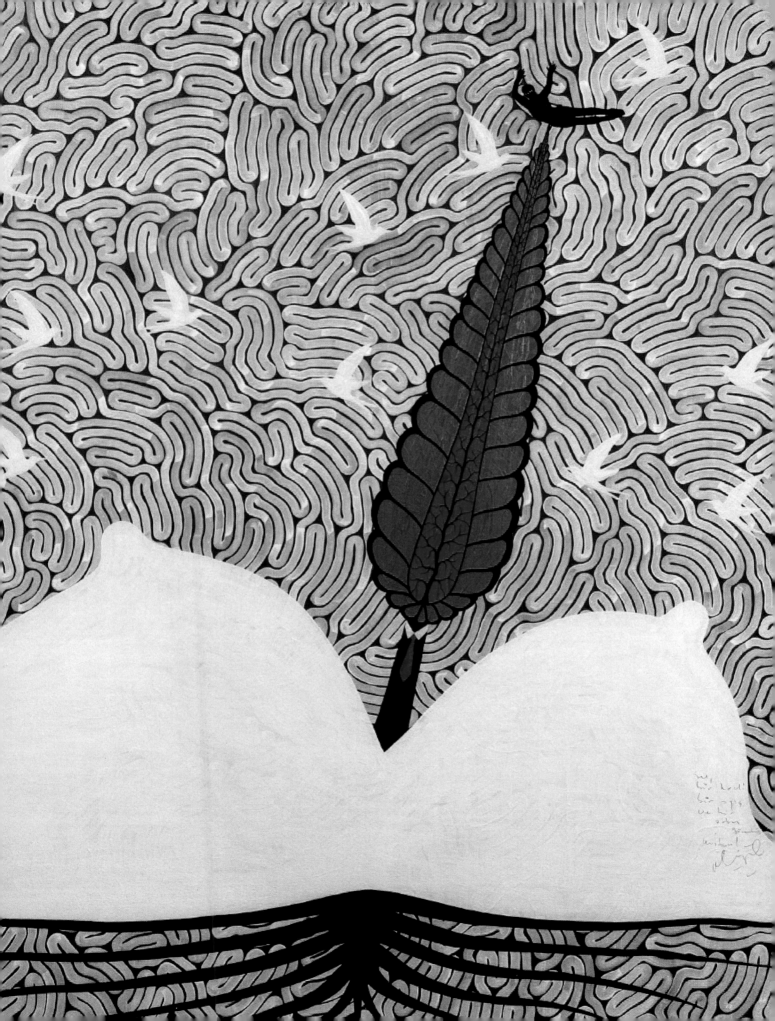

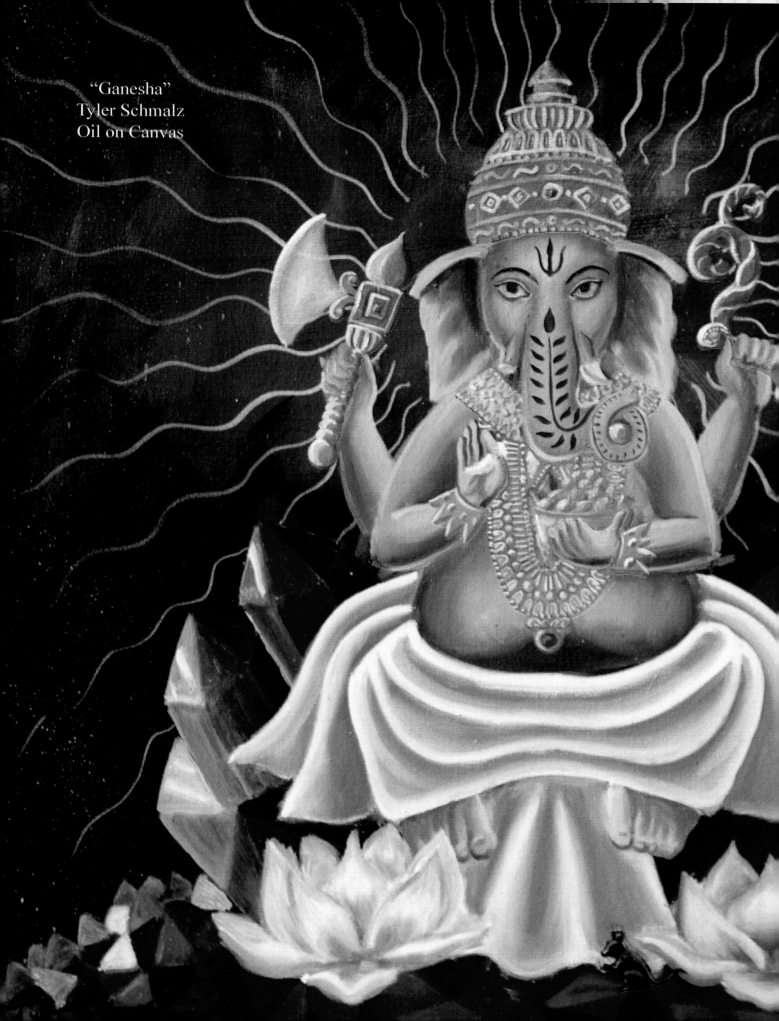

"Ganesha"
Tyler Schmalz
Oil on Canvas

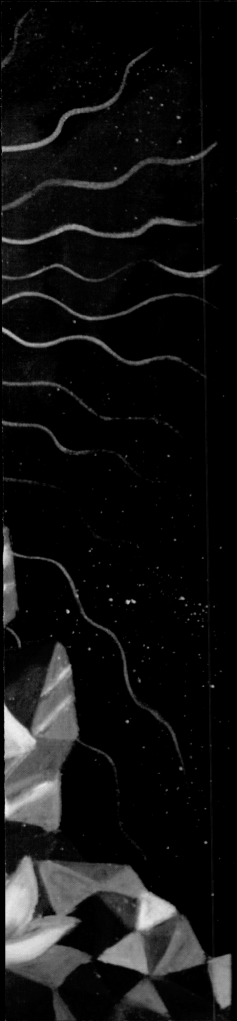

"There are hundreds of paths up the mountain, all leading to the same place, so it doesn't matter which path you take. The only person wasting time is the one who runs around the mountain, telling everyone that his or her path is wrong."
-Hindu Proverb

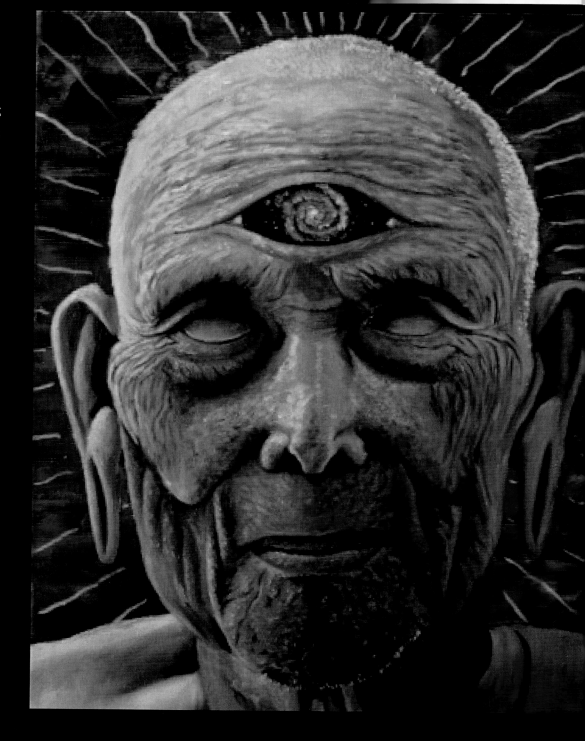

"Youniverse"
Tyler Schmalz
Oil on Canvas

Still your mind in me, still yourself in me, and without a doubt you shall be united with me, Lord Of Love, dwelling in your heart. -Bhagavad Gita

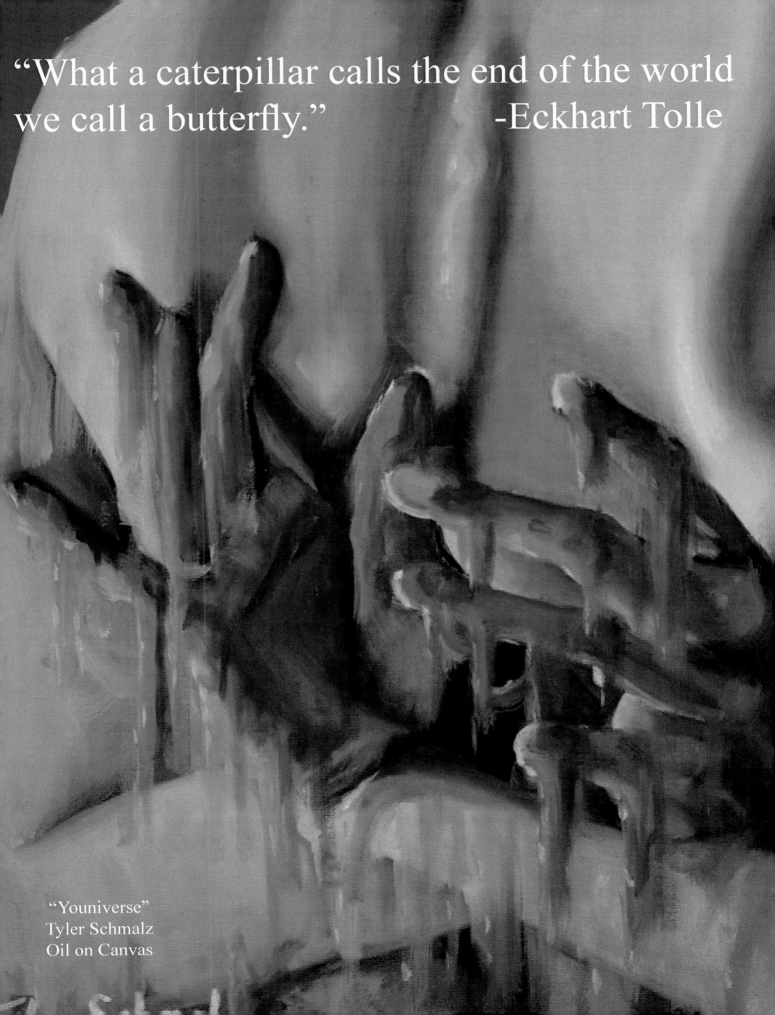

"What a caterpillar calls the end of the world we call a butterfly." -Eckhart Tolle

"Youniverse"
Tyler Schmalz
Oil on Canvas

"He who is not self-restrained will have no steadiness of mind or perseverance in the pursuit of self-knowledge. There is no tranquility for the person who doesn't persevere in the pursuit of self-knowledge—and without tranquility, how can there be happiness?"
 - Bhagavad-Gita

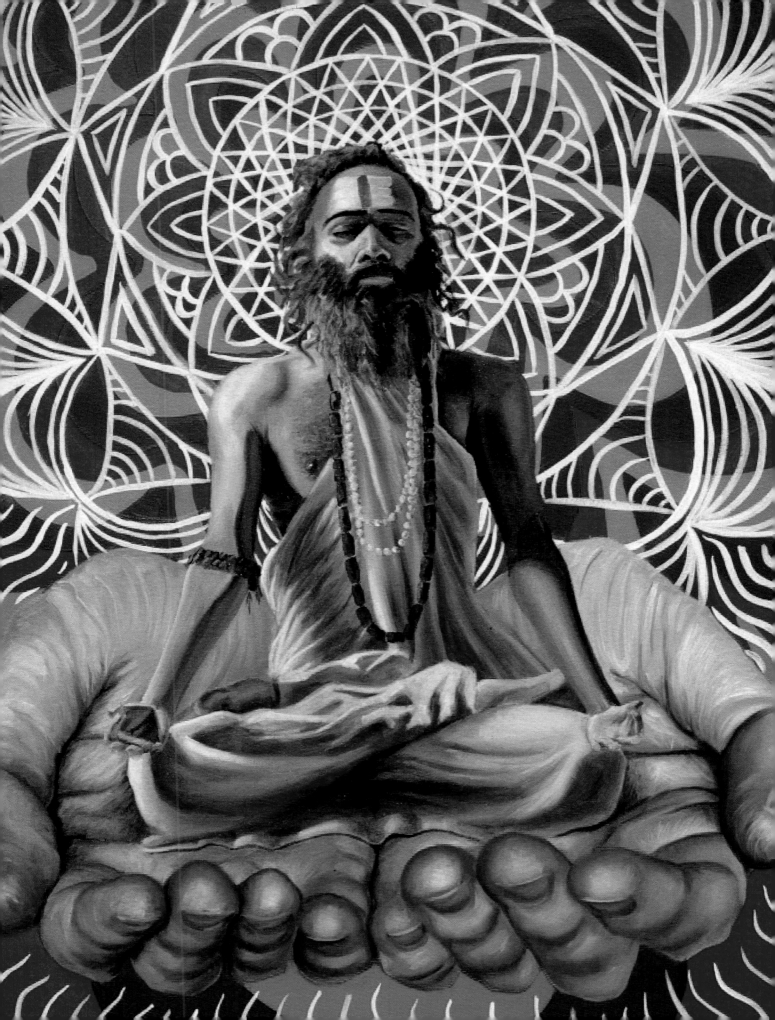

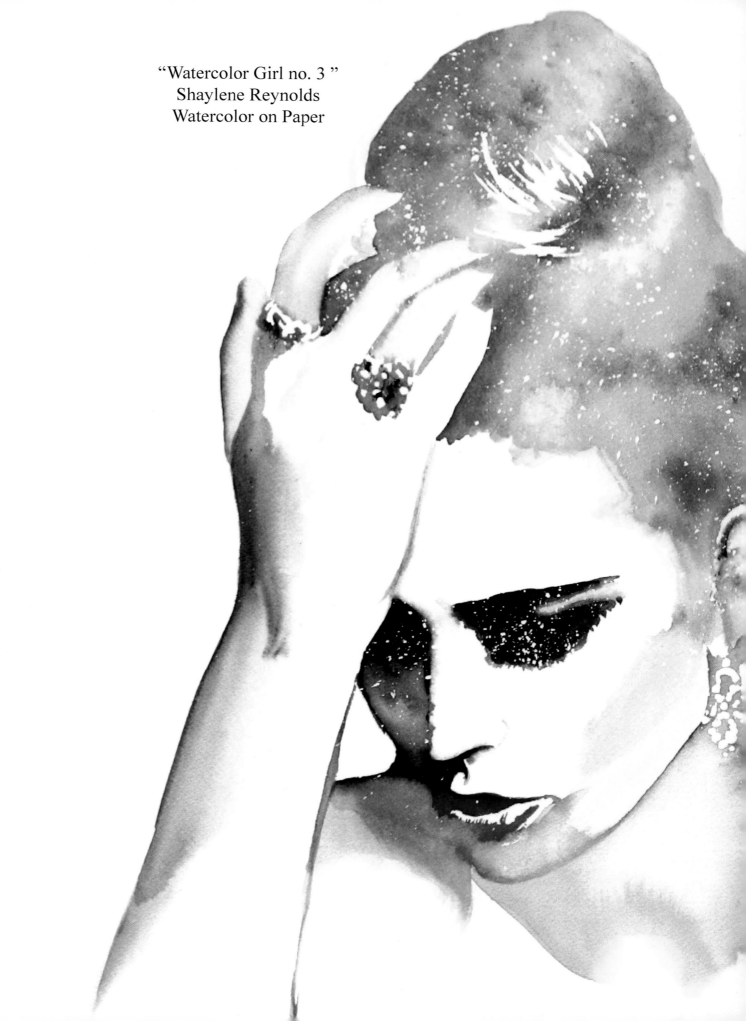

"Watercolor Girl no. 3 "
Shaylene Reynolds
Watercolor on Paper

"Prayer is the medium of miracles. It is a means of communication of the created with the Creator. Through prayer love is received, and through miracles love is expressed."
- A Course In Miracles

"Tell your heart that the fear of suffering is worse than the suffering itself. And that no heart has ever suffered when it goes in search of its dreams, because every second of the search is a second's encounter with God and with eternity"
-Paulo Coelho

"Watercolor Girl no. 2"
Shaylene Reynolds
Watercolor on Paper

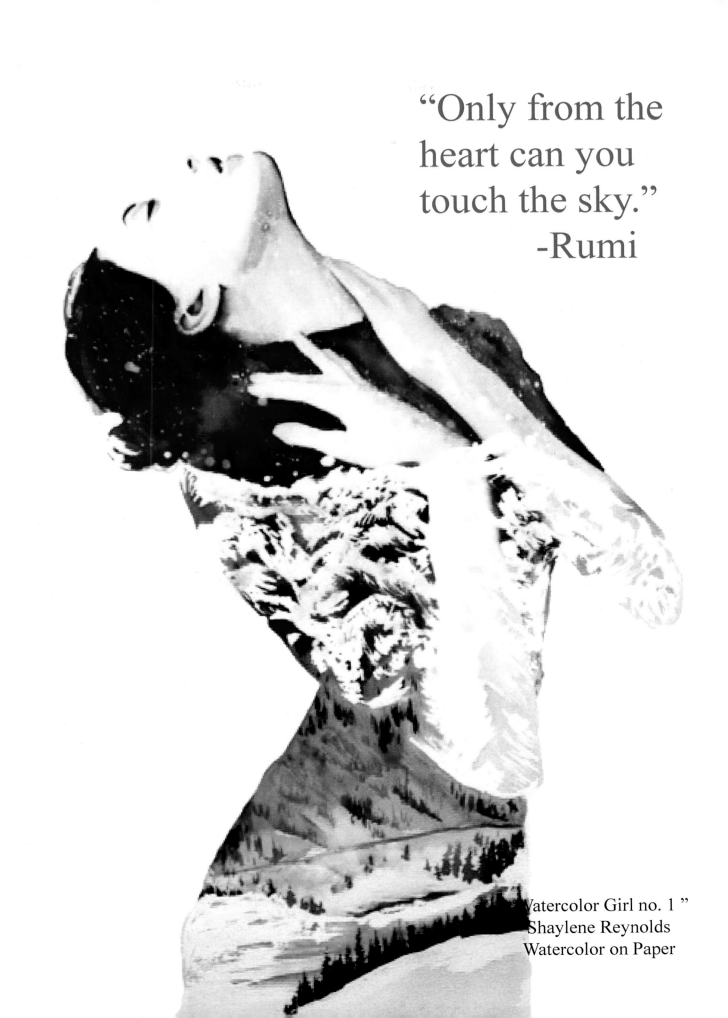

"Only from the
heart can you
touch the sky."
-Rumi

Watercolor Girl no. 1 "
Shaylene Reynolds
Watercolor on Paper

"There comes a time when the world gets quiet and the only thing left is your own heart. So you'd better learn the sound of it. Otherwise you'll never understand what it's saying."

-Sarah Dassen

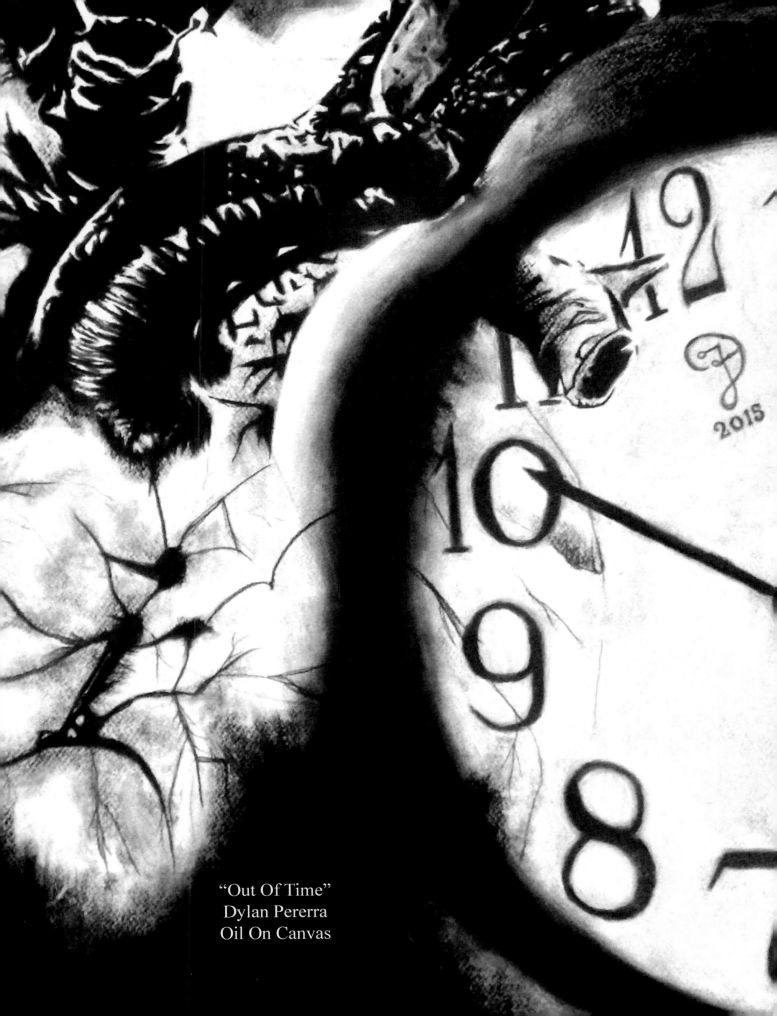

"Out Of Time"
Dylan Pererra
Oil On Canvas

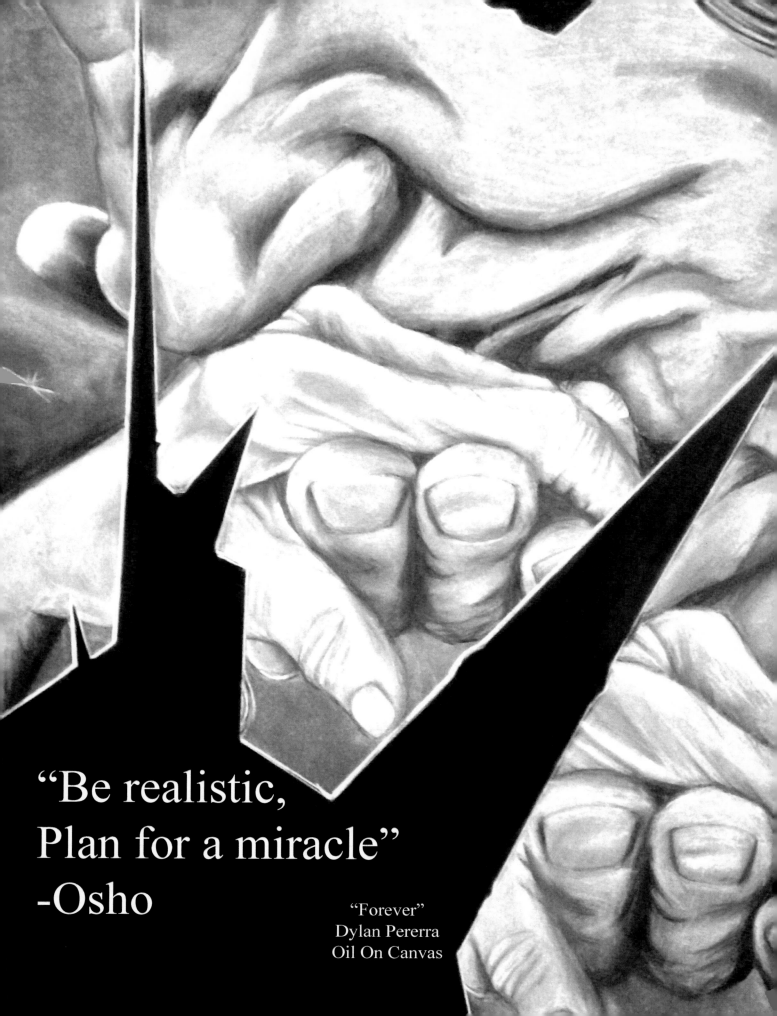

"Be realistic,
Plan for a miracle"
-Osho

"Forever"
Dylan Pererra
Oil On Canvas

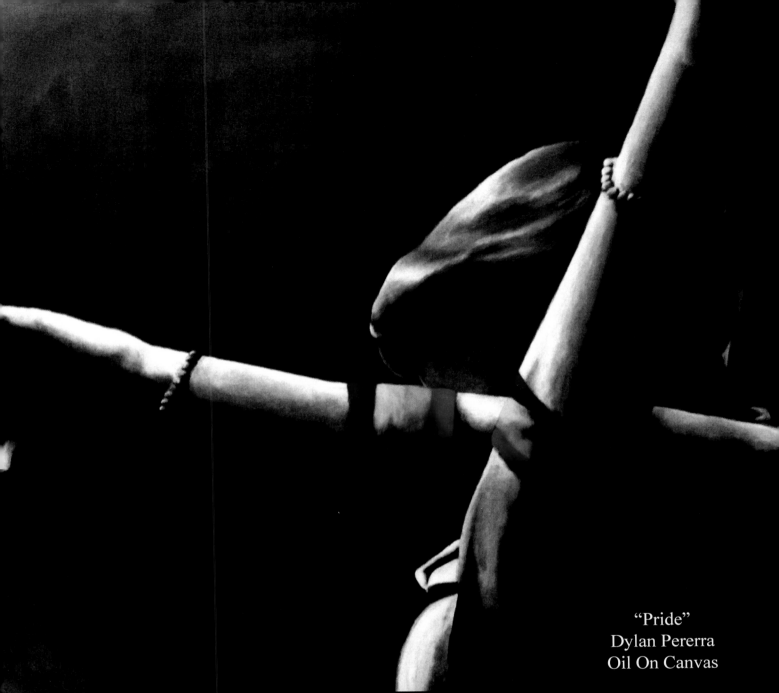

"Pride"
Dylan Pererra
Oil On Canvas

"Being an outsider to some extent, someone who does not "fit it" with others or is rejected by them for whatever reason, makes life difficult, but it also places you at an advantage as far as enlightenment is concerned"
-Eckhart Tolle

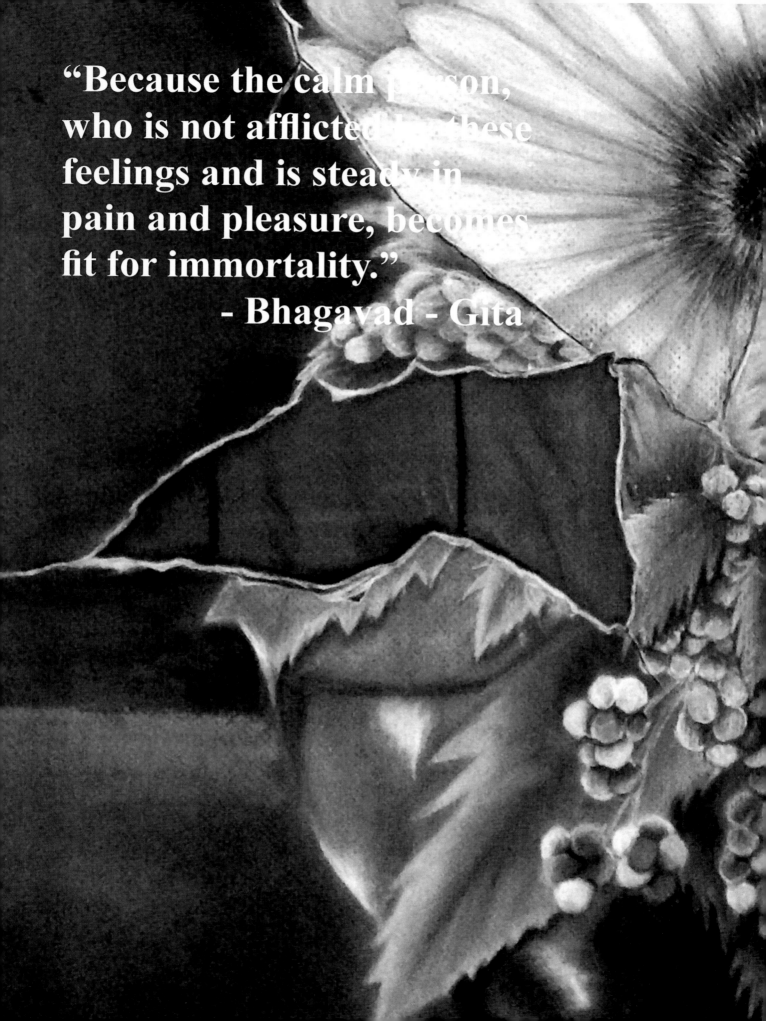

"Because the calm person, who is not afflicted by these feelings and is steady in pain and pleasure, becomes fit for immortality."
- Bhagavad - Gita

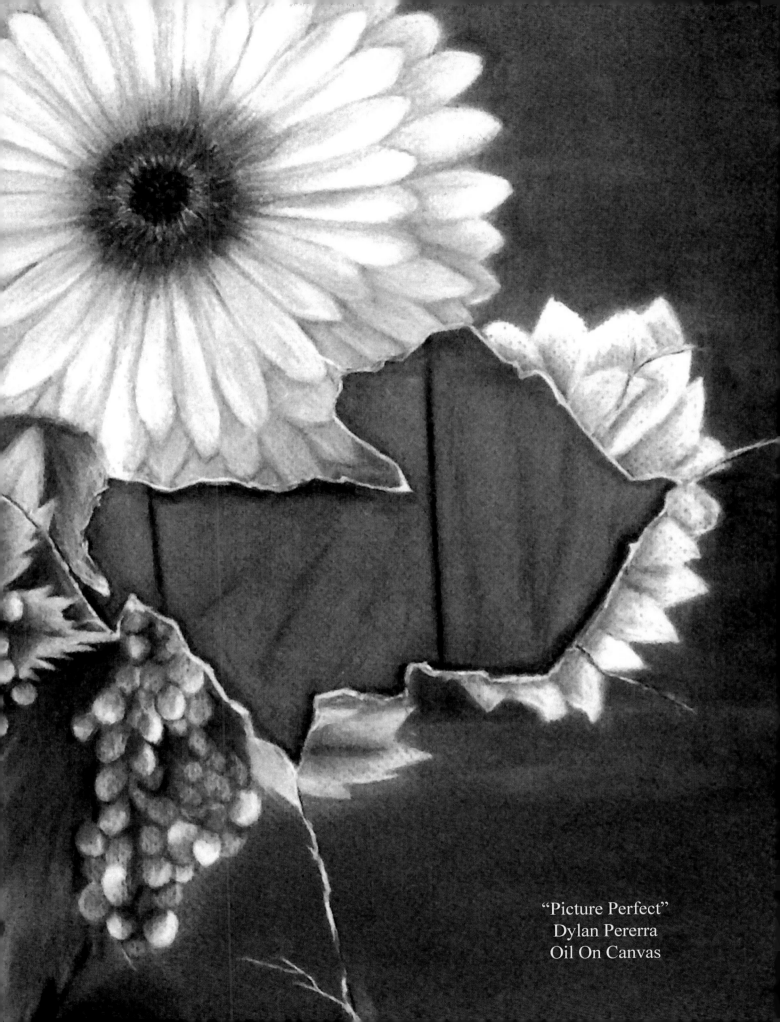

"Picture Perfect"
Dylan Pererra
Oil On Canvas

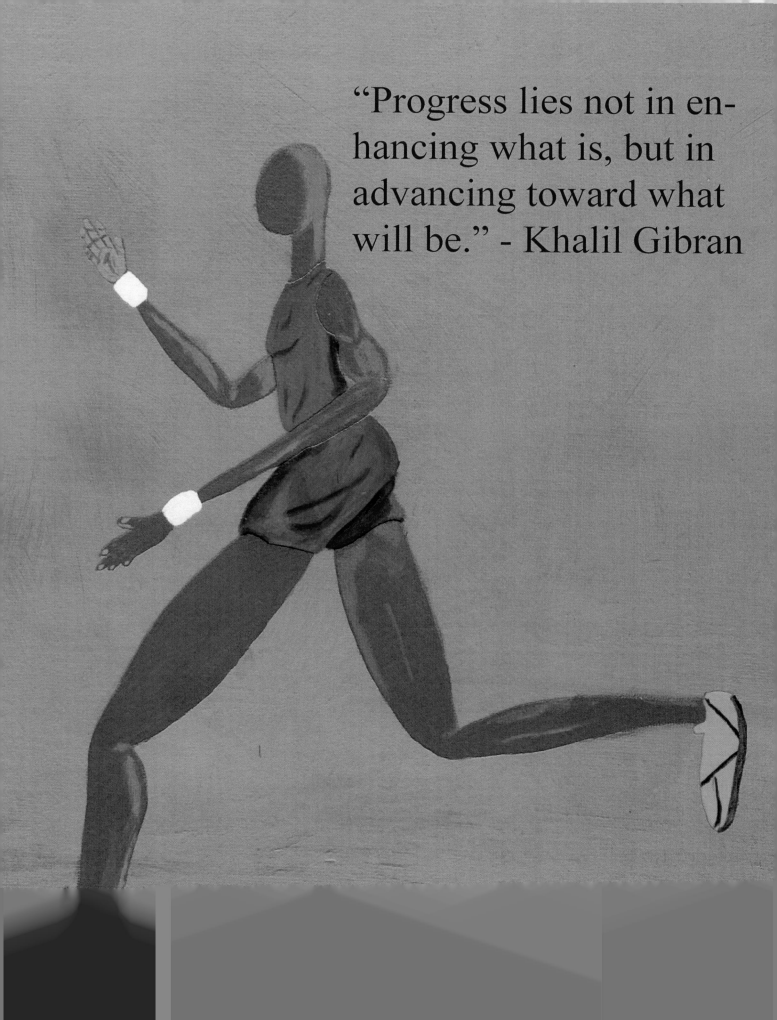

"Progress lies not in enhancing what is, but in advancing toward what will be." - Khalil Gibran

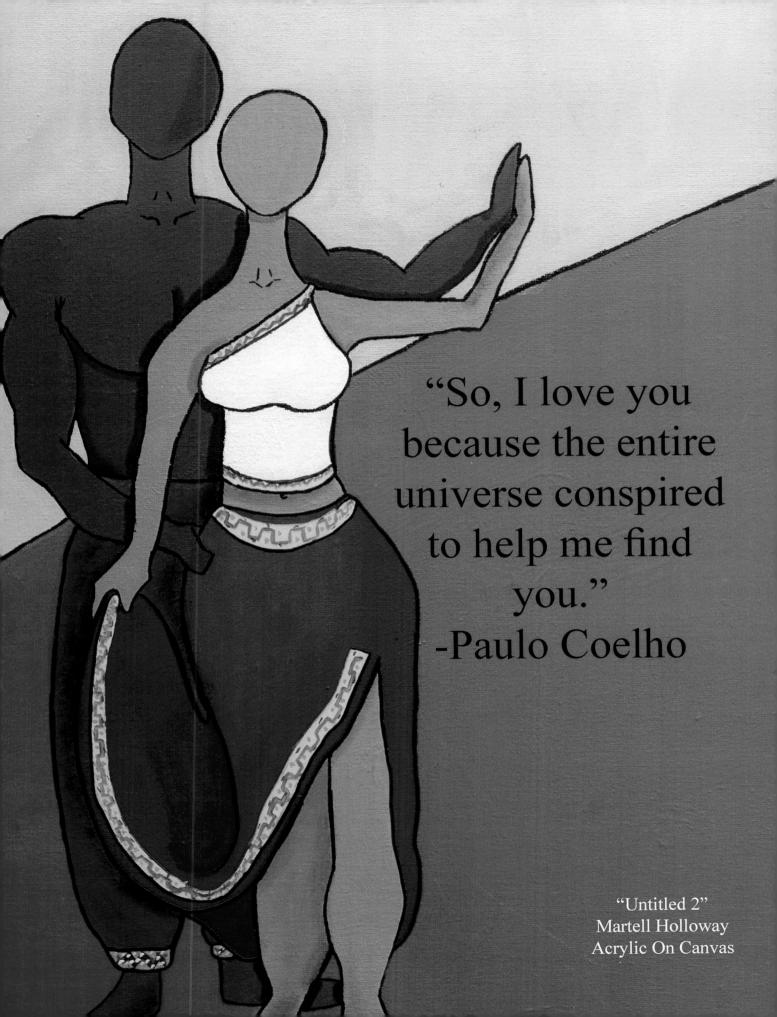

"So, I love you because the entire universe conspired to help me find you."
-Paulo Coelho

"Untitled 2"
Martell Holloway
Acrylic On Canvas

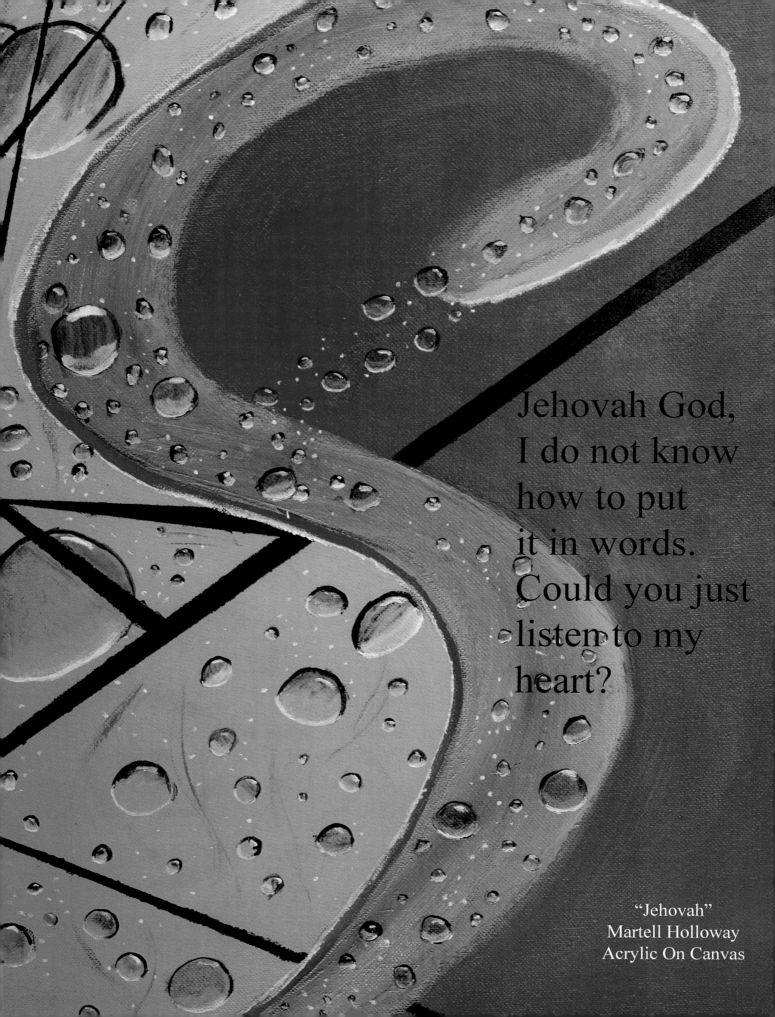

Jehovah God, I do not know how to put it in words. Could you just listen to my heart?

"Jehovah"
Martell Holloway
Acrylic On Canvas

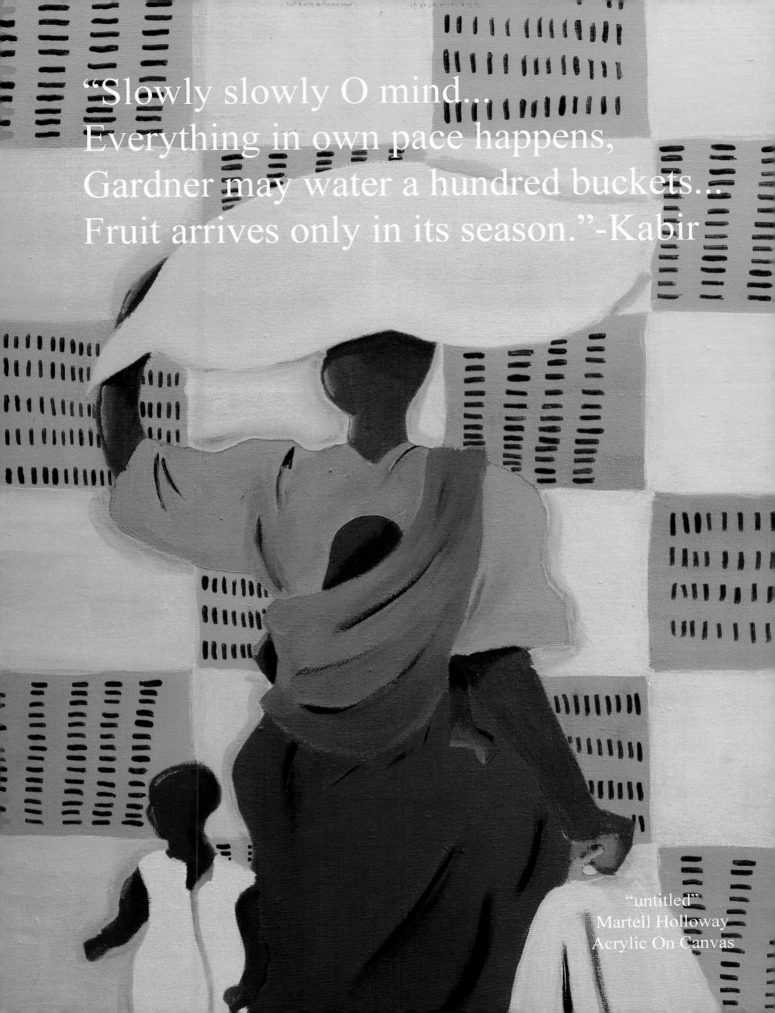

"Slowly slowly O mind...
Everything in own pace happens,
Gardner may water a hundred buckets...
Fruit arrives only in its season."-Kabir

"untitled"
Martell Holloway
Acrylic On Canvas

"To heal the ancient battle between darkness and light, we may find that it's less about defeating one or the other, and more about choosing our relationship to both."
-Gregg Braden

"When you make a choice, you change the future." - Deepak Chopra

"Peace is stronger than war because it heals." - A Course In Miracles

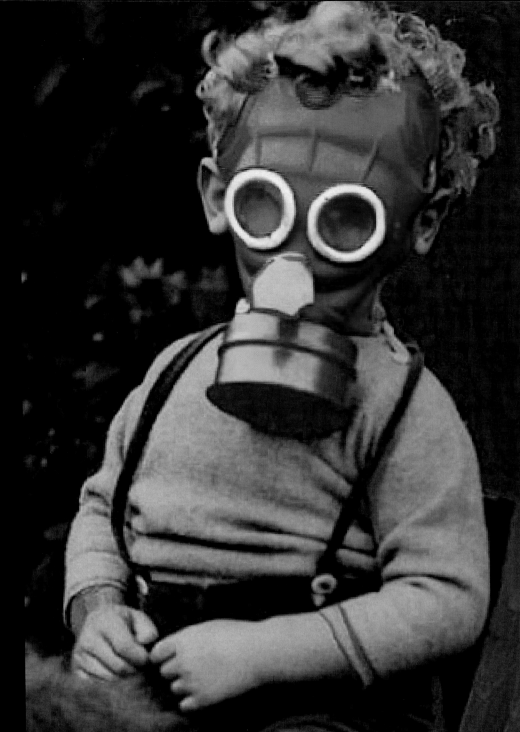

"As long as the mind and ego control the direction of creating, there will always be problems in the outer world, for the ego thinks only of itself and lives in duality. But when the heart is in control, everything comes back to balance, for the heart feels and knows only the oneness of life."
-Drunvalo Melchizedek

"Do not fight the darkness, let the lig

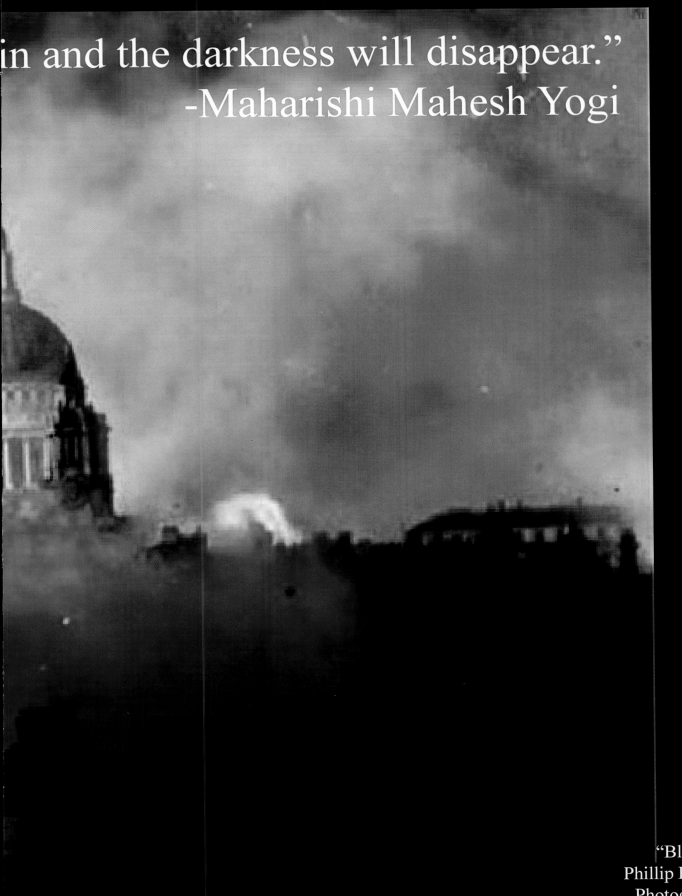

in and the darkness will disappear."
-Maharishi Mahesh Yogi

"Blitz"
Phillip Hopkin
Photography

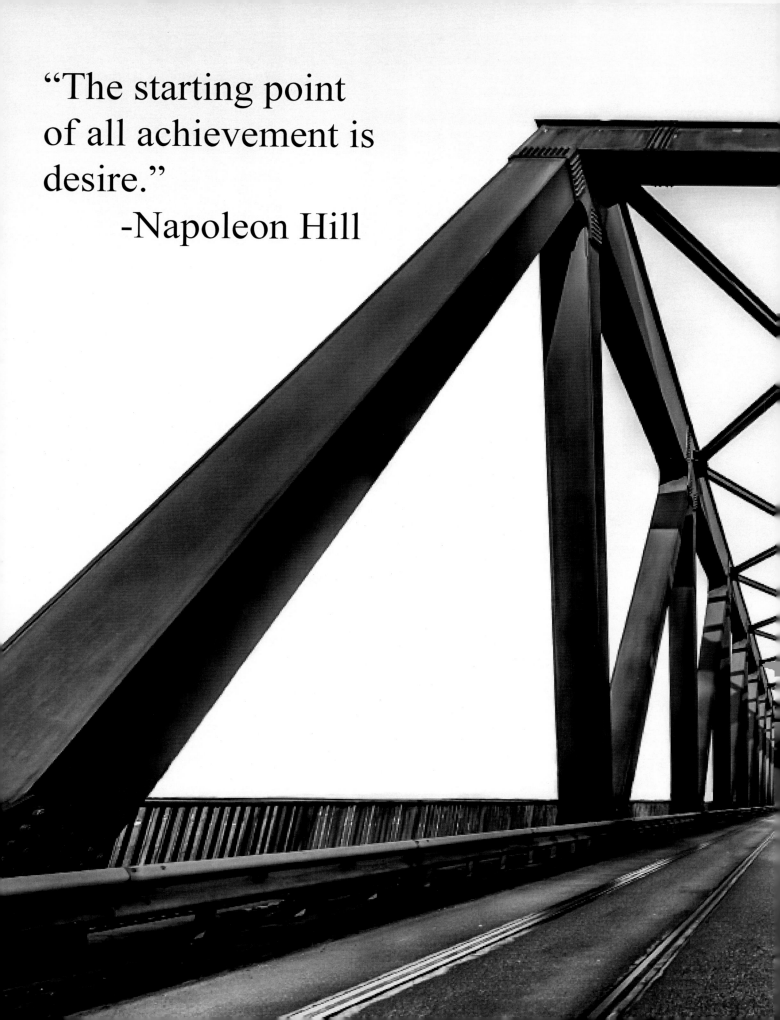

"The starting point of all achievement is desire."
	-Napoleon Hill

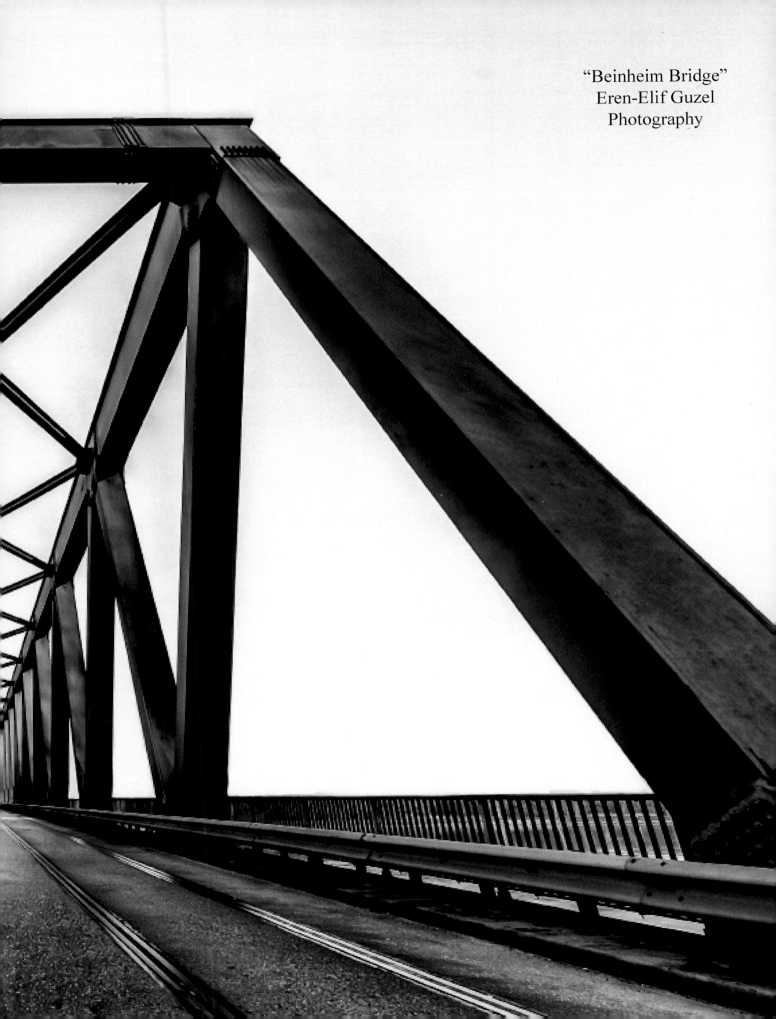

"Beinheim Bridge"
Eren-Elif Guzel
Photography

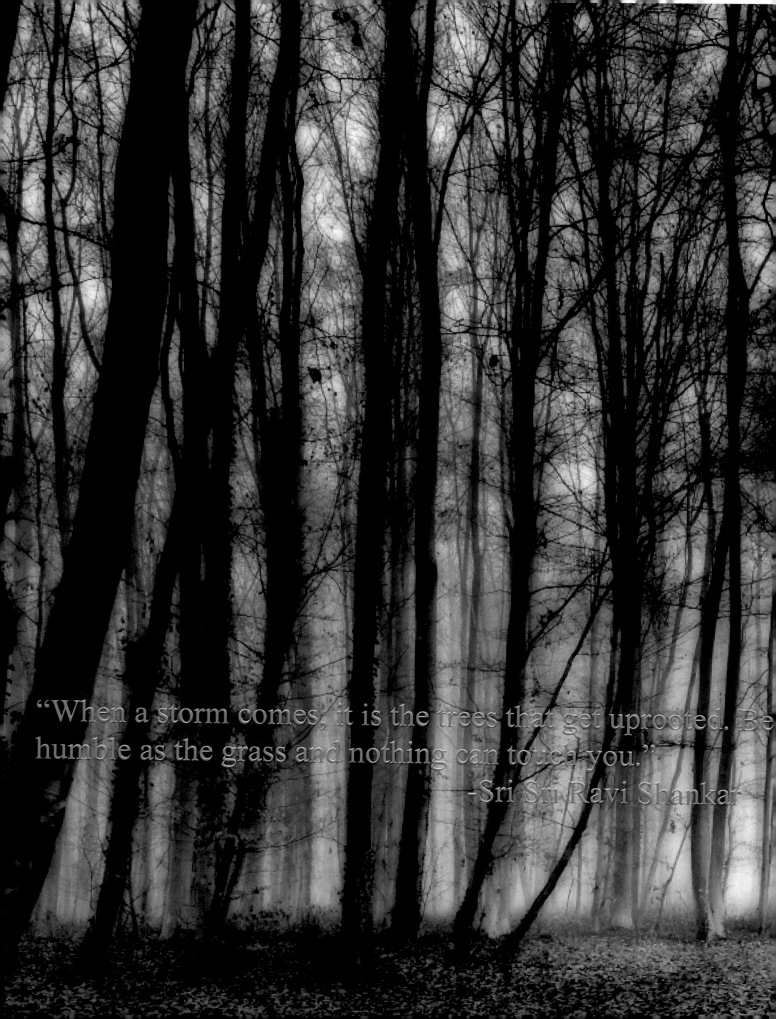

"When a storm comes, it is the trees that get uprooted. Be humble as the grass and nothing can touch you."
					-Sri Sri Ravi Shankar

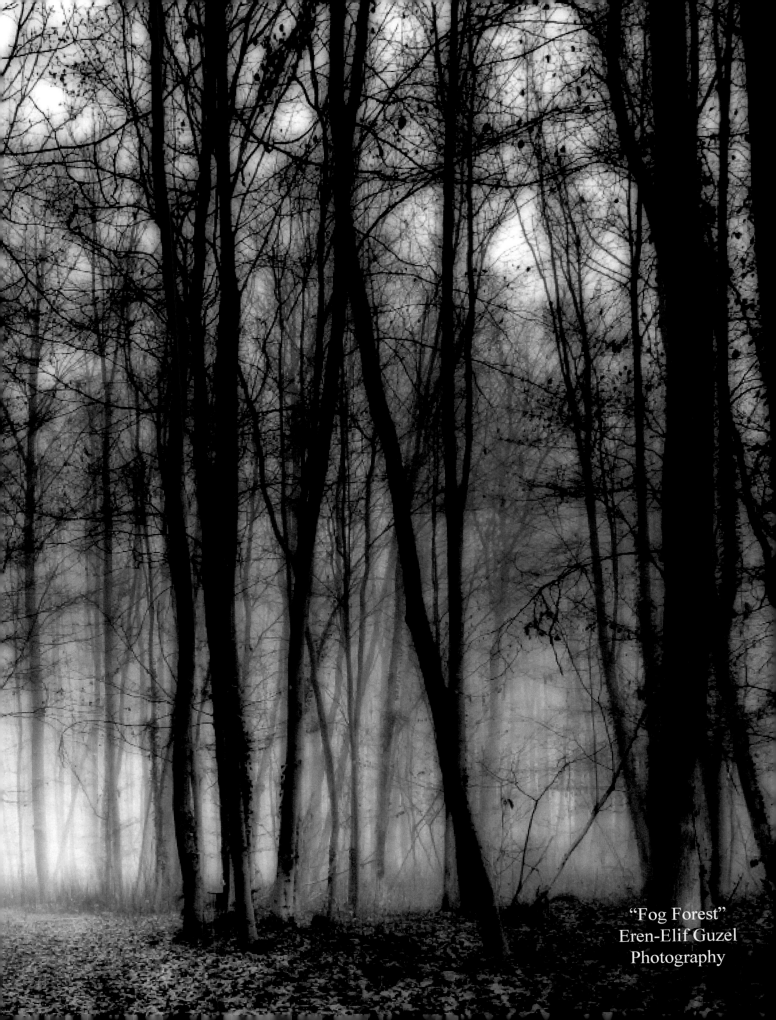

"Fog Forest"
Eren-Elif Guzel
Photography

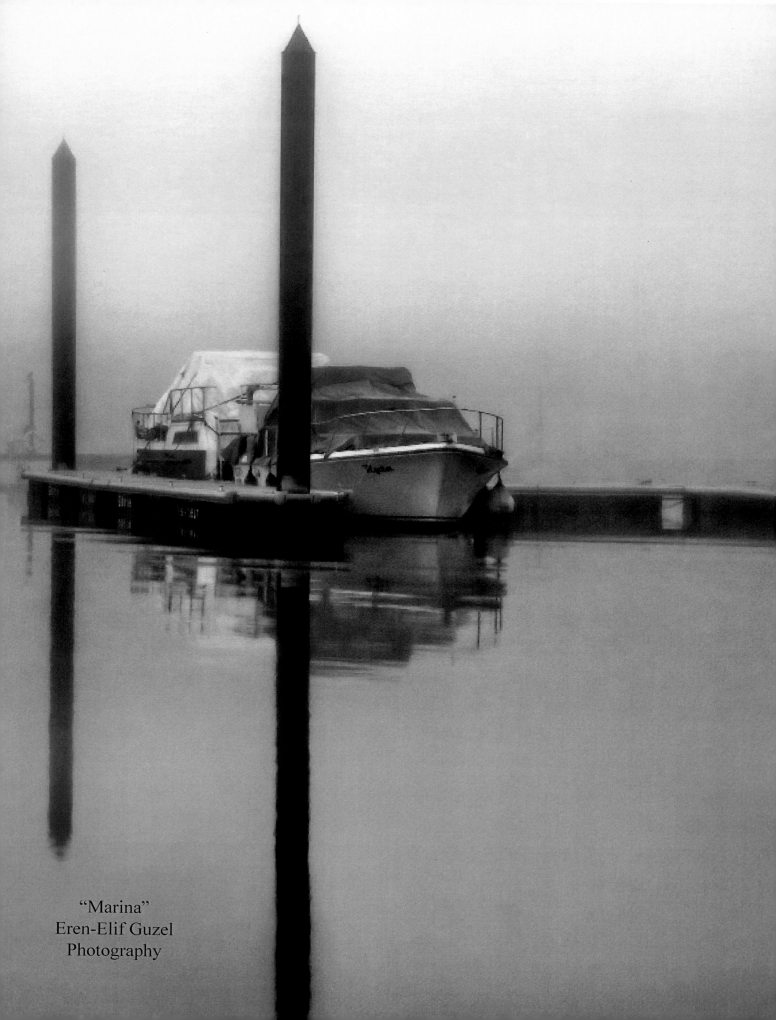

"Marina"
Eren-Elif Guzel
Photography

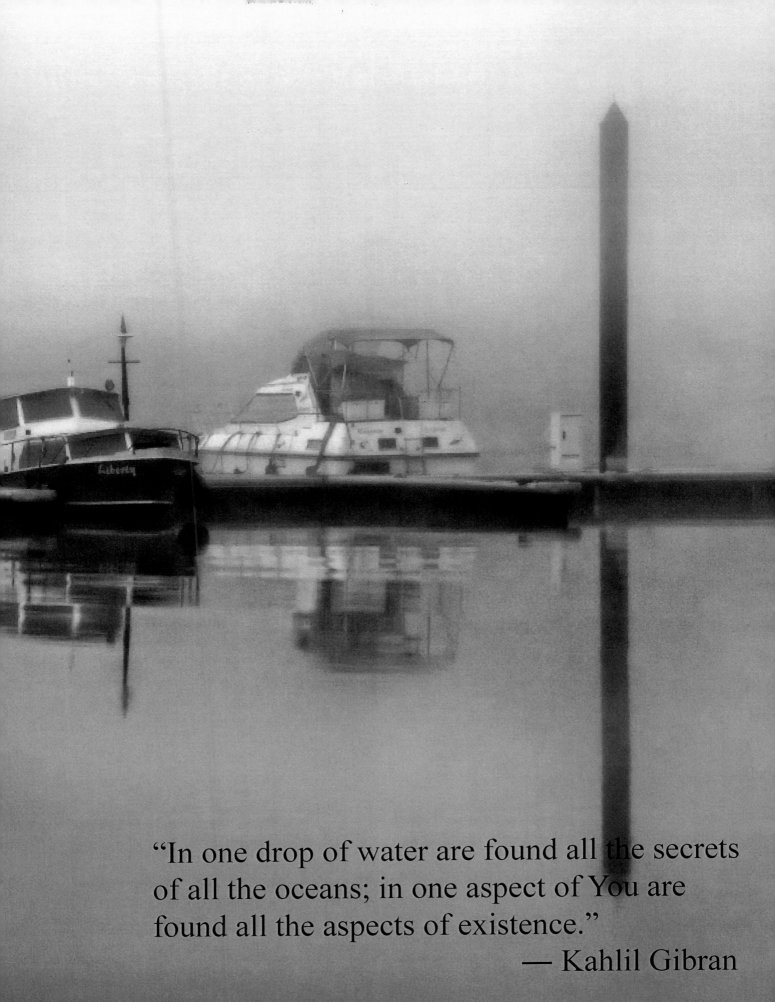

"In one drop of water are found all the secrets of all the oceans; in one aspect of You are found all the aspects of existence."
— Kahlil Gibran

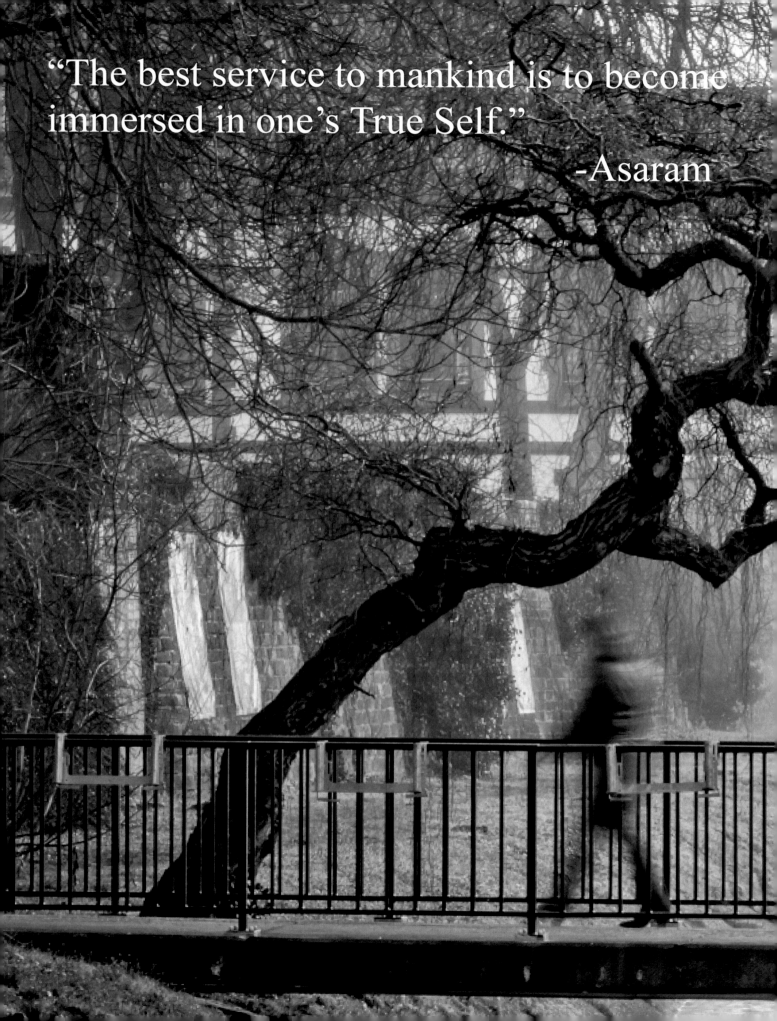

"The best service to mankind is to become immersed in one's True Self."

-Asaram

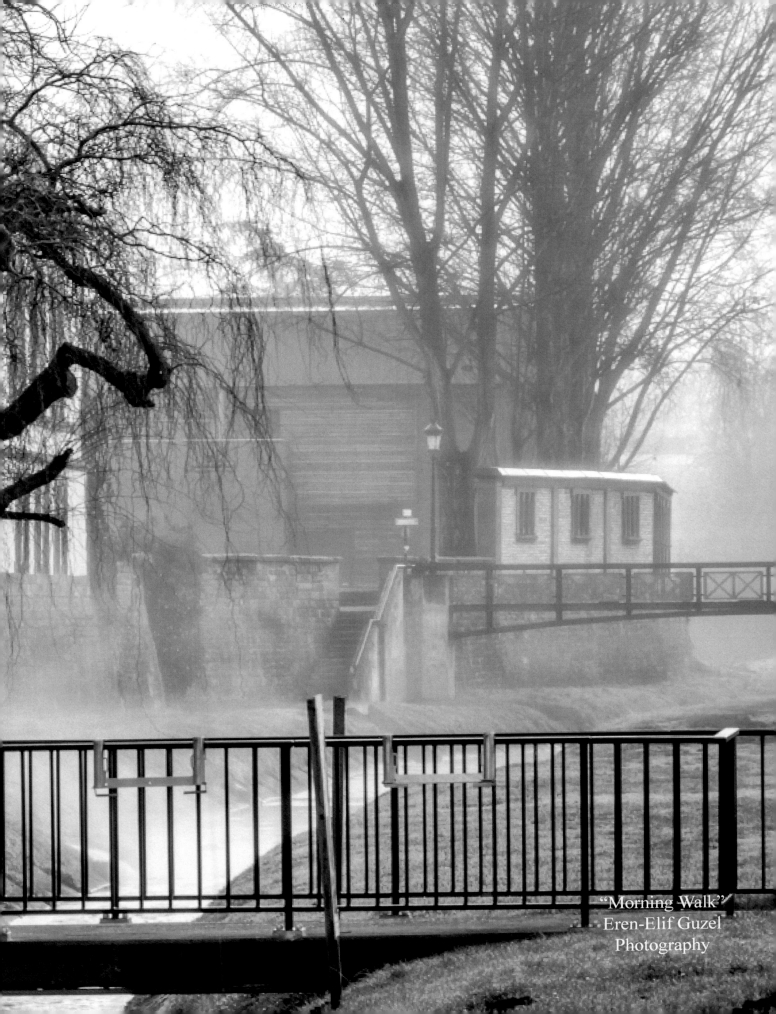

"Morning Walk"
Eren-Elif Guzel
Photography

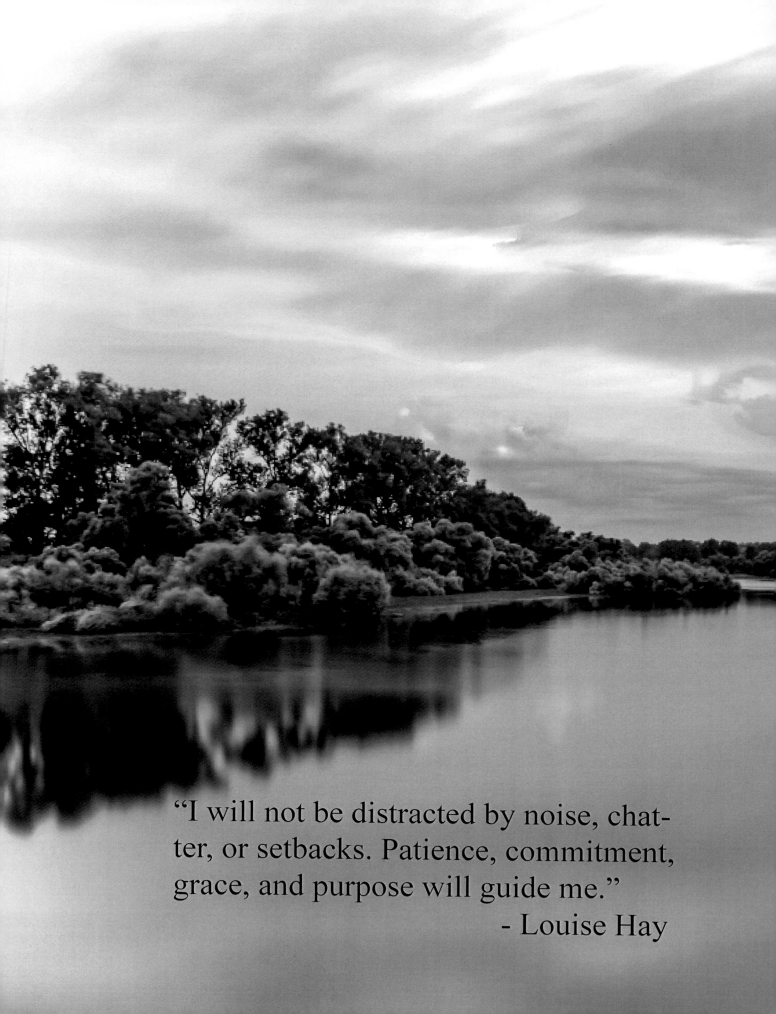

"I will not be distracted by noise, chatter, or setbacks. Patience, commitment, grace, and purpose will guide me."
- Louise Hay

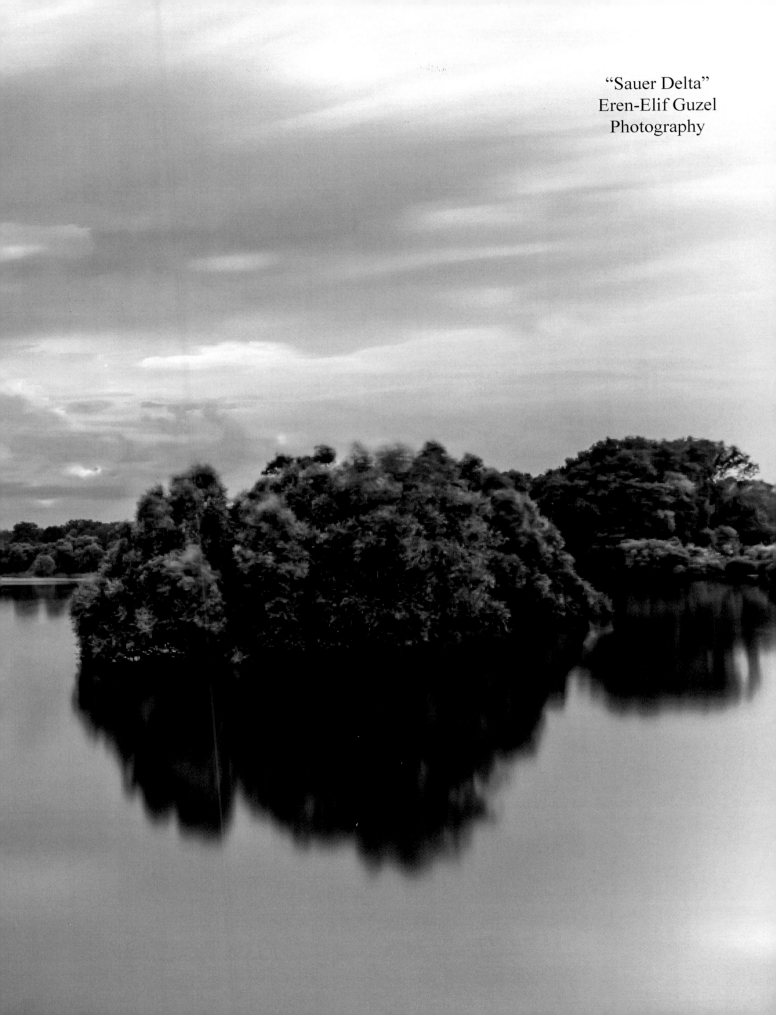

"Sauer Delta"
Eren-Elif Guzel
Photography

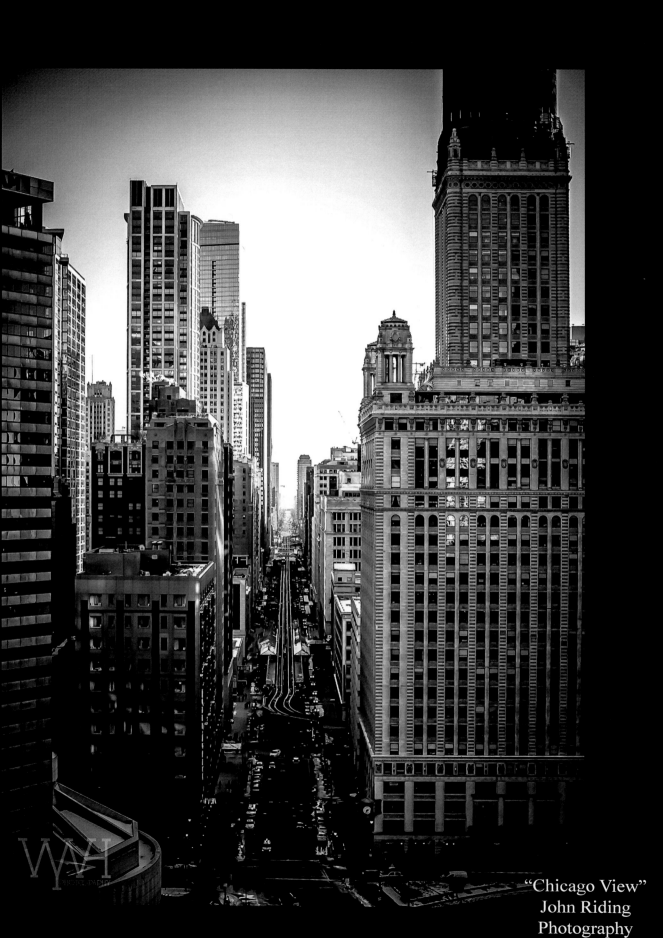

"Chicago View"
John Riding
Photography

"Change in society is of secondary importance; that will come about naturally, inevitably, when you as a human being bring about the change in yourself."
-Jiddu Krishnamurti

"God is speaking to all of us, all the time. The question is not, to whom does God talk? The question is, who listens?"

-Neale Donald Walsch

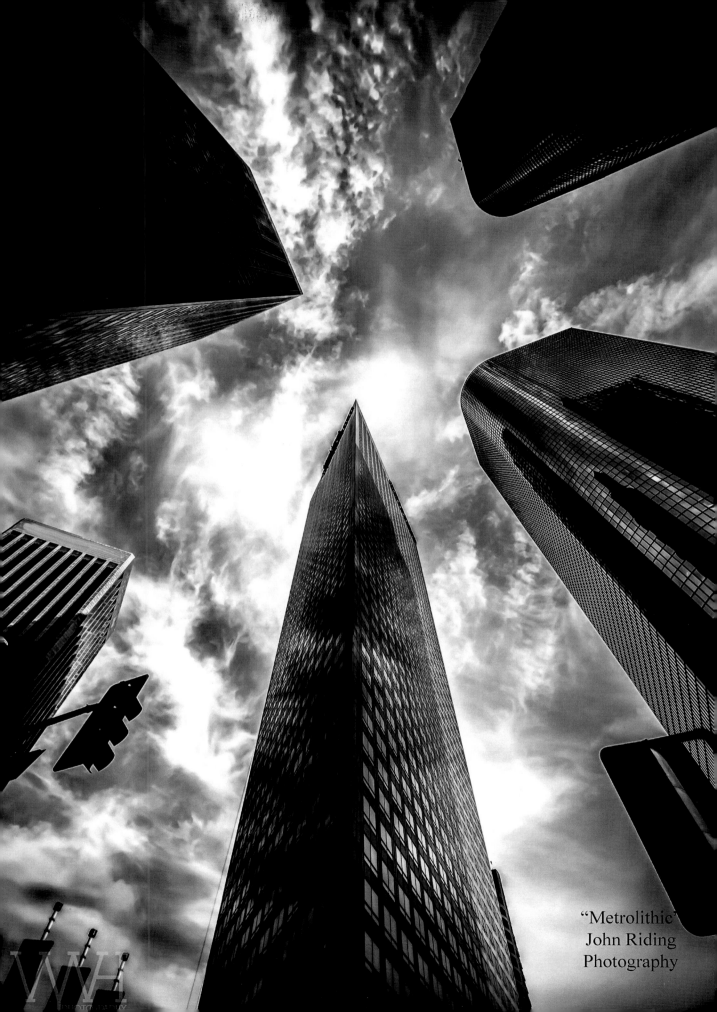

"Metrolithic"
John Riding
Photography

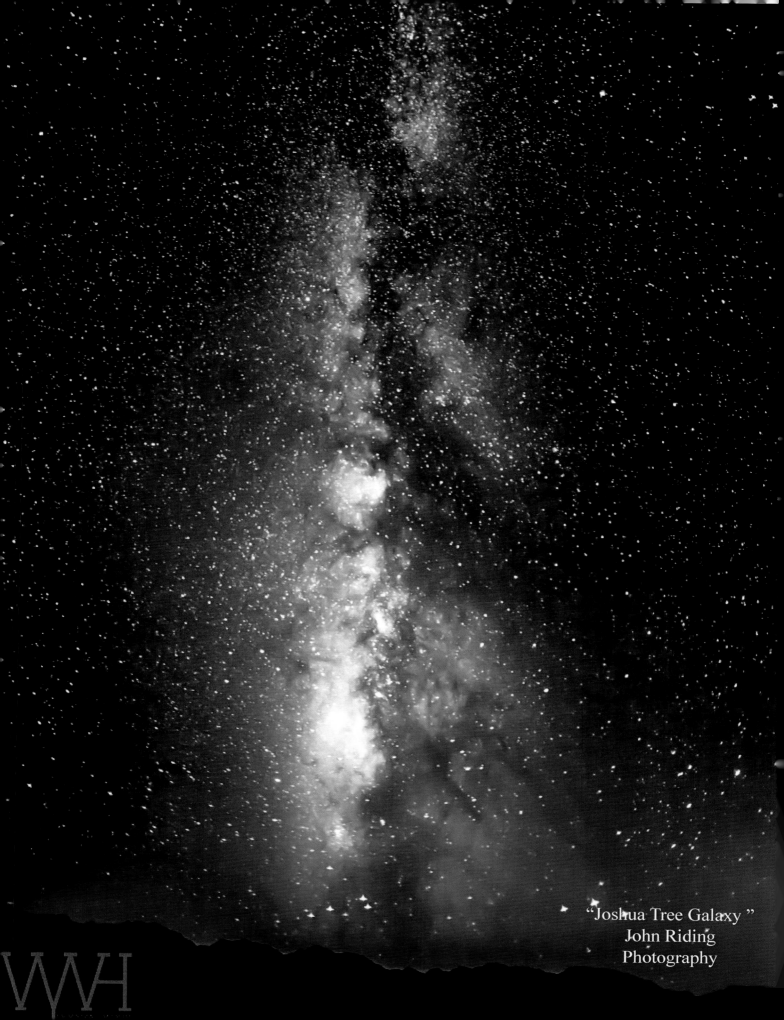

"Joshua Tree Galaxy"
John Riding
Photography

"Look out into the universe and contemplate the glory of God. Observe the stars, millions of them, twinkling in the night sky, all with a message of unity, part of the very nature of God."

-Sai Baba

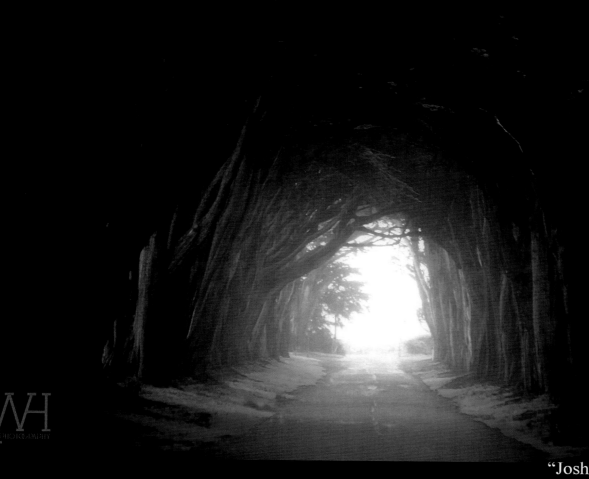

"Joshua Tree Galaxy "
John Riding
Photography

"The spiritual journey is individual, highly personal. It can't be organized or regulated. It isn't true that everyone should follow one path. Listen to your own truths."

-Ram Dass

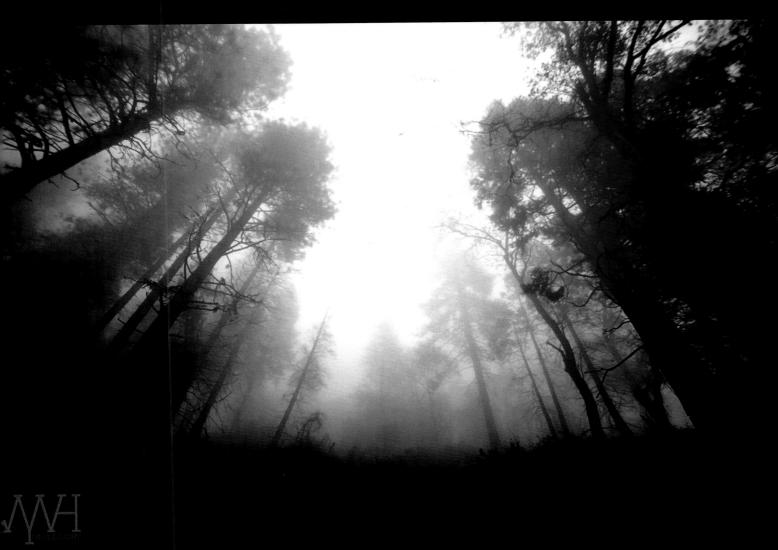

"Yosemite Haze "
John Riding
Photography

"You are one with the power and the frequency and the energy that created you, whether or not you be-live it."

-Paul Selig

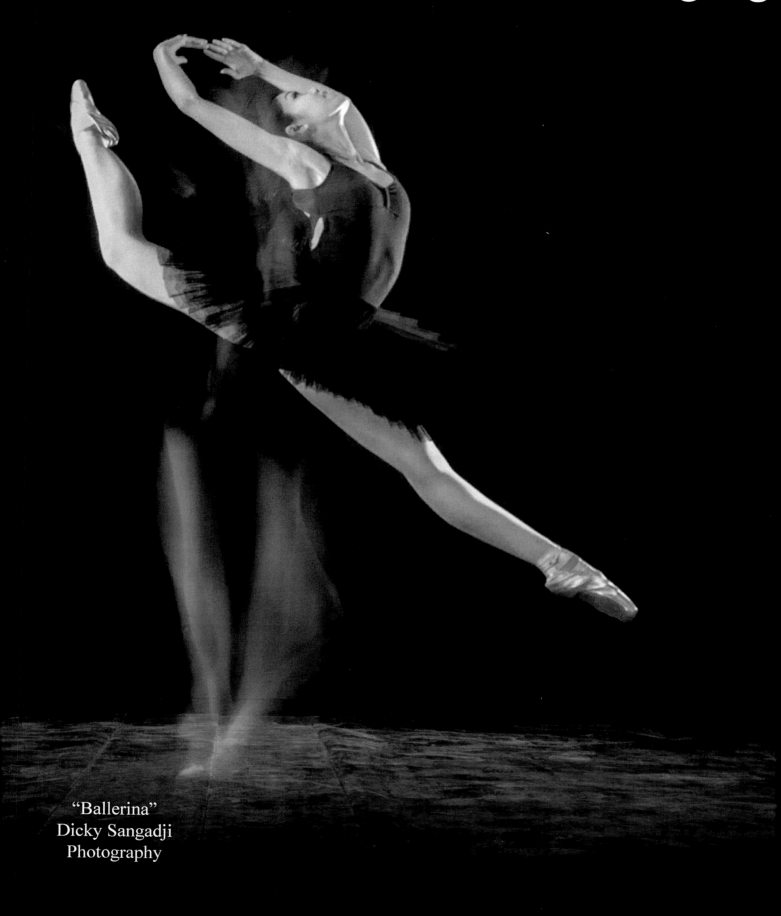

"Dance is the hidden language

"Ballerina"
Dicky Sangadji
Photography

of the soul of the body."
-Martha Graham

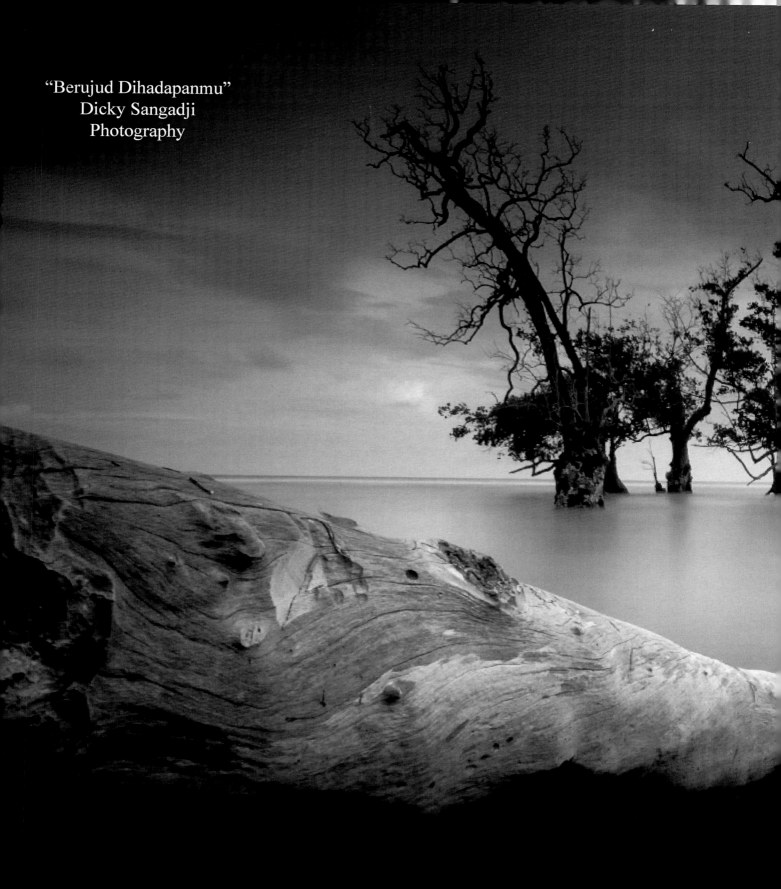

"Berujud Dihadapanmu"
Dicky Sangadji
Photography

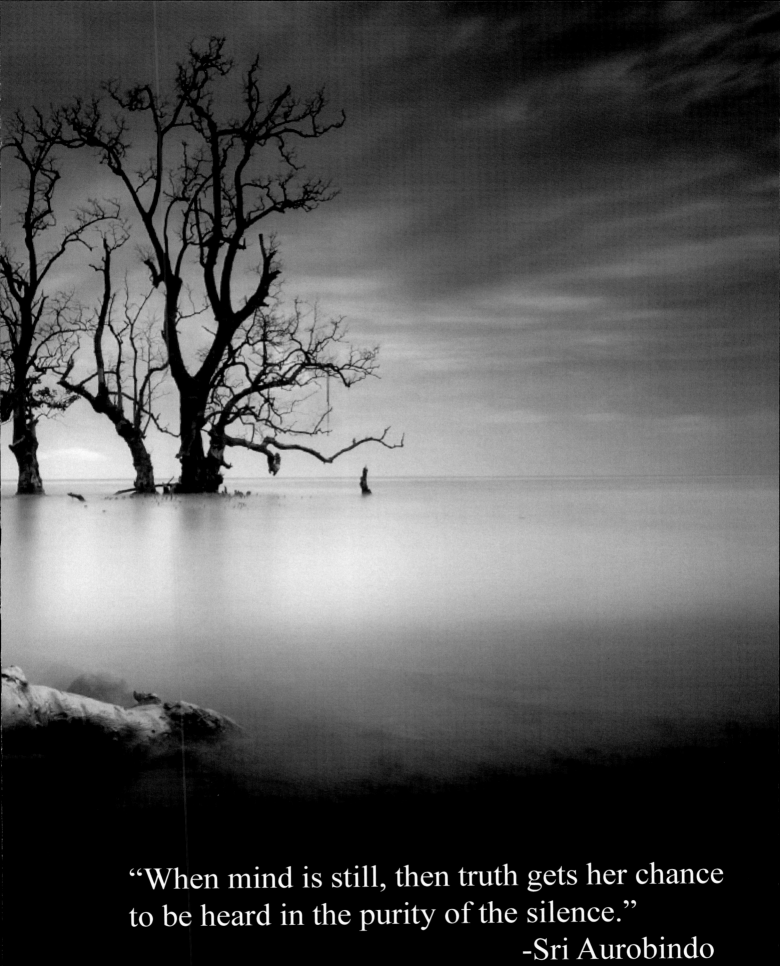

"When mind is still, then truth gets her chance to be heard in the purity of the silence."
 -Sri Aurobindo

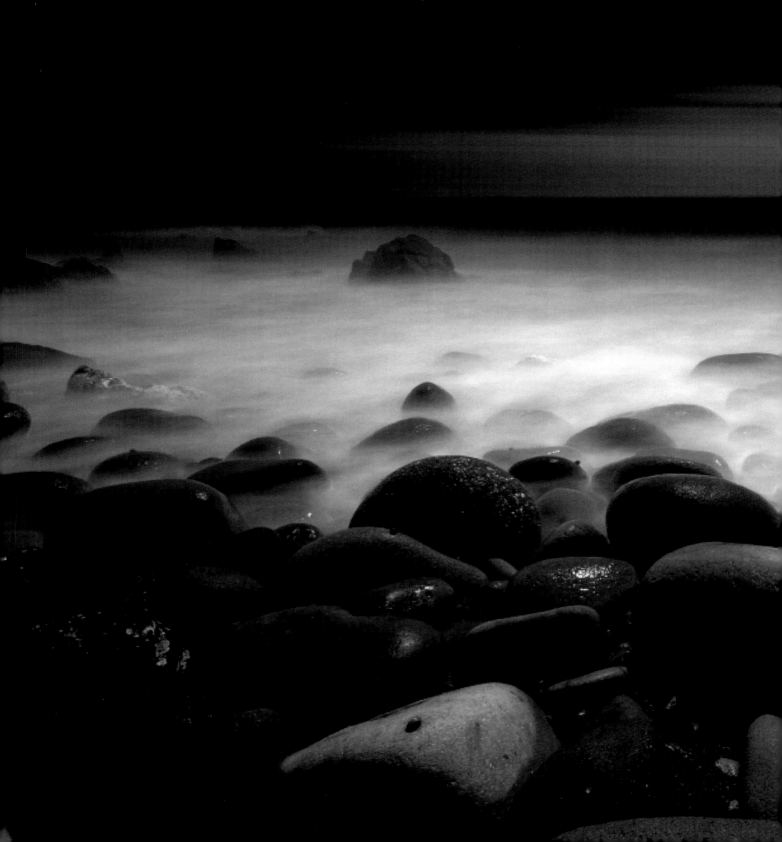

"How people treat you is their karma; how you react is yours."
-Wayne Dyer

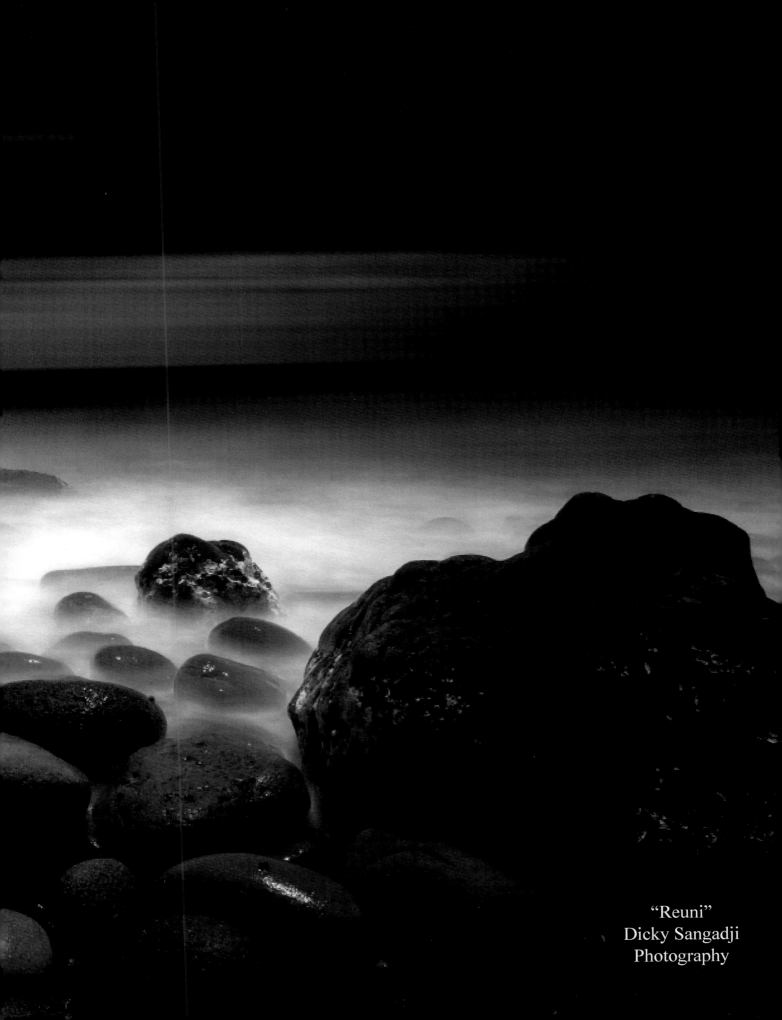

"Reuni"
Dicky Sangadji
Photography

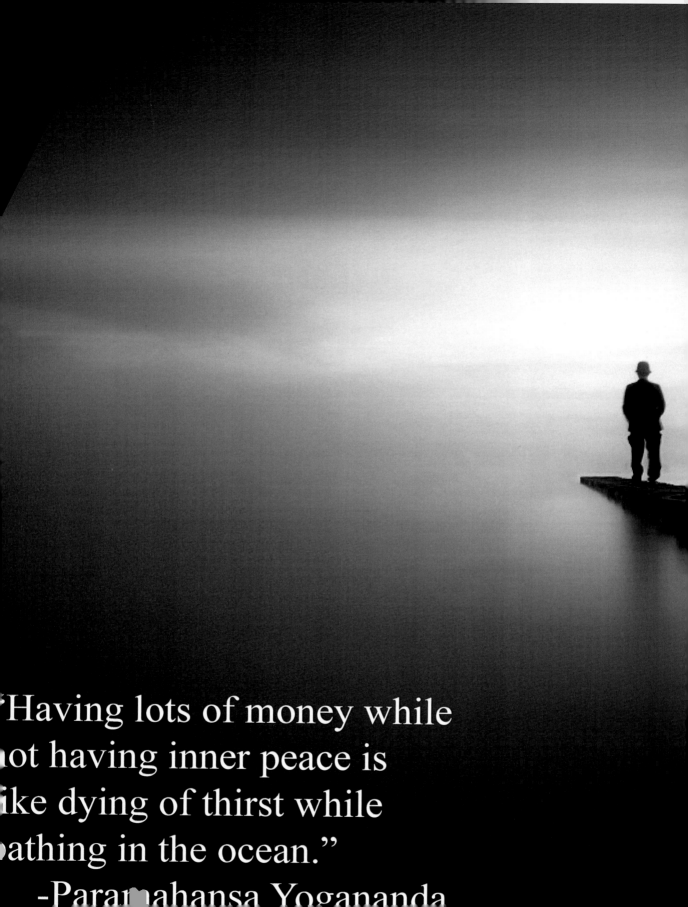

"Having lots of money while
not having inner peace is
like dying of thirst while
bathing in the ocean."
 -Paramahansa Yogananda

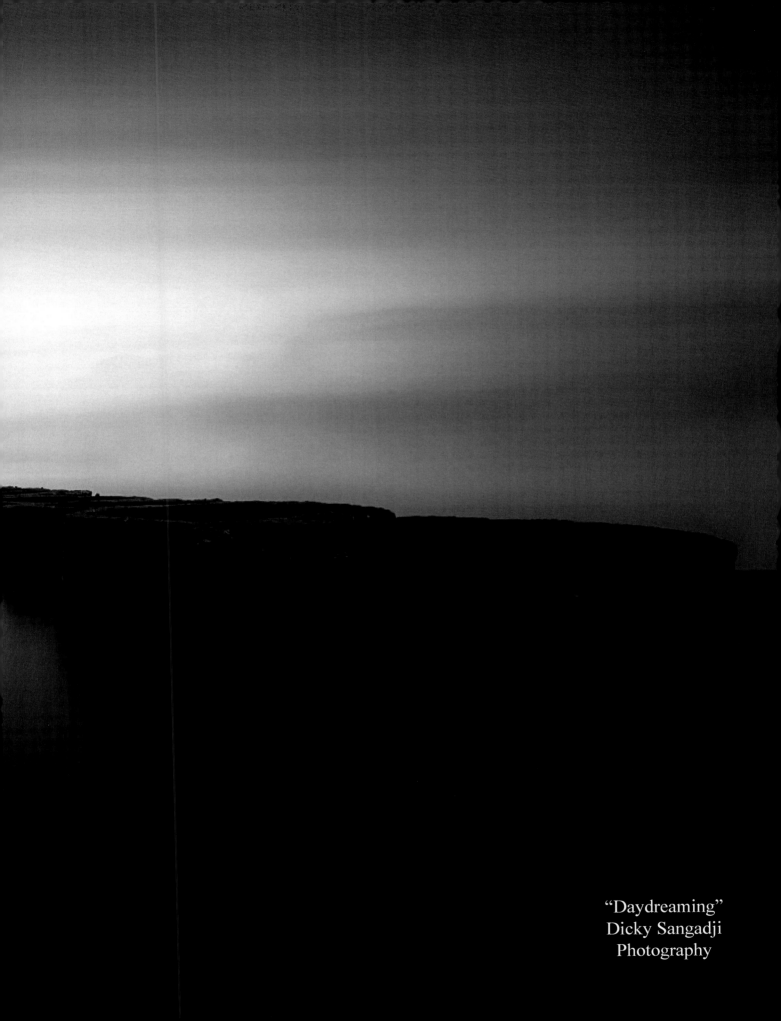

"Daydreaming"
Dicky Sangadji
Photography

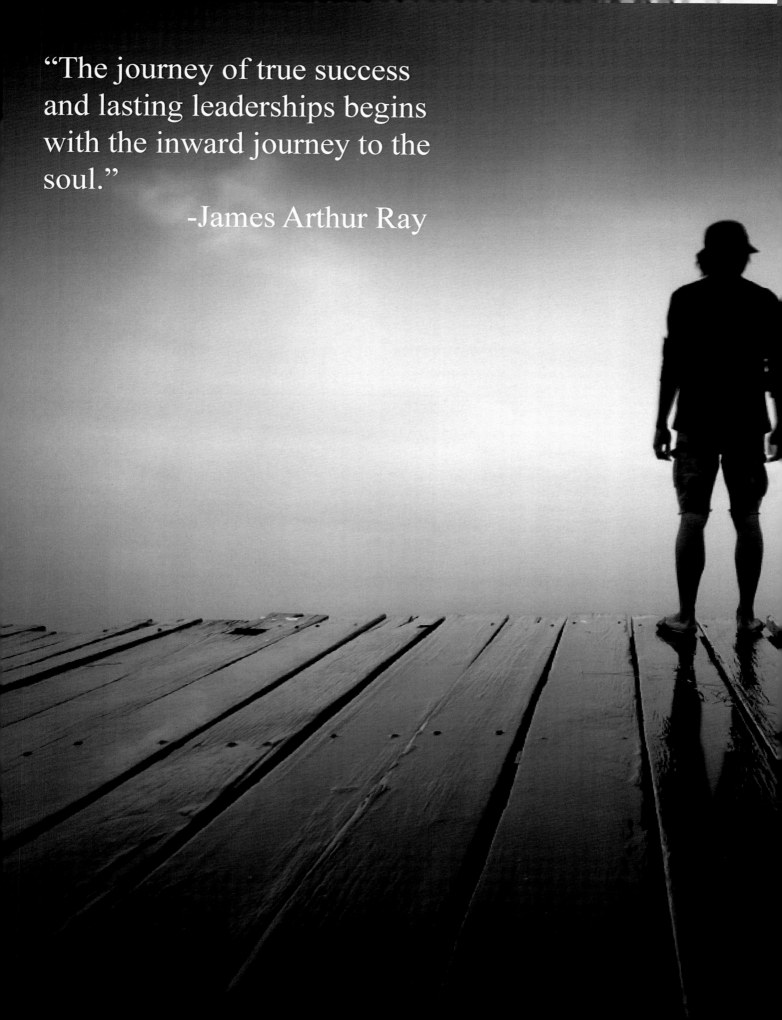

"The journey of true success and lasting leaderships begins with the inward journey to the soul."

-James Arthur Ray

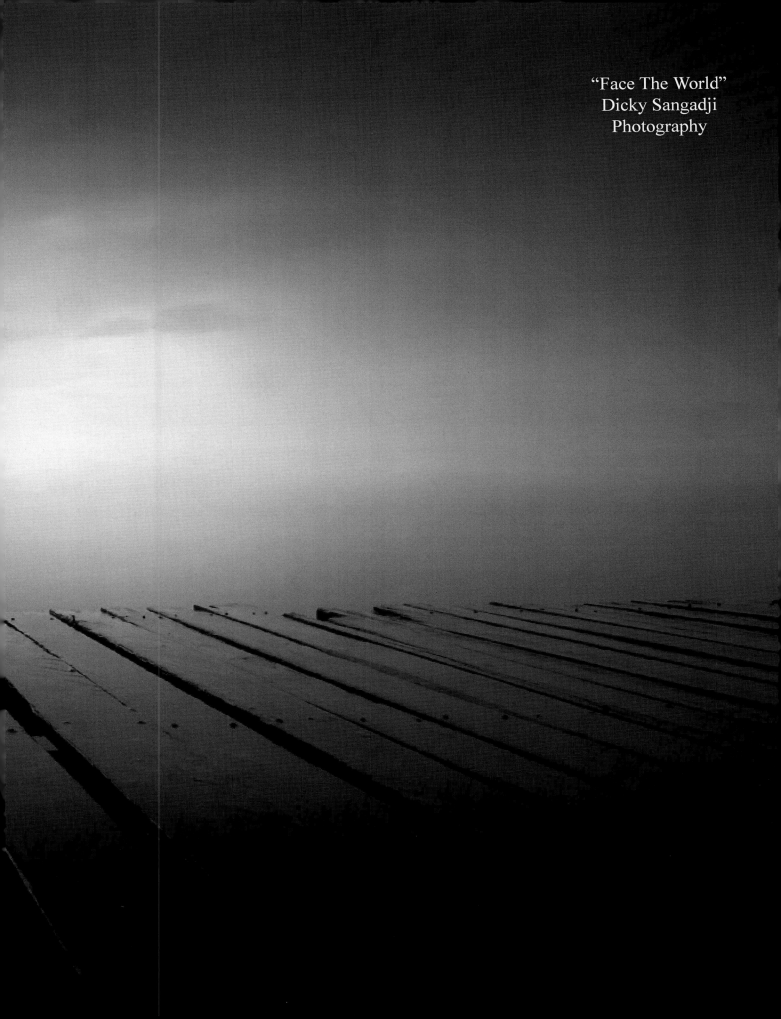

"Face The World"
Dicky Sangadji
Photography

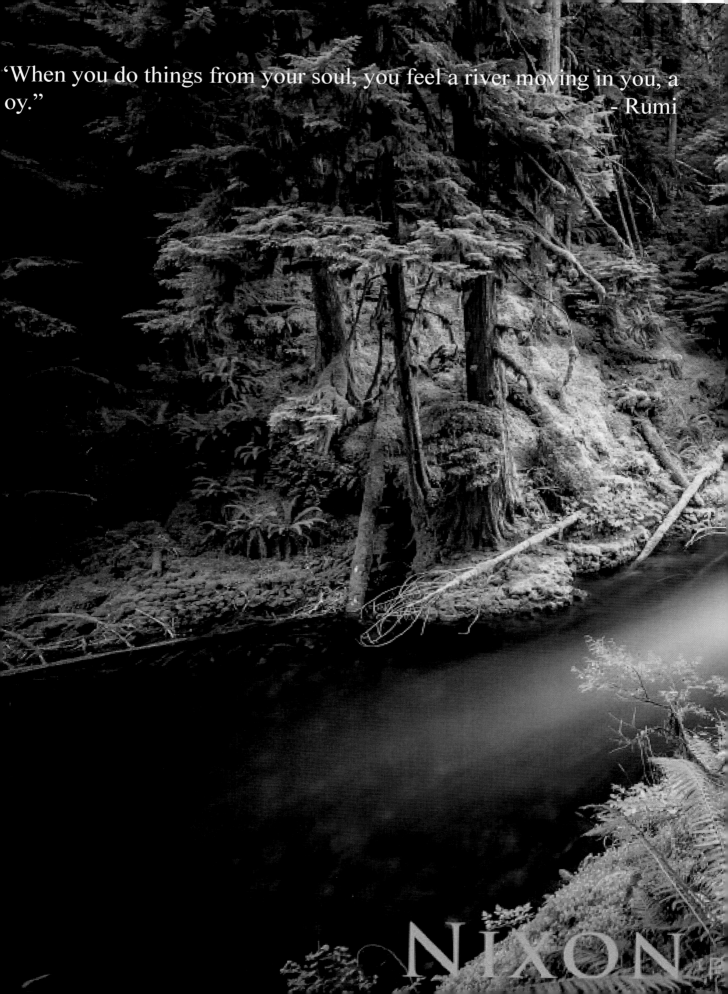

'When you do things from your soul, you feel a river moving in you, a oy."
- Rumi

NIXON

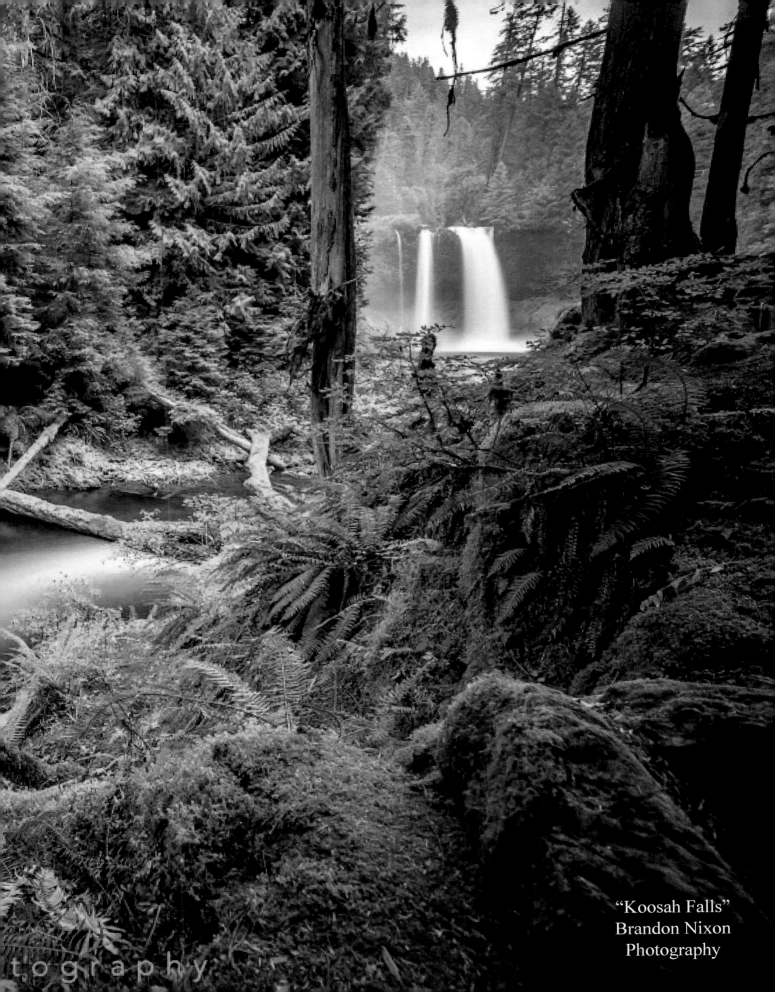

"Koosah Falls"
Brandon Nixon
Photography

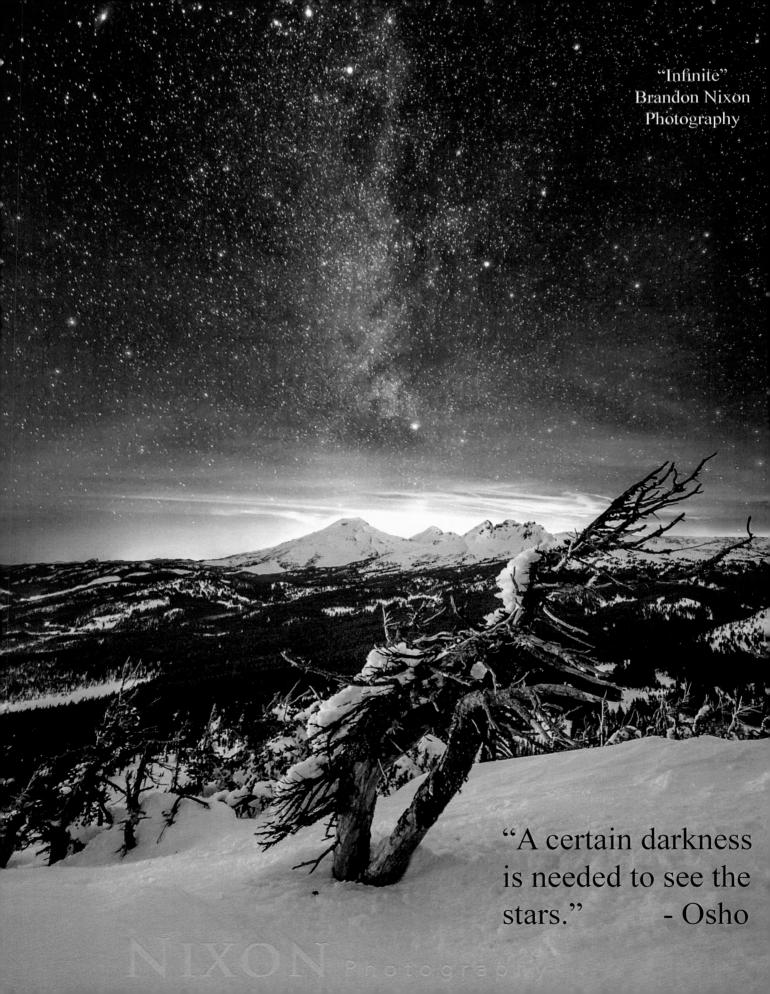

"Infinite"
Brandon Nixon
Photography

"A certain darkness is needed to see the stars." - Osho

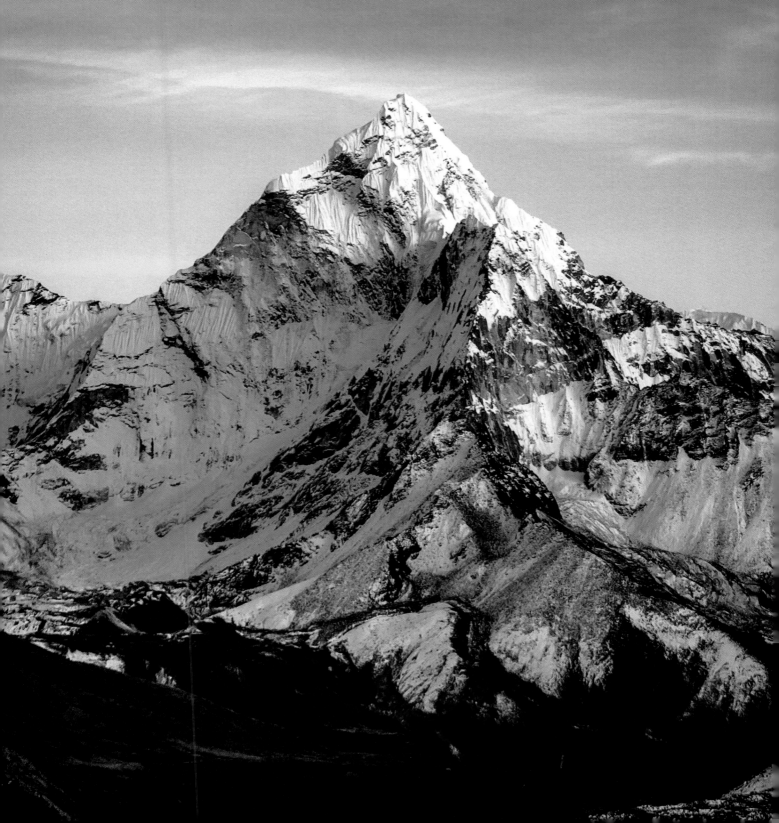

"It is not the mountain we conquer but ourselves."
-Edmund Hillary

"Peaking"
Brandon Nixon
Photography

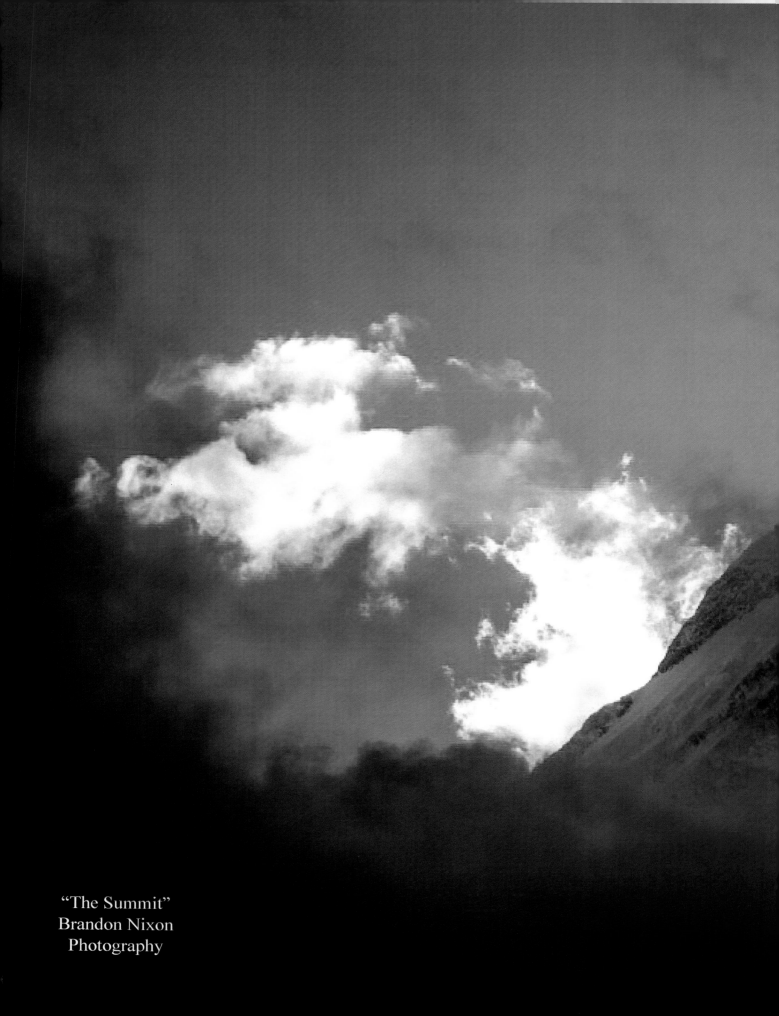

"The Summit"
Brandon Nixon
Photography

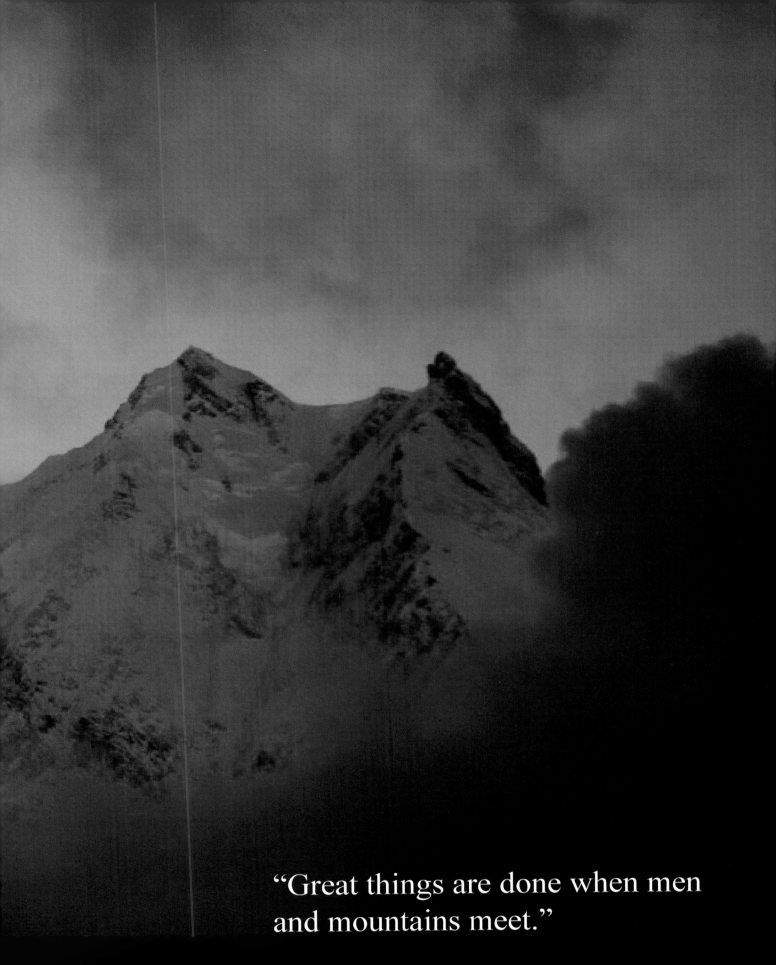

"Great things are done when men and mountains meet."

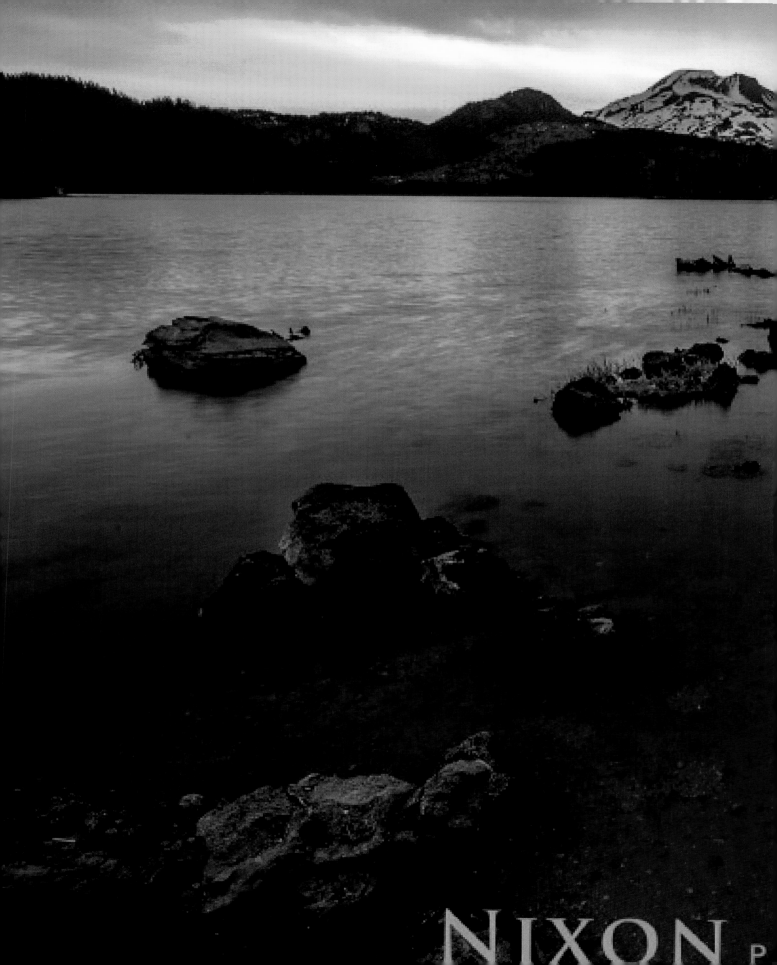

NIXON P

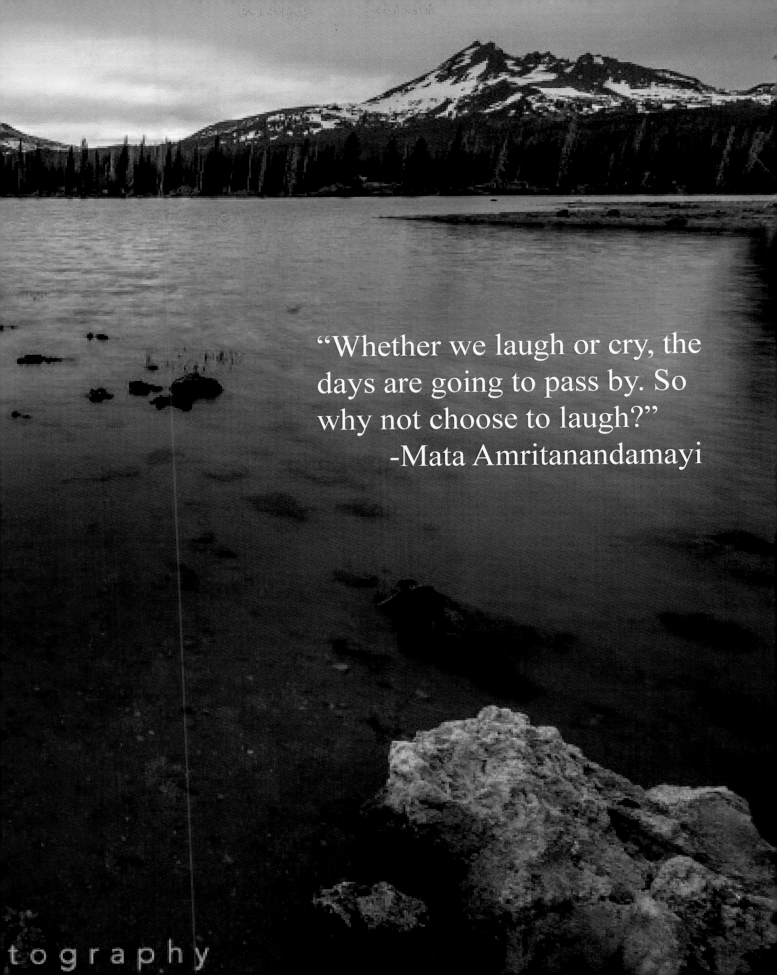

"Whether we laugh or cry, the days are going to pass by. So why not choose to laugh?"
-Mata Amritanandamayi

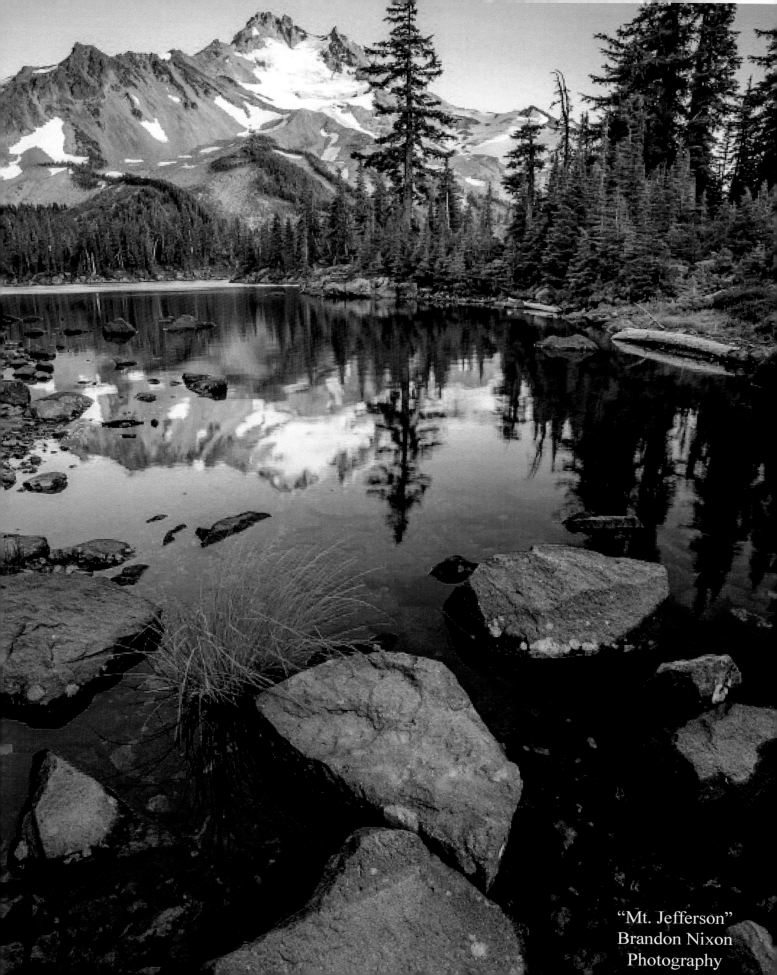

"Mt. Jefferson"
Brandon Nixon
Photography

"The poor long for riches, the rich long for heaven, but the wise long for a state of tranquility."
-Rama Swami

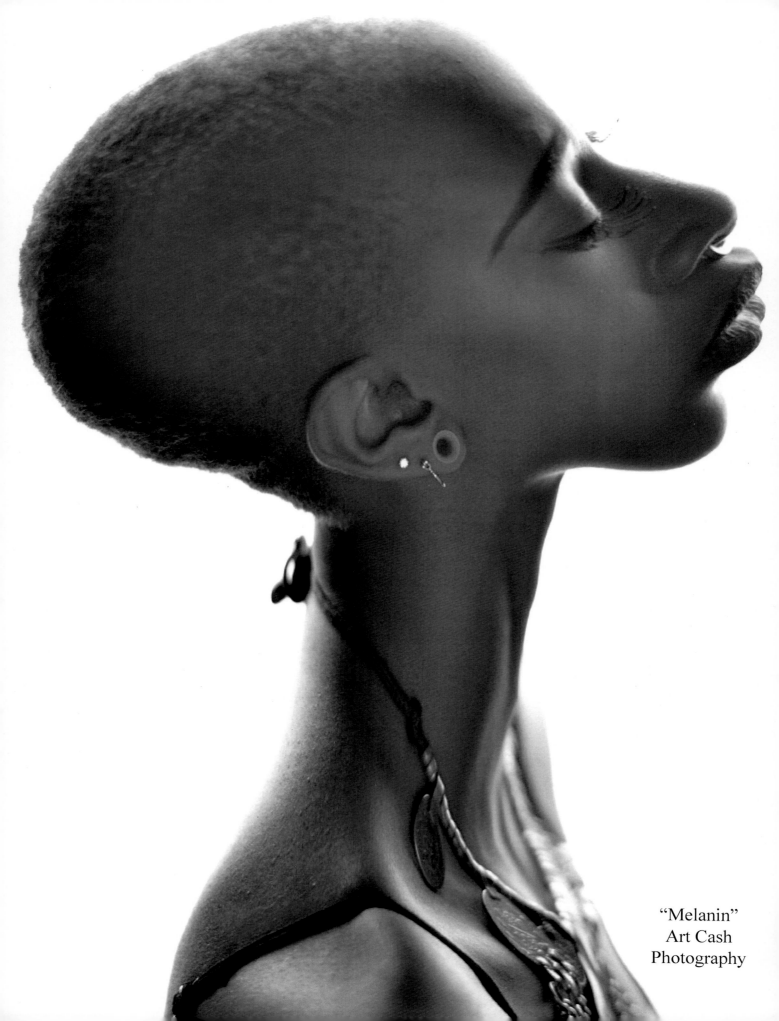

"Melanin"
Art Cash
Photography

"We've gotten caught up in thinking we are what we look like, the physical, the exterior. We think we're the lamp shade. We've forgotten that we are the light-the electricity and the luminosity that lights up every man, woman, and child. The light is who we truly are."

-Michael Beckwith

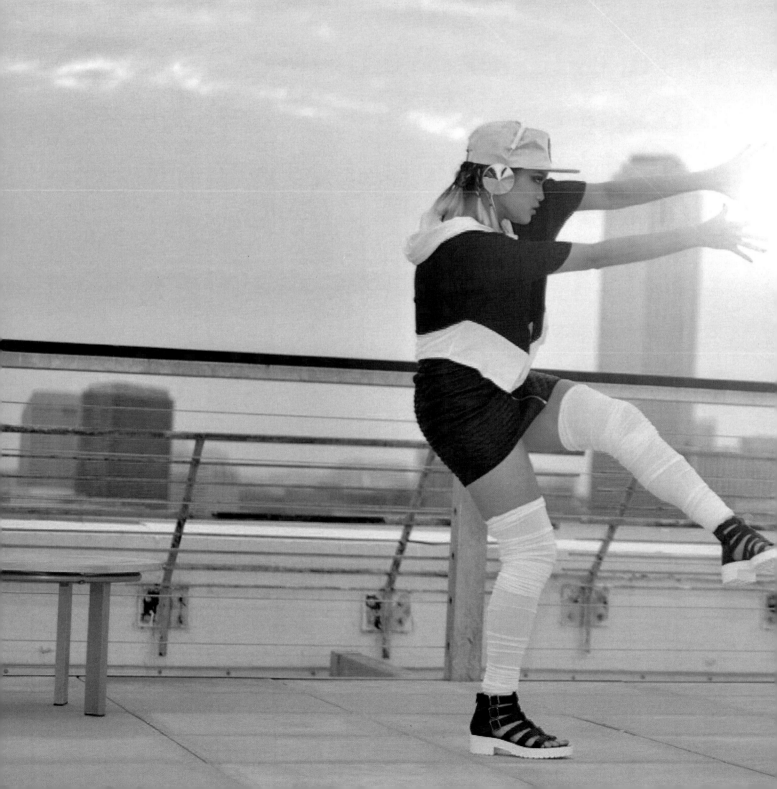

"Do not lower your goals to the level of your abilities. Instead, raise your abilities to the height of your goals."
-Swami Vivekananda

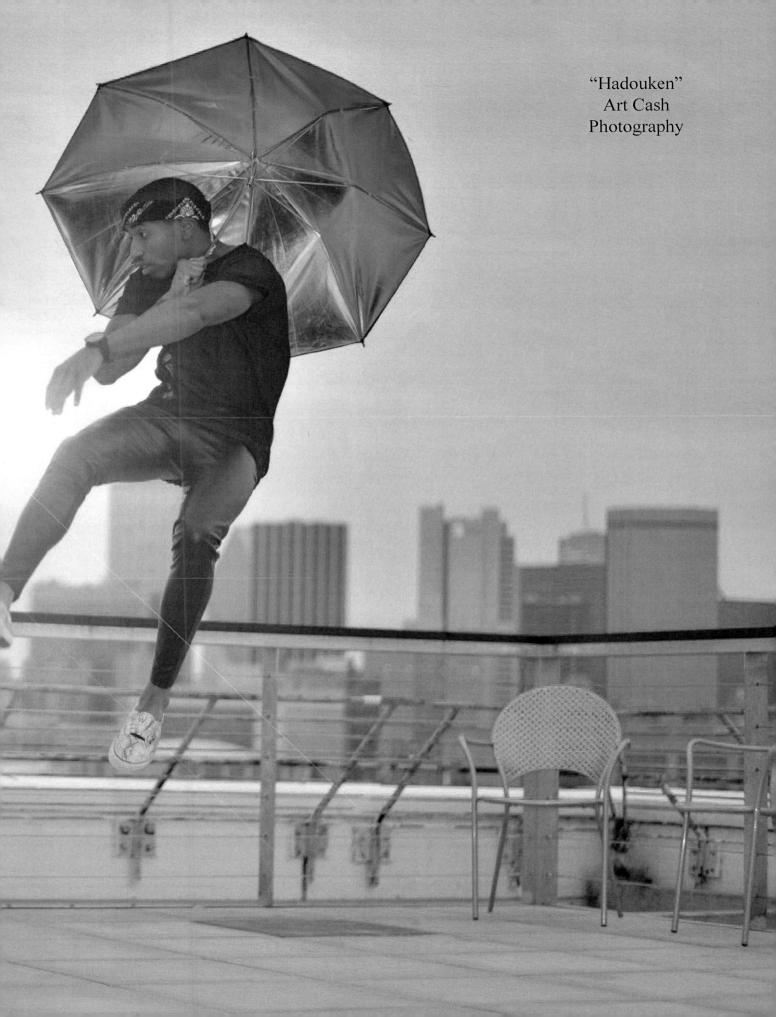

"Hadouken"
Art Cash
Photography

"Our mind is full of anger, jealousy and other negative feelings. Yet we do not realize that these are incompatible with inner peace and joy."
	-Gautama Buddha

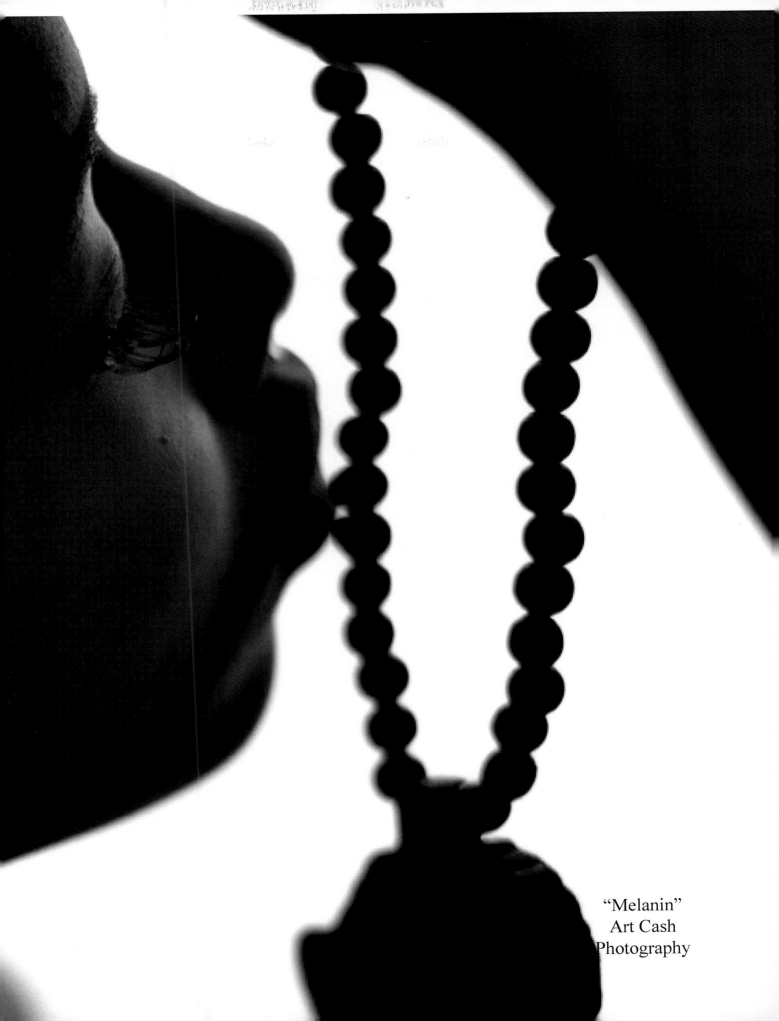

"Melanin"
Art Cash
Photography

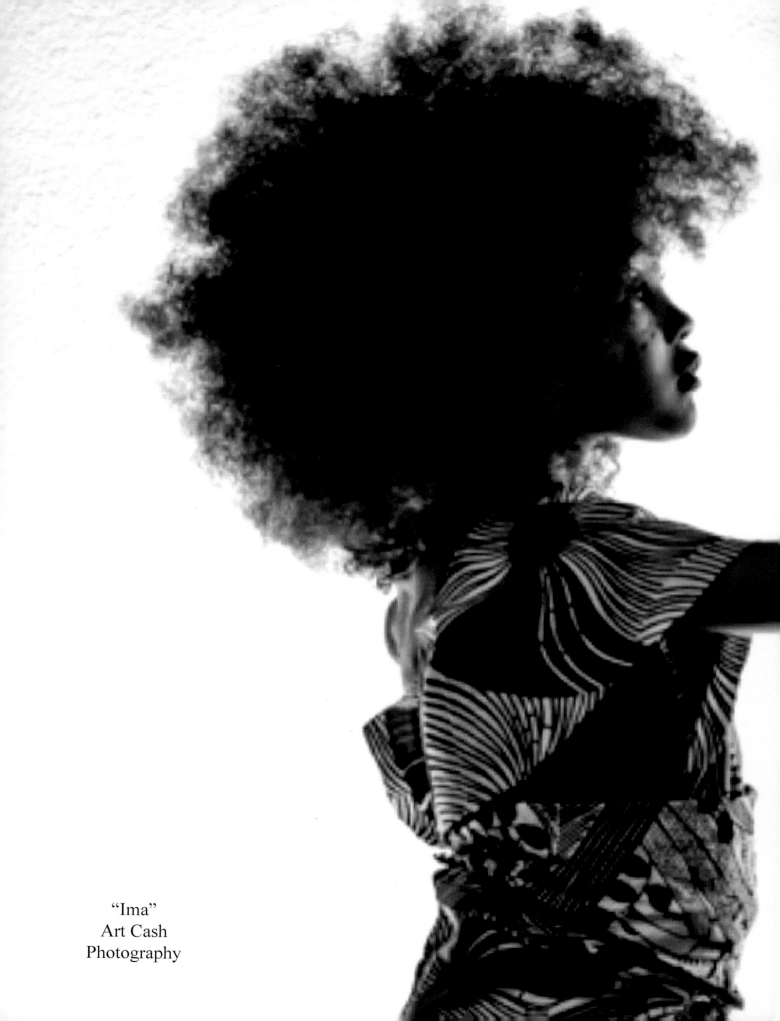

"Ima"
Art Cash
Photography

"Those who approach life like a child playing a game, moving and pushing pieces, possess the power of kings." -Heraclitus

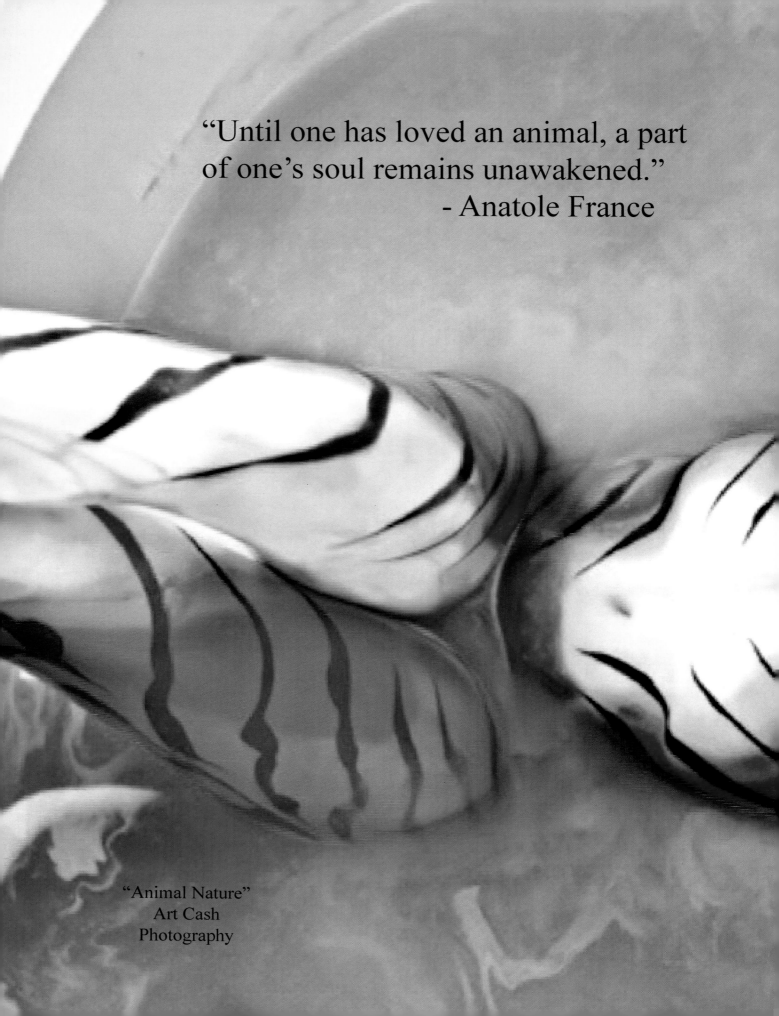

"Until one has loved an animal, a part of one's soul remains unawakened."
- Anatole France

"Animal Nature"
Art Cash
Photography

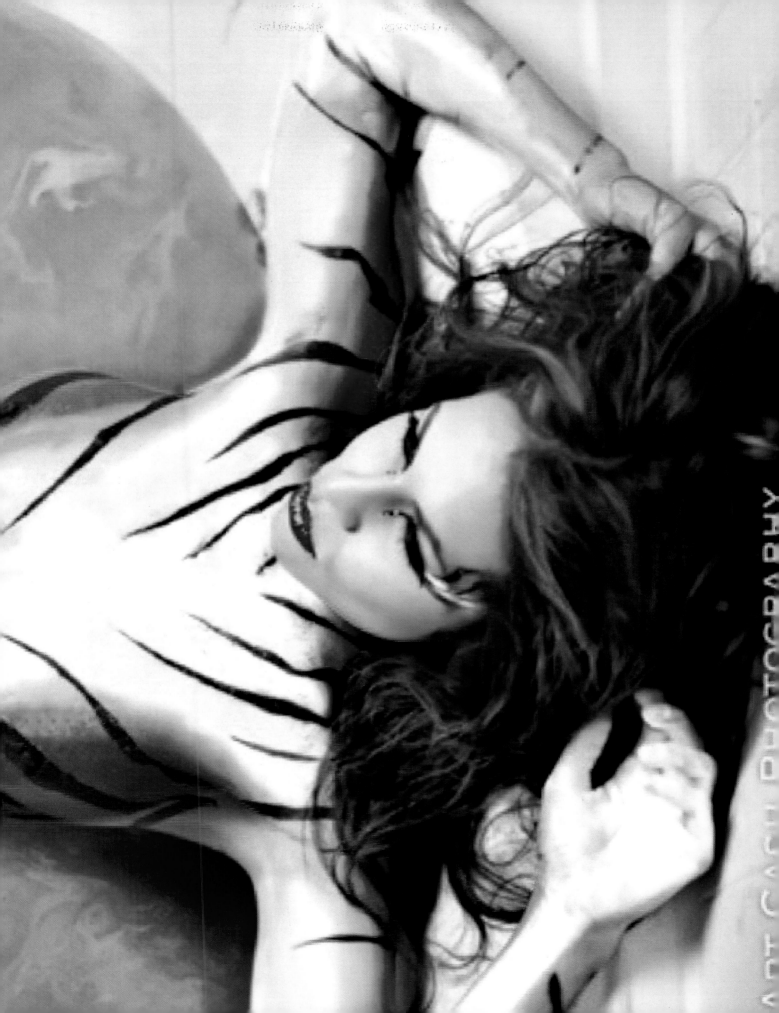

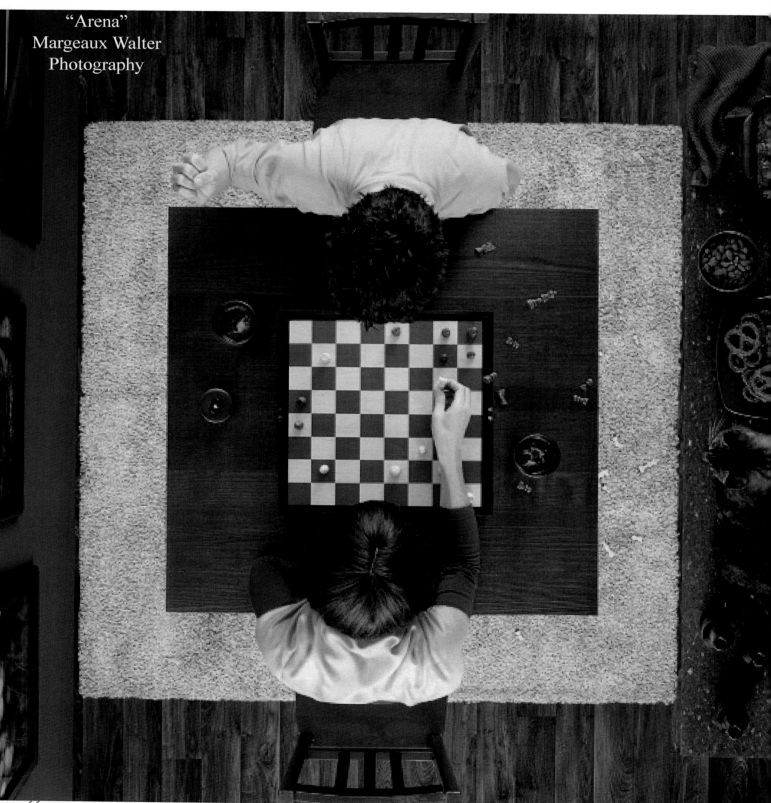

"One Best Book is Equal To Hundred Good Friends But One Good Friend is Equal To A Library."

-Abdul Kalam

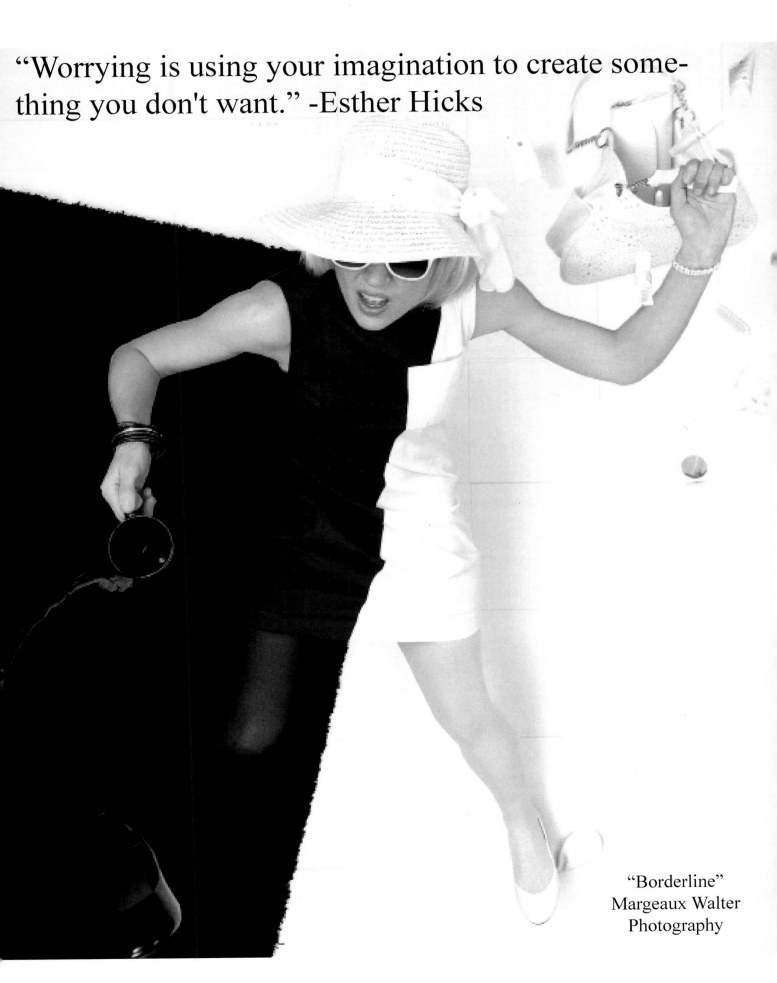

"Worrying is using your imagination to create something you don't want." -Esther Hicks

"Borderline"
Margeaux Walter
Photography

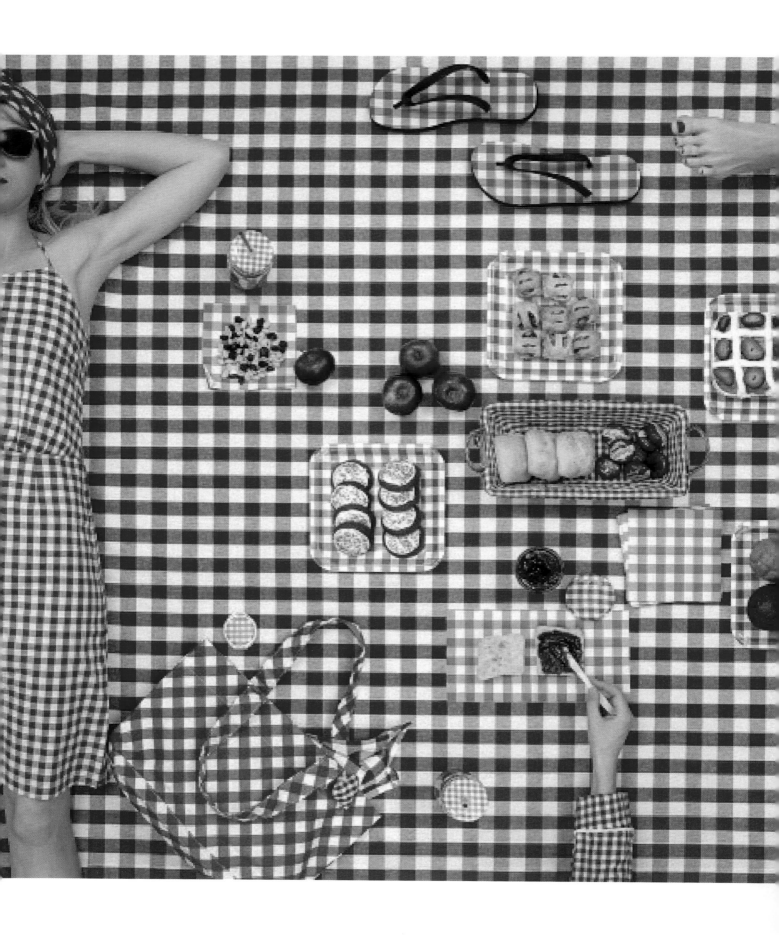

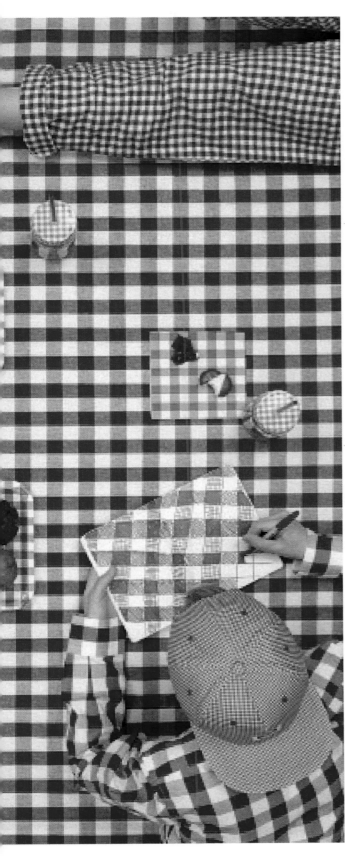

"The best things in life are free. And it is important never to lose sight of that. So look around you. Wherever you see friendship, loyalty, laughter, and love... there is your treasure."
-Neale Donald Walsch

"Checkmate"
Margeaux Walter
Photography

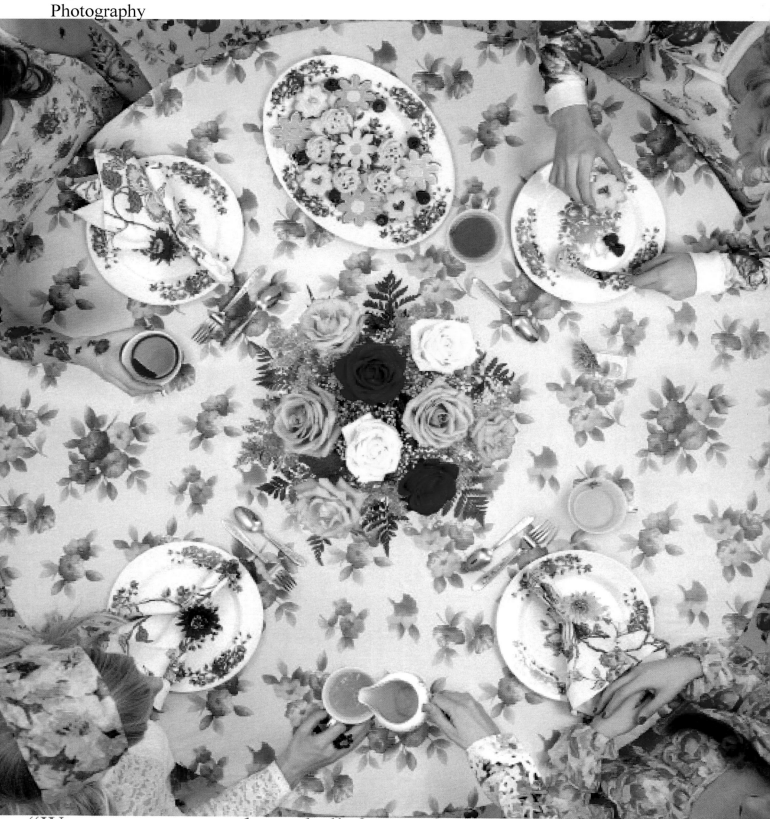

"In Bloom"
Margeaux Walter
Photography

"We are never more than a belief away from our greatest love, deepest healing, and most profound miracles."-Gregg Braden

"Good manners without sincerity are like a
beautiful dead lady." -Sri Yukteswar Giri

"Primary"
Margeaux Walter
Photography

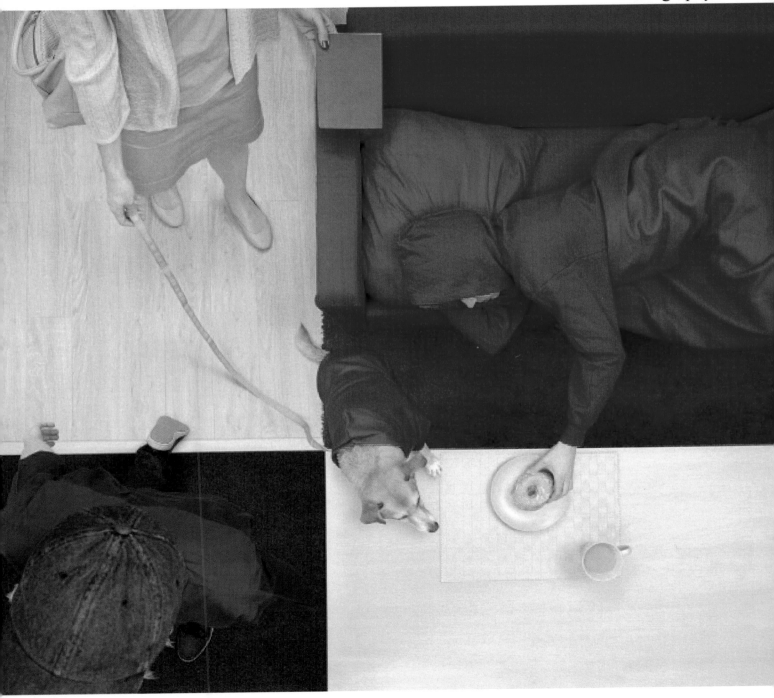

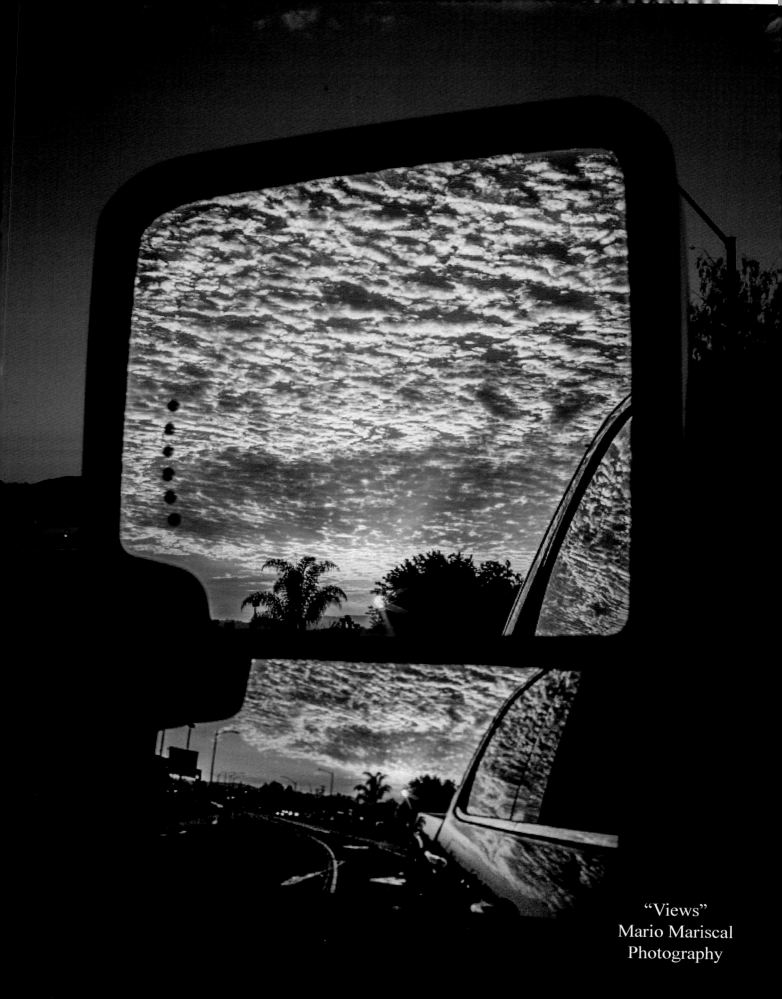

"Views"
Mario Mariscal
Photography

"I will practice coming back to the present moment...not letting regrets and sorrow drag me back into the past or letting anxieties, fears, or cravings pull me out..."

-Nhat Hanh

Ego says, "Once everything falls into place, I'll feel peace". Spirit says, "Find your peace, and then everything will fall into place".
 -Marianne Williamson

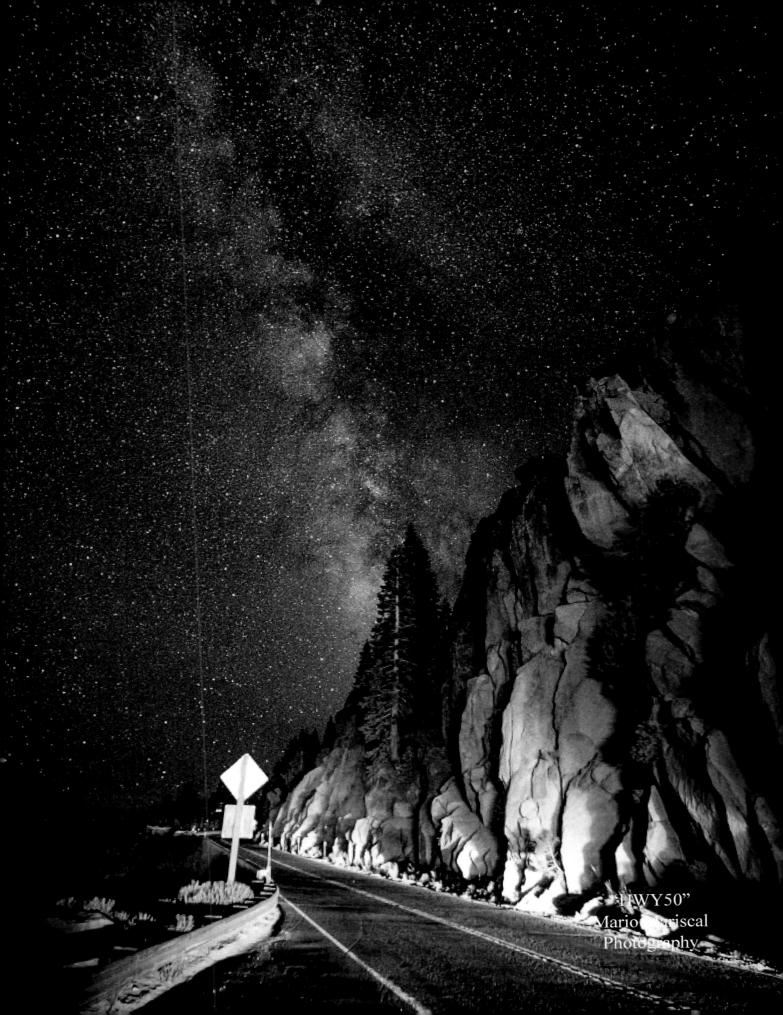

"HWY50"
Mario Mariscal
Photography

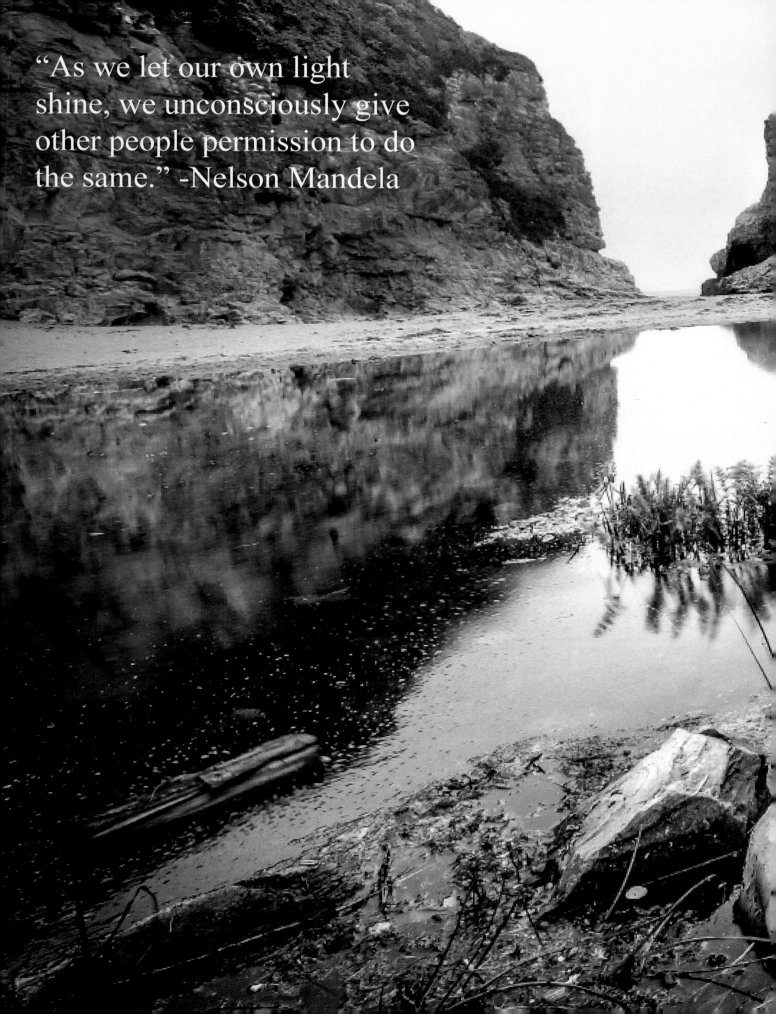

"As we let our own light shine, we unconsciously give other people permission to do the same." -Nelson Mandela

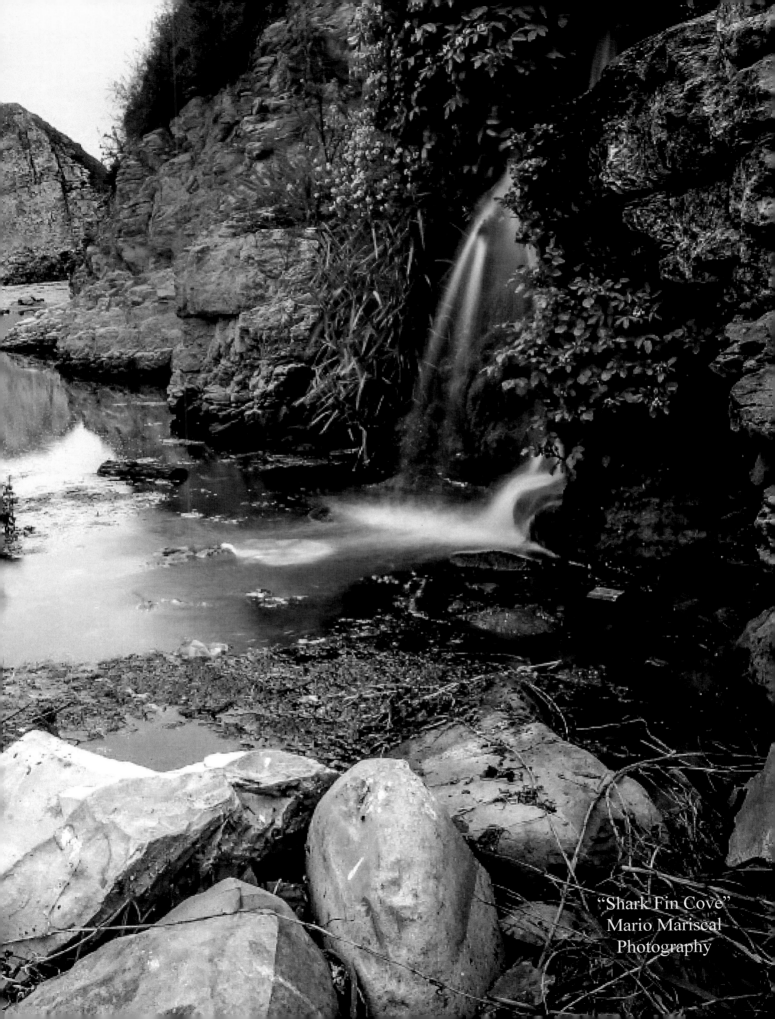

"Shark Fin Cove"
Mario Mariscal
Photography

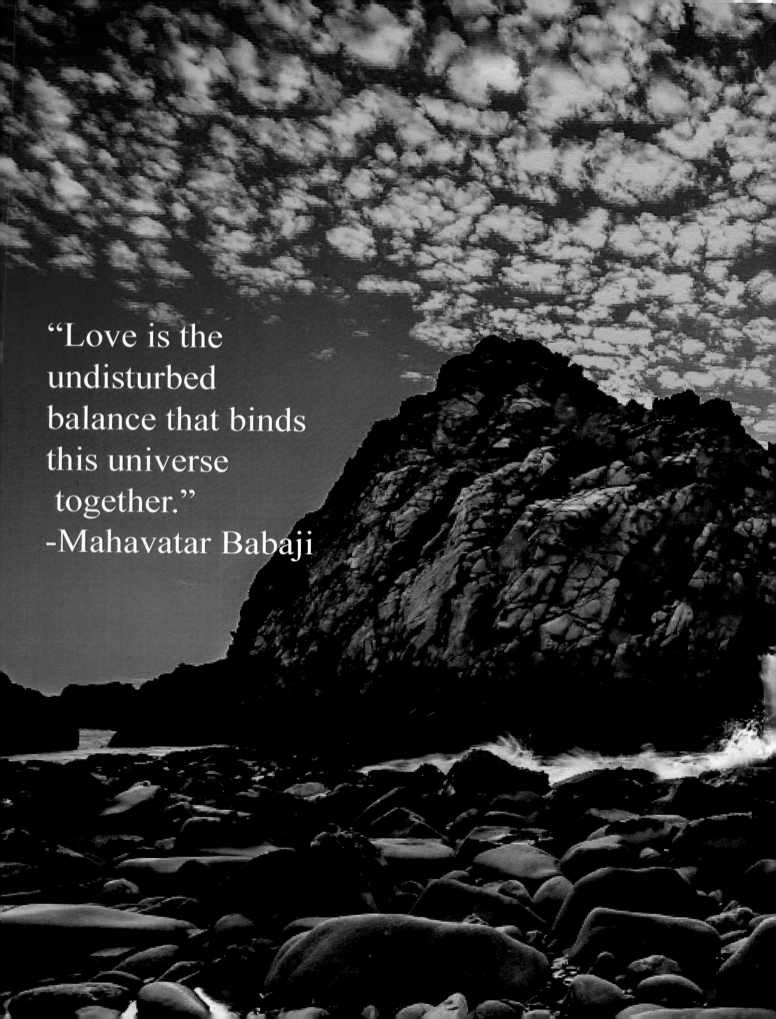

"Love is the undisturbed balance that binds this universe together."
-Mahavatar Babaji

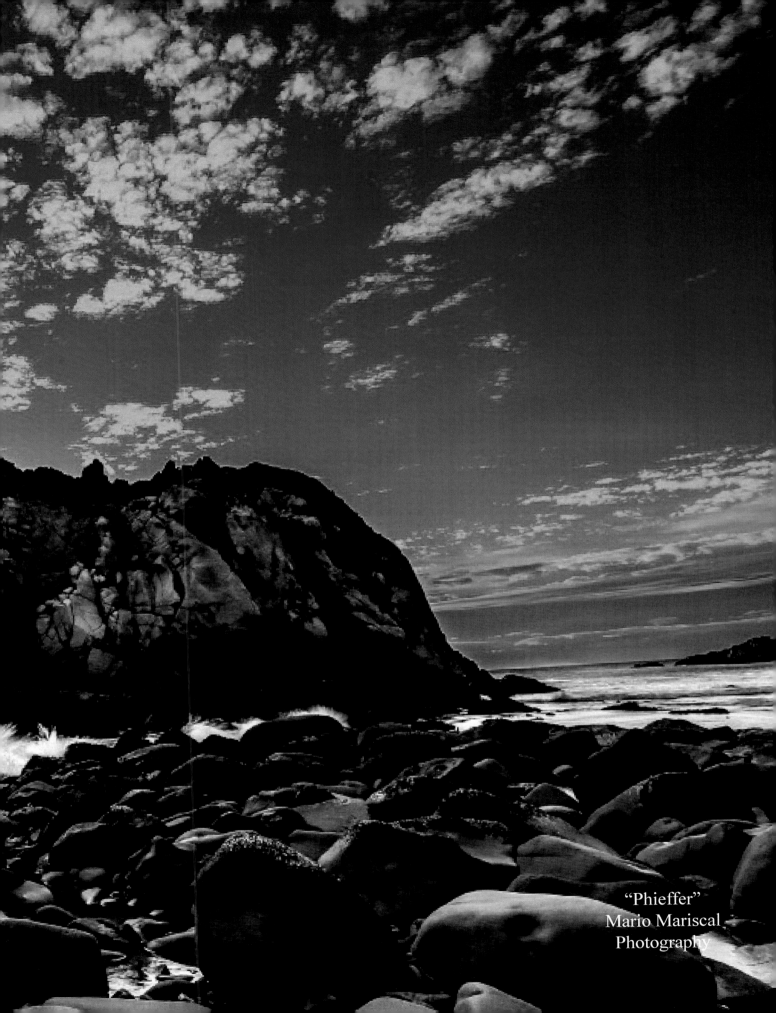

"Phieffer"
Mario Mariscal
Photography

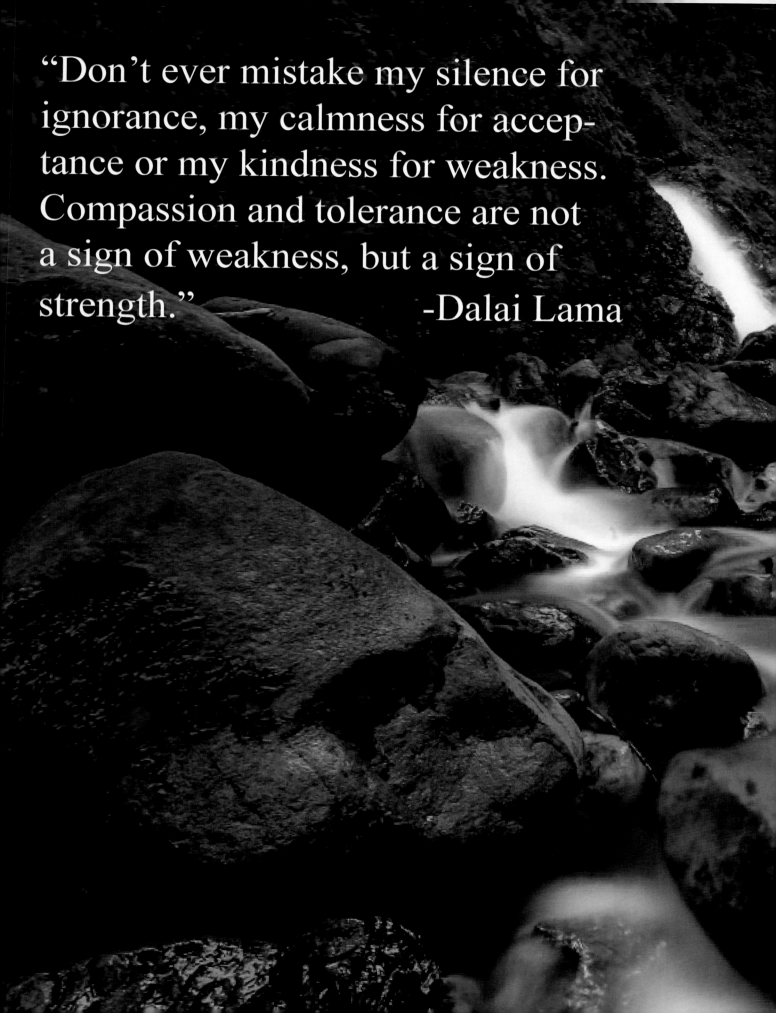

"Don't ever mistake my silence for ignorance, my calmness for acceptance or my kindness for weakness. Compassion and tolerance are not a sign of weakness, but a sign of strength." -Dalai Lama

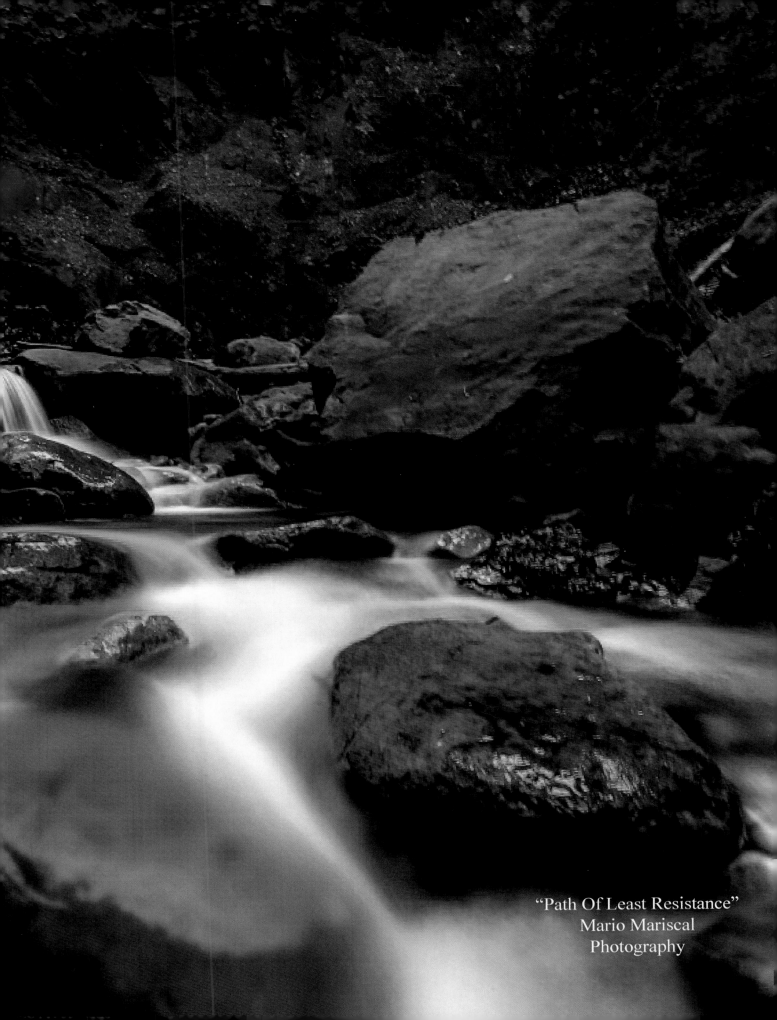

"Path Of Least Resistance"
Mario Mariscal
Photography

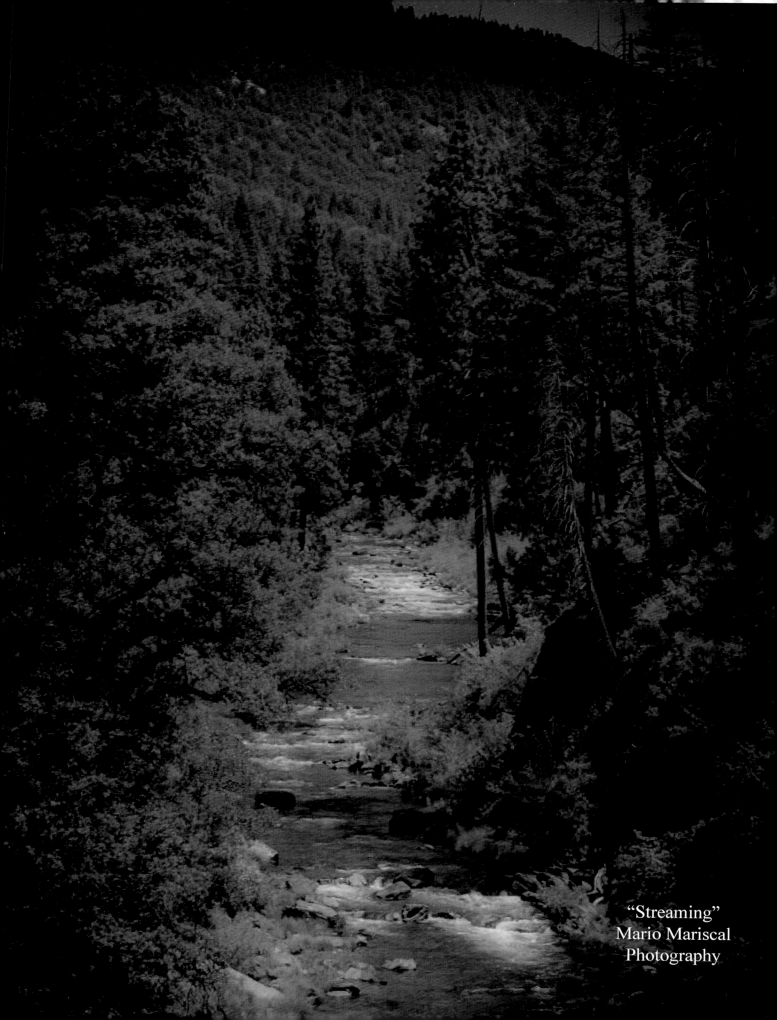

"Streaming"
Mario Mariscal
Photography

"Six mistakes mankind keeps making century after century: Believing that personal gain is made by crushing others; Worrying about things that cannot be changed or corrected; Insisting that a thing is impossible because we cannot accomplish it; Refusing to set aside trivial preferences; Neglecting development and refinement of the mind; Attempting to compel others to believe and live as we do."
-Marcus Tullius Cicero

Fajar P Domingo

EMAIL: OHFAJAR@GMAIL.COM
IG: @OHFAJAR
WWW.THELAWOFART.COM/COLLAGES/FAJARDOMINGO

Kerry Lambert

EMAIL: KERRY@ARTISANRECORDS.CO.UK
IG: @KERRY_FIN
WWW.THELAWOFART.COM/COLLAGES/KERRYFIN

Leni Smoragdova

EMAIL: NG.PITTORA@GMAIL.COM
IG: @SMORAGDOVA
WWW.THELAWOFART.COM/COLLAGES/LENISMORAGDOVA

Vasilis Delis

EMAIL: B_DELIS@HOTMAIL.COM
IG: @BLDELIS
WWW.THELAWOFART.COM/COLLAGES/BILLYDELIS

Esteban Ibarra

EMAIL: ESTEBANIB@GMAIL.COM
IG: @ESTEBANIB
WWW.THELAWOFART.COM/COLLAGES/ESTEBANIBARRA

Jeremy Patton

Email: jtpatton@TheLawOfArt.com
IG: @JimStone1911
www.TheLawOfArt.com/FineArt/JeremyPatton

Leonardo Lili

Email: Lili.Leonardo.1992@gmial.com
IG: @Leonardo.Lili.Art
www.TheLawOfArt.com/FineArt/Florini

Ozgur Demirci

Email: dmrciozgur@gmail.com
IG: @ozgurroma
www.TheLawOfArt.com/FineArt/OzgurDemirci

Tyler Schmalz

Email: AnattaArt333@gmail.com
IG: @AnattaArt
www.TheLawOfArt.com/FineArt/AnattaArt

Shaylene Reynolds

Email: Info@ShayleneReynolds.com
IG: @ShayleneReynolds
www.TheLawOfArt.com/FineArt/ShayleneReynolds

DylanPerera

EMAIL: H7DYLAN@GMAIL.COM
IG: @H7DYLAN
WWW.THELAWOFART.COM/FINEART/DYLANPERERA

Martell Holloway

EMAIL: MRHOLLOWAY@YAHOO.COM
IG: @ARTBYMARTELL
WWW.THELAWOFART.COM/FINEART/MARTELLHOLLOWAY

Phillip Hopkins

EMAIL: GARAGENATION@ICLOUD.COM
IG: @COLOUR_EDIT_IMAGE
WWW.THELAWOFART.COM/PHOTOGRAPHY/PHILLIPHOPKINS

Eren-Elif Guzel

EMAIL: ERENGUZEL@YAHOO.COM
IG: @ELIFERENGUZEL
WWW.THELAWOFART.COM/PHOTOGRAPHY/ERENELIF

JohnRiding

EMAIL: JOHN.K.RIDING@GMAIL.COM
IG: @RIDINGSTAGRAM
WWW.THELAWOFART.COM/PHOTOGRAPHY/JOHNRIDING

Dicky Sangadji

EMAIL: DickySangadji@gmail.com
IG: @Dicky_Sangadji
www.TheLawOfArt.com/Photography/DickySangadji

Brandon Nixon

EMAIL: Brandon.C.Nixon@gmail.com
IG: @Nixon_Photography
www.TheLawOfArt.com/Photography/BrandonNixonPhotography

Art Cash

EMAIL: ArtCashPix@gmail.com
IG: @ArtaviusCash
www.TheLawOfArt.com/Photography/ArtCashPhotography

Margeaux Walter

EMAIL: Margeaux.Walter@gmail.com
IG: @MargeauxWalter
www.MargeauxWalter.com

Mario Mariscal

EMAIL: mmariscal12@hotmail.com
IG: @M_Mariscal12
www.TheLawOfArt.com/Photography/MarioMariscalPhotography

The Beginning.